# Mod
# New York

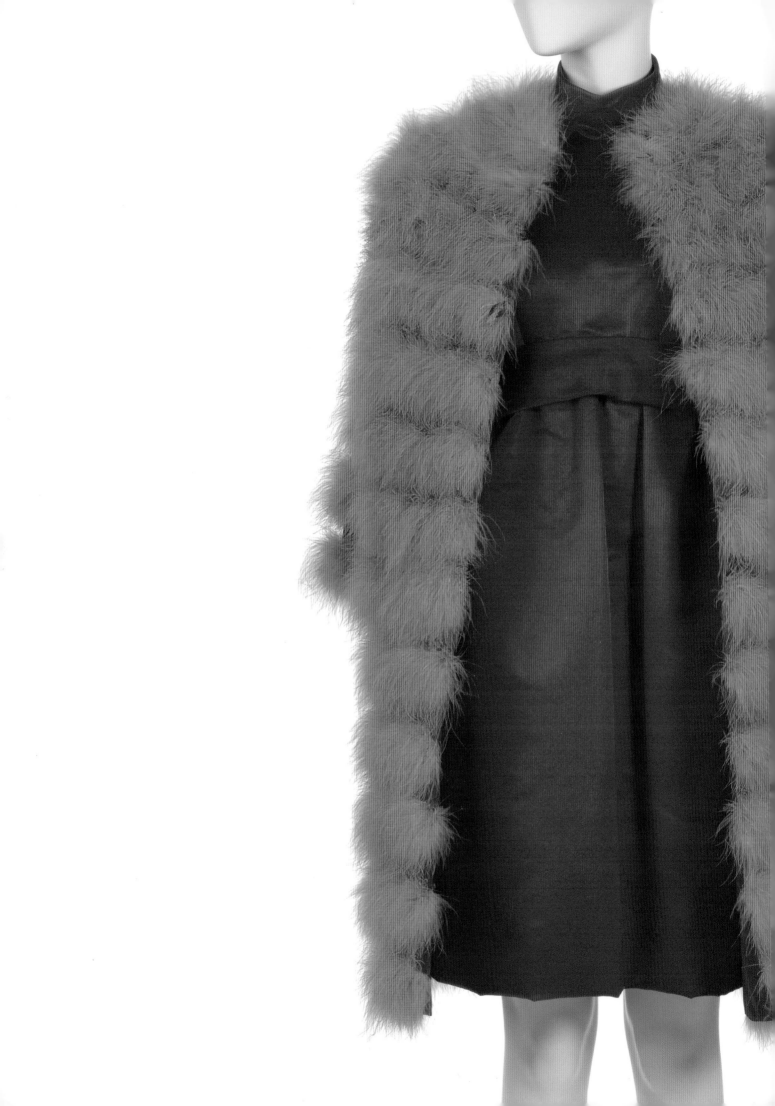

# Mod
# New York
# Fashion
# Takes a Trip

Edited by
**Phyllis Magidson and Donald Albrecht**

Foreword by
**Whitney W. Donhauser**

With essays by
**Kwame S. Brathwaite, Hazel Clark, Sarah Gordon,
Phyllis Magidson, and Caroline Rennolds Milbank**

**Museum of the City of New York**
**The Monacelli Press**

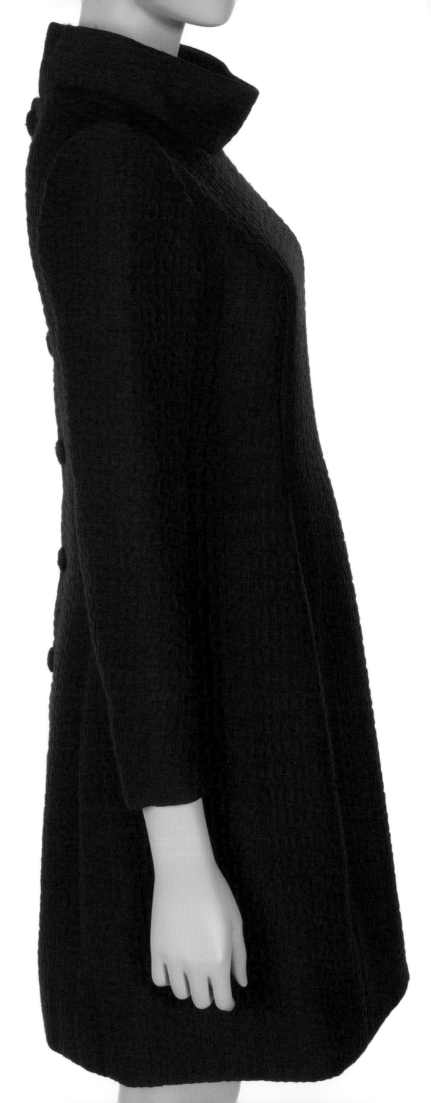

Cover: Simone, photograph by
Saul Leiter for *Harper's Bazaar,*
ca. 1963.

Frontispiece: Geoffrey Beene,
evening ensemble comprising satin
dress and maribou coat, 1967.

Right: Arnold Scassi, dress of
matelessé, 1969.

First published in the United States
by The Monacelli Press

Library of Congress Control Number
2017939375
ISBN 978158093-498-5

Designed by Yve Ludwig
Printed in China

The Monacelli Press
6 West 18th Street
New York, New York 10011

# Foreword

*Mod New York: Fashion Takes a Trip* accompanies a major exhibition of the same name that has been organized by the Museum of the City of New York to highlight a selection of its aesthetically groundbreaking and historically significant garments from the 1960s. *Mod New York* demonstrates that between 1960 and 1973, American fashion underwent radical aesthetic transformations that brought about a wider stylistic diversity in silhouette, length, and pattern than had been seen in earlier decades as well as still-relevant changes in the way clothes were constructed, marketed, and sold. Clothing also assumed communicative powers—reflecting contemporary societal changes such as the emergence of a counterculture, the women's liberation movement, and the rise of African-American consciousness. New York City, the nation's fashion capital, served as the stage where these revolutions played out.

In order to tell this complex story, *Mod New York* combines essays devoted to the aesthetics of fashion alongside texts exploring clothing's cultural and social contexts. The era's aesthetic transformations are examined in four parts, showcasing newly created photographs of the museum's extraordinary collections. Starting in 1960, the first part focuses on the influence of the young and stylish First Lady Jacqueline Kennedy, whose classically styled suits and coats and coordinated ensembles bridged the conformist 1950s and the anything-goes 1960s. The next part looks at the mid-1960s, a time when both Seventh Avenue veterans and striving newcomers embraced everything young, adopting sleek, body-skimming silhouettes and experimental fabrics. The third part examines the new bohemia of the late 1960s, when even the most traditional of fashion designers could not resist the beguiling excesses

of exoticism, romanticism, and theatrical fantasy. The last part chronicles the emergence of a tamer, more subdued response to the preceding decade's boldness in fashion, concluding in 1973, when a fashion show at Versailles pitted Parisian designers against their New York counterparts and resulted in American fashion gaining unprecedented stature in the eyes of the French.

In addition to these essays focusing on aesthetics, four additional essays explore broader themes. They analyze fashion and merchandising, most notably the rise of the hip boutique in New York; fashion and modern art, demonstrating how the era's simple chemise became a canvas for visual movements from Op Art to Art Nouveau; fashion as both a source and a symbol of the decade's feminism; and, finally, the emergence of African-American consciousness and the "Black is Beautiful" movement.

*Mod New York* has been undertaken under the guidance of Phyllis Magidson, the Museum's Elizabeth Farran Tozer Curator of Costumes and Textiles, and Donald Albrecht, the Museum's Curator of Architecture and Design. I want to thank them for their efforts, as well as those of the book's other authors: Kwame S. Brathwaite, Hazel Clark, Sarah Gordon, and Caroline Rennolds Milbank. I also want to acknowledge the skills of Yve Ludwig, who created the book's elegant and stylish design. It is also a pleasure to work once again with Elizabeth White of The Monacelli Press.

Finally, I want to thank the funders who made *Mod New York* possible, most notably the Laura S. Johnson Fund and the Coby Foundation. Additional support has been provided by the New York State Council on the Arts, Bonnie Cashin Fund, Geraldine Stutz Trust, the Nando and Elsa Peretti Foundation, Marcia Dunn and Jonathan Sobel, Kamie Lightburn, Claire B. Shaeffer, William Buckner, and the Courtauld Institute. I thank them all.

Whitney W. Donhauser
*Ronay Menschel Director and President*

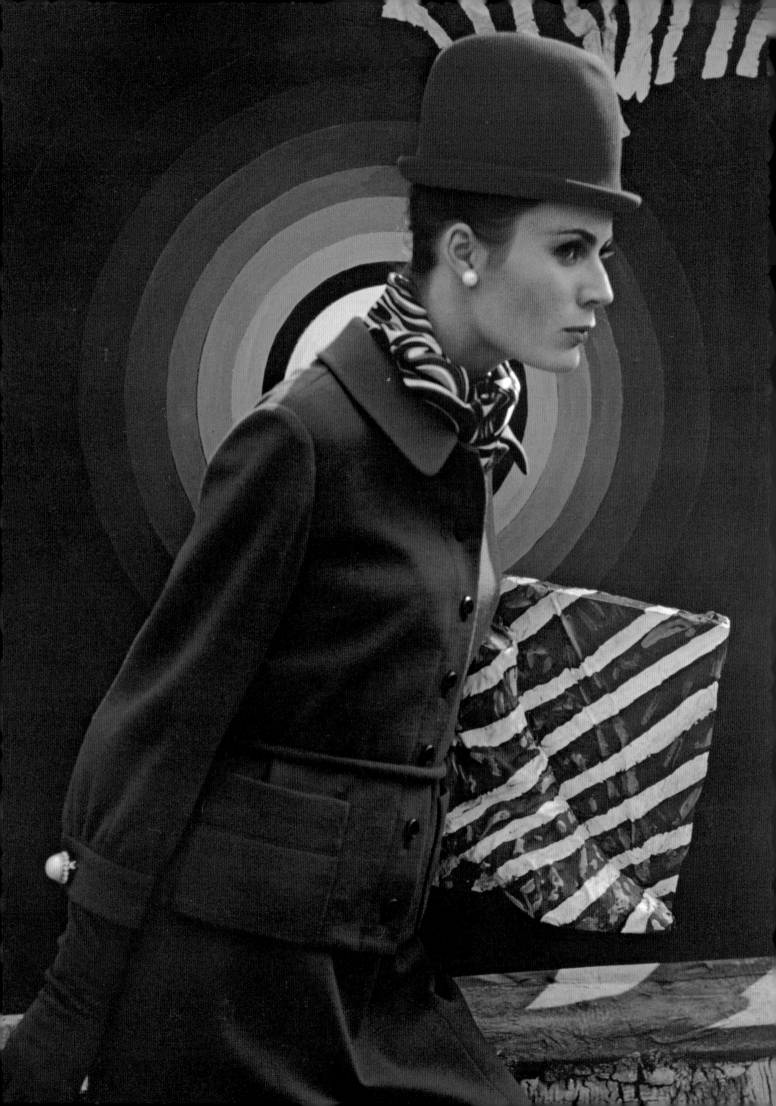

# A Brief History

**Donald Albrecht and Phyllis Magidson
with Sarah Jane Rodman**

## 1940–1960

American fashion came of age during World War II. The nation was forced to relinquish its centuries-old reliance on Paris's fashion leadership when the Nazi occupation in June 1940 isolated the city's couture houses from the rest of the world. While the New York-based American fashion industry had demonstrated its manufacturing and retailing prowess, it was still not widely recognized for design creativity, and the fashion-conscious public was skeptical of its ability to substitute for Paris's fashion leadership. Magazines such as *Harper's Bazaar* and *Vogue* set out to change this perspective and, in the process, helped foster the maturing of the United States as a center of fashion design. Inaugurating special issues devoted to American style, these magazines promoted confidence in home-grown fashion and, most notably, New York designers such as Valentina and Hattie Carnegie, as well as the anonymously designed products of New York stores like Henri Bendel and Bergdorf Goodman's Custom Salon. Another boost to America's self-image as a fashion center occurred with the relocation to New York of Parisian couturier Mainbocher in November 1940. In the eyes of American consumers, Paris couture's acceptance of Chicago-born Mainbocher in the 1930s validated him and, by extension, native talent. The public's confidence in the nation's fashion independence was further enhanced by the 1942 inauguration of the Coty American Fashion Critics' Award. Sponsored by fragrance house Coty, conceived and coordinated by New York-based fashion publicist Eleanor Lambert, and conferred by a panel of jurors, the awards (known as Winnies) recognized outstanding interpretations of American fashion trends and made New York designers' names increasingly familiar to the public.

Postwar American fashion continued to evolve into a distinctive style led by New York designers even after Paris's return to full productivity and high status with the celebrated Dior New Look of 1947. Throughout the late 1940s and 1950s, designers like Norman Norell, Nettie Rosenstein, Adele Simpson, and Clare Potter masterminded an "American look." In contrast to Paris's emphasis on fashion aesthetics and clothing as high art, these New York designers created clothes for the American woman that were informal and easy to wear—dresses, suits, and separates that followed the decade-defining hourglass silhouette, with its fitted body and small shoulders, a cinched waistline, and a voluminous skirt. "American chic," *Vogue* announced in 1957, consciously using a French word to acknowledge New York's newfound capacity to vie with Paris, "is easier to spot than to analyze . . . It is a look and more than a look . . . that grows out of the woman—not on the woman."

The election of John F. Kennedy as President in November 1960 launched not only an era of changes in the political, social, and cultural order, but also in the fashion realm, introducing a stylish First Lady, Jacqueline Kennedy. Her youthful beauty and fashionable elegance quickly made her an influential trendsetter for American women and an international icon of a new American sense of style and taste.

Photograph by Saul Leiter for *Harper's Bazaar*, 1963.

# 1960

## Women's Wear Daily

John Fairchild takes over *Women's Wear Daily,* transforming the trade publication, which was founded in 1910, into a hip fusion of fashion, entertainment, and celebrity.

Four African-American college students stage a sit-in at a Woolworth store in Greensboro, North Carolina.

First presidential debates are televised, featuring Richard M. Nixon and John F. Kennedy, who defeats Nixon in the election.

## Norman Norell

Norman Norell dissolves his partnership in Traina-Norell and opens his own fashion house.

## Coty Awards

Coty Awards go to Italian-born Sarmi ("famous for his evening clothes," according to the Coty committee of American fashion critics) and French-born Jacques Tiffeau, designer of coats and suits. A Special Award is given to Rudi Gernreich.

United States Food and Drug Administration (FDA) announces the first oral contraceptive.

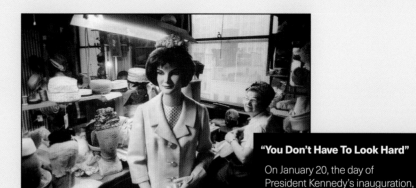

East German government begins construction of the Berlin Wall, dividing the city into two.

# 1961

**"You Don't Have To Look Hard"**

On January 20, the day of President Kennedy's inauguration, *Life* magazine publishes the article "You Don't Have To Look Hard . . . To See Another Jackie." It chronicles Jackie-inspired fashions, including where to buy them at affordable prices.

**I. Miller**

I. Miller's new shoe emporium, designed by Victor Lundy, opens at West 57th Street and Fifth Avenue. "It is breathtaking, this interior," Olga Gueft writes in *Interiors* magazine, "where sinuous ribs of weathered wood rise to sheathe the walls and columns."

**International Best-Dressed List**

Jacqueline Kennedy is elected to the Best-Dressed List. According to the list's creator, fashion publicist Eleanor Lambert, Kennedy "swept to the top of the list of 12 women."

**Breakfast at Tiffany's**

The film version of Truman Capote's novella opens, popularizing Audrey Hepburn in her "little black dress."

President Kennedy vows to win the space race against the Soviet Union and to land an American on the moon within a decade.

**"Paris Original"**

The musical *How to Succeed in Business Without Really Trying* premieres on Broadway. It features the number "Paris Original," in which the female lead arrives at a reception wearing the same dress as all the other women. The scene reflects a contemporary manufacturing and marketing trend—the Paris copy.

**Coty Awards**

A Coty Award goes to Bill Blass, who is designing for Maurice Rentner and honored for his "consistently elegant, well-bred approach to design." Special Awards go to Bonnie Cashin, cited for her "leather-trimmed styles for Philip Sills," and Mr. Kenneth (Battelle), a hairstylist for Daché salon and Jacqueline Kennedy.

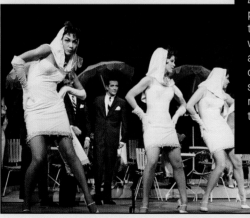

# 1962

John Glenn is the first American to orbit Earth.

## "Black is Beautiful"

At Harlem's "Purple Manor," photographer Kwame Brathwaite and his brother Elombe Brath present a fashion show called *Naturally '62: The Original African Coiffure and Fashion Extravaganza Designed to Restore Our Racial Pride and Standards*, which evolves into an annual series.

The Cuban Missile Crisis comes to a head with an American blockade of the Caribbean island, forcing Soviet ships to turn back.

## Diana Vreeland

Diana Vreeland joins *Vogue* and soon becomes editor-in-chief, inaugurating the concept of a doyenne of high fashion, a position she retains for the balance of the decade.

## Coty Awards

The Coty Award goes to Donald Brooks, a designer for Townley, for his "clean, clear lines, marvelous prints which he designs himself and sporty American clothes." A Special Award goes to Halston, a custom milliner at Bergdorf Goodman.

First Walmart opens in Rogers, Arkansas.

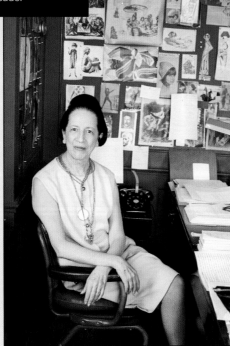

Civil rights advocates gather on the Mall in Washington, D.C., where Martin Luther King Jr. delivers his "I Have a Dream" speech.

# 1963

## David Webb

David Webb, whose boldly colored geometric and animal-inspired bracelets, necklaces, and earrings are the decade's signature fine jewelry, opens a boutique at 7 East 57th Street.

## Design Research International

D/R International, the Cambridge-based shop specializing in modern products, opens on East 57th Street with an interior by architect Ben Thompson. Its wares include clothes by the Finnish company Marimekko.

President Kennedy is assassinated in Dallas and Vice President Lyndon B. Johnson is sworn in as President.

## Coty Awards

The Coty Award goes to Rudi Gernreich, cited for his "kookie Kabuki" knit dresses designed for Harmon Knitwear. Bill Blass, who first received a Coty in 1961, wins a Return Award.

The Feminine Mystique by Betty Friedan is published.

### Topless Bathing Suit

Rudi Gernreich's "monokini" makes its photographic debut in the June 2, 1964, issue of *Look*.

United States Civil Rights Act is enacted, banning discrimination based on race or sex.

### Miniskirts

*Vogue* endorses Mary Quant's newly introduced miniskirt in its March issue.

# 1964

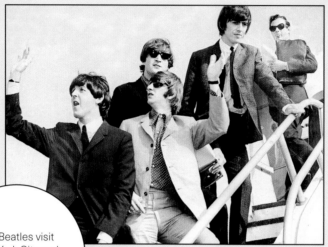

Lyndon B. Johnson is elected President, defeating Arizona Senator Barry Goldwater.

The Beatles visit New York City and appear on Ed Sullivan's television show.

### Serendipity 3

Serendipity 3 boutique on East 60th Street hires designer Leila Larmon to create a wholesale collection that is presented to buyers from neighboring Bloomingdale's as well as Henri Bendel.

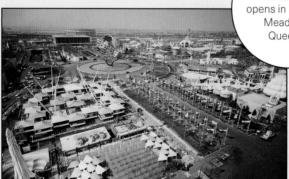

New York World's Fair opens in Flushing Meadows, Queens.

### Coty Awards

The Coty Award goes to Geoffrey Beene and a Return Award to Jacques Tiffeau of Tiffeau and Busch; both are cited for their "non-static, non-traditional, and witty approach to fashion." A Special Award goes to David Webb. The awards were presented at the Metropolitan Museum of Art. "Action backdrops," according to the *New York Times*, "included shots of Watusi tribesmen, moon landings, the Beatles, skyscrapers soaring, and 'Dig We Must' signs."

### "No Bra" Bra

Rudi Gernreich introduces the un-constructed "No Bra" bra, manufactured by Exquisite Form.

## 1965

**Malcolm X is assassinated in New York.**

### Youthquake

In *Vogue*'s January 1 issue, Diana Vreeland's lead editorial declares a fashion "Youthquake." "The year's in its youth," she writes, "the youth in its year . . . Here. Now. Youthquake 1965."

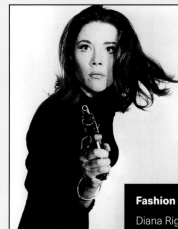

### Fashion on Television

Diana Rigg, costumed in leather catsuits and bold, avant-garde designs by John Bates, assumes the role of Mrs. Emma Peel in the British television series *The Avengers*, furthering the popularity of the British Mod look.

### Hattie Carnegie

The Hattie Carnegie Custom Salon, a mainstay of pre- and postwar New York fashion, closes. The company continues to produce hats, jewelry, and accessories until 1976.

**United States Voting Rights Act is signed into law.**

**Highway Beautification Act is enacted.**

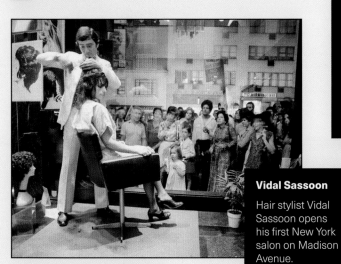

### Paraphernalia

Paraphernalia boutique opens on Madison Avenue between 67th and 68th Streets, adjacent to Vidal Sassoon's salon.

### Youthquake Fashion

The Puritan Fashions Corporation under Carl Rosen works with Paul Young and launches the "Youthquake" clothing label.

### Vidal Sassoon

Hair stylist Vidal Sassoon opens his first New York salon on Madison Avenue.

### Donyale Luna

A drawing of Donyale Luna appears on the January cover of *Harper's Bazaar,* the first time an African-American model is featured.

**Riots break out in the Watts neighborhood of Los Angeles.**

### Coty Awards

A Coty Award goes to Pablo, a make-up artist for Elizabeth Arden, for his "imaginative eye treatments." Nine designers received special recognition for their creation of "young fashion."

# 1966

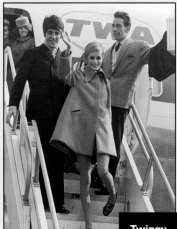

**Medicare** federal insurance program goes into effect.

## Fashion on Film

Fashion is the subject of both Michelangelo Antonioni's *Blow Up*, which examines the life of a fashion photographer and features top model Veruschka, and William Klein's *Qui êtes vous, Polly Maggoo*, which spoofs French couture.

## Twiggy

London's *Daily Express* declares model Twiggy the face of 1966, noting "The Cockney Kid with a face to launch a thousand shapes . . . and she's only 16!"

United States warplanes bomb North Vietnam targets for the first time.

## Latinas

Designed by fashion designer Bill Hock, Latinas boutique opens on Madison Avenue at 66th Street. Its entry doors are a psychedelic spectacle of mirrored hubcaps.

## Bigi

Bergdorf Goodman opens its Bigi boutique, designed by Tom Lee and targeted at 12 to 17 year olds.

National Organization for Women (NOW) is founded in Washington, DC.

United States space probe Surveyor I lands on the moon.

## Black and White Ball

Inspired by the sensational debut of his novel *In Cold Blood*, Truman Capote holds his "Black and White Ball" at the Plaza Hotel in honor of *Washington Post* publisher Katharine Graham. The evening marked the confrontation of disparate fashion worlds, from New York's establishment to its rising avant-garde.

## Whitney Museum

The Whitney Museum of American Art opens on Madison Avenue. "One of the most eclectic fashion shows of the decade" as fashion writer Marilyn Bender describes the opening party.

## Coty Awards

Return Awards go to Rudi Gernreich and Geoffrey Beene. A Special Award is presented to costume jeweler Kenneth Jay Lane for his "chandelier-like rhinestone earrings and bulky bracelets."

## 1967

### James Galanos

*Women's Wear Daily* declares James Galanos the "leader of American fashion" on its front page.

Thurgood Marshall is appointed the first African-American Supreme Court justice.

### Ralph Lauren

Ralph Lauren is founded by the Bronx-born fashion designer, initially retailing ties.

Thousands attend a Be-In in New York's Central Park.

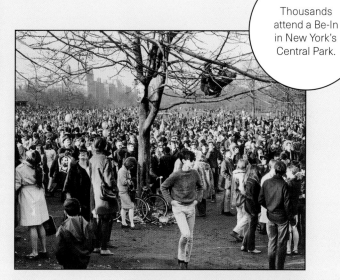

### Fashion on Film

*Bonnie and Clyde,* set in the Depression, fuels an interest in vintage clothing and nostalgic looks. Later films to build on this phenomenon include *The Damned* (1969) and *Lady Sings the Blues* (1972).

### Charivari

Selma Weiser's Charivari boutique opens on Broadway between 85th and 86th Streets.

First issue of *Rolling Stone* magazine is published.

### Naomi Sims

On August 27, Naomi Sims is the first African-American model to be shown on the cover of *Fashions of the Times*, a supplement to the *New York Times Magazine.*

### Coty Awards

The Coty Award goes to Oscar de la Renta.

### Deanna Littell

After designing for Paraphernalia, Deanna Littell is wooed by Geraldine Stutz to design for Henri Bendel's Fancy private label collection, called "Deanna Littell for Bendel's Studio."

The Black Panther Party opens its first headquarters in Oakland, California.

**1968**

### Anne Klein

Anne Klein and Co. is founded in collaboration with fashion guru Gunther Oppenheim.

Martin Luther King Jr. is assassinated in Memphis.

### Rive Gauche

French couturier Yves Saint Laurent opens Rive Gauche, the city's first boutique to retail a pret-a-porter collection with a couture aesthetic, at Madison Avenue and 71st Street. It follows two years after Saint Laurent's 1966 Paris debut of his revolutionary ready-to-wear collection and the Rive Gauche label and store.

### Halston

Departing Bergdorf Goodman's Custom Salon, Roy Halston Frowick, better known as Halston, creates his Halston Ltd. label, producing form-defining clothing in silk jersey and body-enhancing chiffons. Halston also opens his first boutique at East 68th Street and Madison Avenue.

### Calvin Klein

Calvin Klein founds Calvin Klein Limited, initially a coat shop in the York Hotel.

The rock musical *Hair* opens on Broadway.

Robert F. Kennedy is assassinated in Los Angeles.

### Coty Awards

A Coty Award goes to George Halle, cited as a "specialist in spectacular evening dresses," and Return Awards go to Bonnie Cashin and Oscar de la Renta.

Anti-Vietnam War protestors battle with Chicago police during the Democratic National Convention.

### Clinique

Estée Lauder launches a new line of cosmetics under the name Clinique.

*Julia*, the first prime-time television sit-com starring an African-American actress, Diahann Carroll, premieres.

### O Boutique

Stephen Burrows and associates open O Boutique, his first retail showcase, on 19th Street off Park Avenue South.

Richard M. Nixon defeats Minnesota Senator Hubert Humphrey to win the presidency.

**Ralph Lauren**

Ralph Lauren opens Ralph Lauren Polo Shop within Bloomingdale's, the first in-store designer boutique.

LGBT New Yorkers demonstrate at the Stonewall Inn, launching the modern gay rights movement.

**L'eggs**

Hanes introduces the L'eggs brand of pantyhose, sold in distinctive white plastic, egg-shaped containers.

# 1969

**Bergdorf Goodman's Custom Salon**

Bergdorf Goodman closes its Custom Salon. "Everyone is much more conscious of the problems of the ghetto areas and world-wide problems," store president Andrew Goodman says in the *New York Times*, "and being overly extravagant is in poor taste and not of the moment."

***Interview***

Andy Warhol's *Interview* magazine is launched as a nexus of art, fashion, and celebrity.

Woodstock music festival takes place on a farm in upstate New York.

**Design Works**

Design Works of Bedford-Stuyvesant is founded in Brooklyn. This operation recruits and trains local residents to work as designers and printers of textiles, often with African inspiration.

Charles Manson and his "family" commit a series of murders, including that of actress Sharon Tate, in California.

**Jacqueline Kennedy Onassis**

A transformed Jacqueline Kennedy Onassis is a paparazzi favorite on New York streets.

The ARPANET, a precursor of the Internet, is established.

American astronaut Neil Armstrong is the first man on the moon.

**Dakota Transit**

Andrea Aranow founds Dakota Transit, a boutique in the East Village specializing in custom-made patchwork clothes and accessories made of exotic materials like snakeskin. Clients include musicians Jimi Hendrix and Miles Davis, among others.

**Coty Awards**

A Coty Award goes to Stan Herman of Mr. Mort, who has given "the American woman soft and swing dresses at prices that most of his public can afford," and a Return Award goes to Anne Klein, noted for her "pulled-together sportswear."

The first Earth Day is observed on April 22.

During a demonstration against the Vietnam War, unarmed Kent State University students are killed by the Ohio National Guard, launching widespread campus unrest.

## Rags

*Rags*, a short-lived magazine that emphasizes counterculture fashion, is launched with editorial and advertising offices in San Francisco and New York. An October cover story denounces "fashion fascism," largely in response to the industry's promotion of midi-length skirts.

## Midi-length skirts

The fashion industry attempts to popularize midi-length skirts. *Life* publishes a cover story under the headline "The Great Hemline Hassle." The midi fails to catch on.

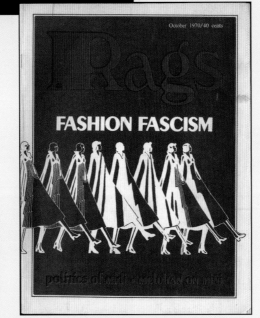

October 1970/40 cents

**Rags**

**FASHION FASCISM**

politics of midi • mcluhan on midi

## Stephen Burrows

Geraldine Stutz, owner of Henri Bendel, gives Stephen Burrows his own boutique, Stephen Burrows' World, on the third floor of the store.

Musicians Jimi Hendrix and Janis Joplin die of drug overdoses at age 27.

## Coty Awards

Coty Awards go to Giorgio di Sant'Angelo and Chester Weinberg.

## Fur

Controversies over wearing fur hit the September issue of *Vogue*, which promises to make every effort not to publish photographs showing the skins of animals threatened with extinction.

President Richard M. Nixon creates the Environmental Protection Agency.

Thousands of women participate in the Women's Strike for Equality March on Fifth Avenue to demand equality with men in many aspects of American life.

# 1971

The Supreme Court rules that the Pentagon Papers may be published by the *New York Times*.

The 26th Amendment is ratified, lowering the voting age to 18.

## Fabergé

New offices for Fabergé cosmetics open on Sixth Avenue, designed by Dallek working with young designers, most notably Stanley Felderman. The interior design expresses the company president's belief that women's and men's attitudes toward cosmetics had been liberated during the 1960s.

## Mainbocher

Mainbocher closes his New York salon.

A ban on radio and television cigarette advertisements, signed into law in 1970, goes into effect in the United States.

## "Hot pants"

Extremely short "hot pants" are introduced.

Singer Jim Morrison dies of a drug overdose at the age of 27.

## Fashion on Film

The film *A Clockwork Orange* premieres, displaying a Mod-meets-punk aesthetic.

The television show *All in the Family* premieres, chronicling intergenerational conflict.

## Coty Awards

Coty Awards go to Halston and Betsey Johnson at Alley Cat.

# 1972

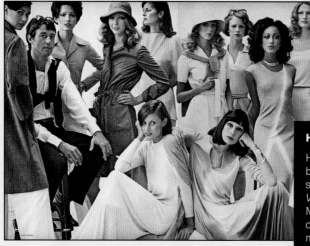

## Halston

Halston expands his couture business to include less expensive, ready-to-wear clothes. *Vogue* publishes Duane Michals's color photograph of Halston posed among his models, signaling the rising celebrity status of American fashion designers.

President Nixon is re-elected.

## Ralph Lauren

With the introduction of Polo designs for women, Ralph Lauren becomes the first major menswear designer to expand into women's apparel. The clothes are tailored like menswear with traditional male fabrics and patterns.

## Grace Mirabella

*Vogue* editor-in-chief Grace Mirabella, who replaced Diana Vreeland the previous year, announces in the magazine's January issue "a whole new *mood* of dressing— a nonchalance . . . This is the era of the woman who cares about how she looks but doesn't care to spend her day thinking about it."

The Apollo 17 flight is the nation's last manned lunar-landing mission.

President Nixon visits China, leading to the normalization of diplomatic relations between the United States and China.

Five men are arrested for burglarizing the Democratic National Committee headquarters at the Watergate office complex in Washington, DC.

## Coty Awards

The Coty Award goes to John Anthony.

## "Stevies"

Stephen Burrows's first lingerie/sleepwear collection, called "Stevies," is introduced at Henri Bendel, Bonwit Teller, Lord & Taylor, and Bloomingdale's, as well as other stores nationwide.

Supreme Court rules in favor of *Roe v. Wade*.

# 1973

The Paris Peace Accords concludes the direct involvement of the United States in the Vietnam War.

## Costume Institute

Diana Vreeland, hired in 1972 by Thomas Hoving as Special Consultant to the Costume Institute at the Metropolitan Museum of Art, mounts her first exhibition, *The World of Balenciaga*.

Vice President Spiro T. Agnew resigns, and Michigan Congressman Gerald R. Ford becomes Vice President.

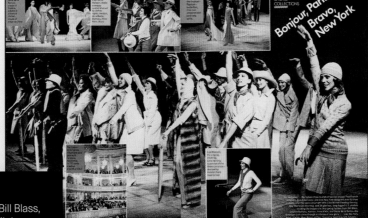

## Versailles

Five New York fashion designers—Bill Blass, Stephen Burrows, Halston, Anne Klein, and Oscar de la Renta—present their collections at a fundraising gala at Versailles outside Paris, facing off against Parisian couturiers Yves Saint Laurent, Emanuel Ungaro, Pierre Cardin, Marc Bohan of Dior, and Hubert de Givenchy. Conceived by American publicist Eleanor Lambert, it is the first time that American designers are invited by the Chambre Syndicale de la Haute Couture to show in Paris. They are cheered by the audience.

The first American space station, Skylab, is launched.

## Coty Awards

Coty Awards go to Calvin Klein and Stephen Burrows, the first African-American designer to receive one.

OPEC oil embargo declared.

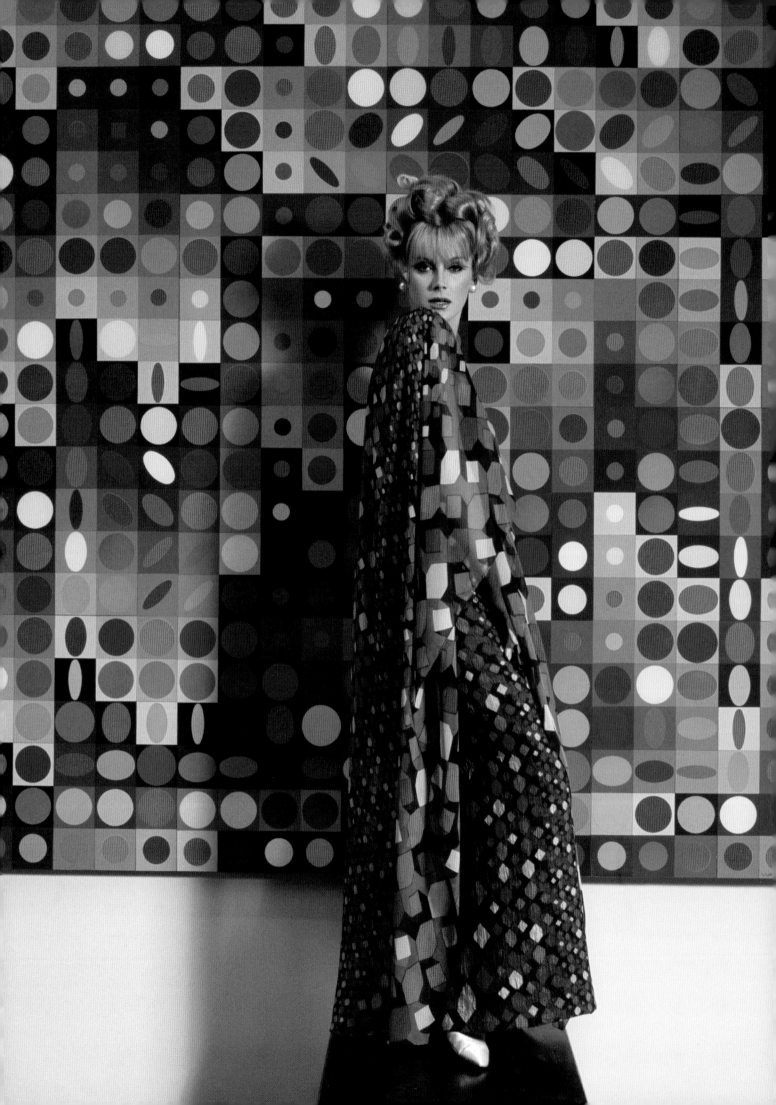

**Caroline Rennolds Milbank**

# A Shift in Fashion

As the 1960s opened, the relatively simple chemise silhouette signaled a modernist simplicity. It was the sartorial equivalent of architect Le Corbusier's "machine for living" and a sign that fashion, as an expression of contemporary life, was finally catching up to modernist furniture, decorative arts, design, and architecture. As worn by American First Lady Jacqueline Kennedy, the eased silhouette represented an immaculate elegance rooted in the haute couture of France, where the design had percolated throughout the 1950s. As the chemise became flatter and more abbreviated over the following years, however, this style came to function as a picture plane that could reflect a rapid succession of new art forms and mores—a billboard of sorts that broadcasted the changing times. In effect, the look would come to provide an ideal blank canvas. By the close of the decade, the silhouette was even adopted by men, having morphed into an ensemble of a tunic worn with pants that was proposed by designers such as Paris couturier-turned-branding impresario Pierre Cardin and New York ready-to-wear designer Geoffrey Beene. This unisex look was aimed at liberating women from mandatory skirts and men from the stultifying white-collar uniform of a business suit.

The distinctive and versatile silhouette of the 1960s was the latest chapter in a long cycle of changing styles. Indeed, the history of Western fashion can be read as a progression of evolving silhouettes. For centuries these had progressed almost organically. But by the middle of the nineteenth century, change came more rapidly, with new looks consciously driven by the dictates of designers, who chose from among three dominant approaches to dressing the female figure: imposing a shape by carving inward with corsetry; adding volume in the form of the crinoline, bustles, or leg-o-mutton sleeves; or respecting the more-or-less natural figure.

This dress by James Galanos was consistent with the Op Art paintings featured in the Museum of Modern Art exhibition *The Responsive Eye*. The image was published in "It's OP from Toe to Top," *Life*, April 16, 1965.

Natural (as opposed to extreme) silhouettes have tended to be adopted in times of greater social change. The French Revolution of the late eighteenth century, for example, banished royal-court-centered fashions and ushered in a period of dress as political statement. The period just before World War I, characterized politically by the fight for suffrage and worker's rights and outrage at the entrenched class system, had its own silhouette—the empire revival/hobble skirt. The 1920s chemise, the briefest-lasting garment in millennia, became synonymous with a liberated flapper who reacted to the horrors unleashed by a world-warring previous generation by flouting convention in all kinds of ways: abandoning underpinnings along with outdated mores, baring knees, wearing makeup, cropping hair, smoking in public. The 1960s would see another seismic cultural shift, as an entire post–World War II generation, given power by sheer numbers, rejected the values of the establishment world of their parents and embraced everything that was new: new music, new art, new experiences.

Although art and fashion had been closely intertwined for most of the decades leading up to the 1960s, what was being called Pop Art was, by its very nature, much more broadly experienced in a culture that blurred the distinctions between the fine and the commercial. Art was not just something to be visited in a museum; it could be experienced in the backdrop of a fashion photograph, in a store window, or at a happening. With just a handful of designs, Paris couturier Yves Saint Laurent established for perpetuity fashion's affinity for Pop Art. His Mondrian dress of 1965/1966 and his short and long dresses inset with stylized nude forms—inspired by the nudes of New York painter Tom Wesselmann—of 1966/1967 have come to symbolize the 1960s. Such styles were almost immediately translated into ready-to-wear and even into bathing suits. Geoffrey Beene reflected the role that team sports played in televised pop culture in his evening gowns that were floor-length, sequined football jerseys, complete with numbers emblazoned across the chest. When worn, these designs became Pop Art in motion—a point driven further home by photographer Hiro's time-lapse image of Beene's glittering jerseys shown in *Harper's Bazaar* across a double-page spread, as if in a frieze.

The simple chemise, at its most elegant in solid colors during the Kennedy administration, absorbed ever-bolder designs as the 1960s became more frantically enamored of the latest thing. Textile designers borrowed from abstract, geometric Op Art; from psychedelic art, with

its hallucinatory swirls in mind-bending color combinations; and from Art Nouveau patterns, reflecting the fonts often used in album covers, rock concert posters, and boutique advertising. Animal prints, formerly an elegant couture sideline, became not just mainstream, but were also incorporated into fashion from head to toe. Ocelot and leopard, giraffe, Dalmatian, and cowhide patterns adorned not only dresses and coats, but also stockings and shoes. Contemporaries described such patterns as "wild"; in the 1967 film *The Graduate*, director Mike Nichols dictated that the daring predator Mrs. Robinson, played by Anne Bancroft, would wear leopard (and occasionally giraffe) in virtually every scene.

The quest for novel fashion also found inspiration in current events. What could possibly be newer than a human landing on the moon? The space spectacle, compounded exponentially by the immediacy of readily available television, was much explored in fashion: most literally in helmet hats, moon boots, and alien-eye sunglasses, but also in the proliferation of spacesuit-like metallics used in all kinds of clothing, makeup, and wigs. Metal discs composed the creations of avant-garde jeweler-turned-couturier Paco Rabanne, who assembled the pieces with pliers rather than with needle and thread; metal-halter-suspended dresses by couture-trained Pierre Cardin; dresses held together with coiled springs by Rudi Gernreich. Along with metals, the new synthetics—many with copyright symbols by their names—glittered like nothing ever seen in nature. New and man-made were synonymous.

Designers in the 1960s also delved into new territory as they explored the possibilities of bared flesh. For fashion designers to celebrate nudity may seem counterintuitive, but glimpses of skin became as designed as clothes themselves. People had, of course, become more and more bare at the beach as the twentieth century progressed, but the 1960s saw a much greater openness to all things sexual. Rudi Gernreich was said to have been inspired by the uninhibited scene at Andy Warhol's nightclub, the Dom, when he designed his topless bathing suit of 1964. Originally intended as a statement about prudery, it sold 3,000 units and firmly established the newsworthiness of nudity. Gernreich would become a nudity activist, and his mini shifts inset with strips of clear vinyl landed him on the cover of *Time* magazine in 1967. By carving away triangles at the side of a little black dress, or by strategically embroidering sequins on shift dresses of silk organza, Yves Saint Laurent brought this sensibility to haute-couture

customers; his completely see-through blouses and dresses would follow. The most widely adopted aspect of bareness was ever-shortening skirts, introduced first in sportswear and then by British boutique designer Mary Quant. Seen everywhere, with lengths policed by school principals, the mini was quintessentially 1960s in that it was simultaneously rebellious and ubiquitous.

Perhaps the archetypal article of 1960s clothing was the paper dress—a timely by-product of technology ideally suited to the shift silhouette. The paper dress as wearable art was created at a time when artists were challenging accepted practice in all media. Painters were altering the picture plane, abandoning the easel-sized rectangle and rondo, and adding three-dimensional elements; sculptors were creating works that were flat or soft; and art itself could be a photograph, a film, or a performance. Sometimes the paper dress was literally printed with art, like one of Andy Warhol's multiples. Dress kits could be Pop Art-ironic, as with boutique designer Betsey Johnson's clear-vinyl mini that came with stick-on appliques; the result was both mass-produced and, once manipulated by the wearer, one-of-a-kind.

While some pursued do-it-yourself fashion, others dressed entirely outside the fashion system, courtesy of the hippie movement that drifted eastward from the drug culture of California. Denizens of the counterculture wore vintage clothes, which were then available only at thrift stores, found in the attic, or perhaps even thrown out in the trash. Styles such as old military jackets, Victorian lace petticoats and shirts, and Edwardian men's clothes were the ruffled, rumpled, eclectic antithesis to the severe dress splashed with deliberately executed, avant-garde patterns. As demonstrated particularly by rock performers, vintage dressing was more genuinely unisex than intentionally gender-neutral clothes had been. Crushed velvet, embroidery, ruffles, and long flowing locks soon influenced "official" fashion as designers absorbed elements of Art Nouveau and nodded to romantic nineteenth-century novels (or the films made about them). In 1967 *New York Times* columnist Charlotte Curtis called photojournalist Bill Cunningham to divert him from Fifth Avenue's quaint annual Easter Parade of formal attire to Central Park's Sheep Meadow, where he could document the styles of flower children. Following Cunningham's lead, couturiers such as Yves Saint Laurent photographed in Central Park.

Change in fashion often takes the form of a reaction; just as intense as the response to the age of space exploration would be the rejection in the 1970s of all that was new and improved and man-made (think plastic). Inspired not just by hippies, but also by old movies played late at night on television, designers were entranced by the past as opposed to the future, resulting in the bias-cut silhouette inspired by 1930s film sirens and women's tailored clothes referencing the sharp menswear of the 1930s and 1940s. Natural fibers and earth tones supplanted psychedelia. The 1960s chemise, which in fabrics like the double-knit favored by French couturier Courrèges could look downright rigid, gave way to a silhouette that was all about ease and flow. The elongated silhouette, seen in both bias-cut dresses and blazer pantsuits for women, was a visual sign that the baby-doll-mini-wearing woman of the 1960s had grown up. Activists in the women's movement often expressed themselves by eschewing "fashion"; women in the workforce, in greater numbers than ever before, adopted professional looks that reflected establishment values loathed by the 1960s and projected gravitas, the antithesis of grooviness.

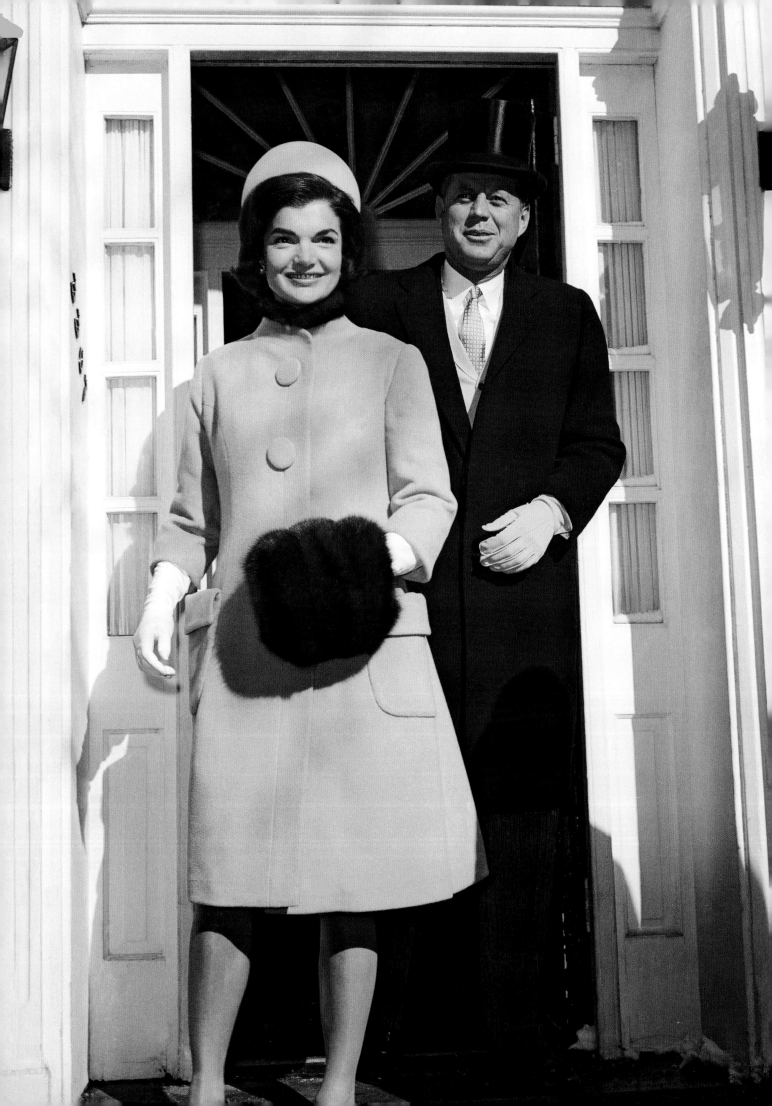

Phyllis Magidson

# First Lady Fashion
## 1960–1963

Jacqueline and John F. Kennedy leave their Georgetown home for the White House before inauguration ceremonies, January 20, 1961. The First Lady wears an understated greige coat designed by Oleg Cassini, accessorized with a sable collar and matching barrel muff, and a coordinated domed pillbox hat from Bergdorf Goodman.

"The 'Jackie Look' is rollercoastering through the retail ads from Coast to Coast," *Women's Wear Daily* announced in 1961. "Directly or indirectly, the stores are using the nation's First Lady to promote everything from the store itself to the gamut of fashion including hats, hairdo's, coats, suits, dresses. The Jackie look model sketched in fashion ads—an almost exact likeness of Mrs. Kennedy—was begun weeks ago in a millinery ad by Jay Thorpe New York, is being copied now by scores of stores. Window mannequins who look like her are popping up all over."[1]

The inauguration of the Kennedy White House on January 20, 1961, also marked the inauguration of an era of youthful energy and challenges to axioms of political, social, and cultural order. With the Kennedys came not only a charismatic, youthful president, radiating energy and ideas about his "New Frontier" programs—from racial equality to urban renewal and a space program—but also Jacqueline Kennedy. She was a chic First Lady who invigorated American fashion by projecting her own elegant, seemingly effortless sense of taste and style to

become a role model for millions of American women.

*Vogue*'s lead editorial in its January 1960 issue ushered in this new era with "hope for a decade that will bring, not the war nobody won, but a peace in which our kind of government will be tried on its merits."[2] Turning from politics to fashion, the magazine heralded the "great naturals of American fashion," from suits and separates to little-nothing dresses and carefully tailored pants.[3] It was a classic and refined style that the soon-to-be First Lady exemplified. French or French-influenced, this style evolved out of the elements of 1950s fashion with some distinctive differences. Unlike the clothes of the 1950s, which featured form-fitting silhouettes accentuating the curves of the waist, hip, and bust, those of the early 1960s flowed more easily over the body in less defining, more sensuous lines. Colors were typically more muted and less saturated than in the 1950s. Embellishments in the form of sequins, pearls, and rhinestones were applied discreetly. All was done in an effort to flatter the wearer, not overwhelm her—an approach that characterized American design

in contrast to the more overt artistry of the French couture. Women, however, continued to abide by the directives issued by upper-echelon Parisian and American designers who set the protocol of wearing coordinated ensembles accessorized with hats, gloves, shoes, and jewelry.

Soon after assuming her White House role, Jacqueline Kennedy appointed designer Oleg Cassini as her "Secretary of Style" in 1961. While Kennedy continued to buy French couture clothes, she looked to Cassini to provide many of the ensembles for her almost-daily public appearances, both in the United States and abroad. Growing up in Italy and trained in the French couture (and thus able to copy its designs), Cassini was also in sync with American styles. He had worked as a costumer on Broadway and in Hollywood. This fusion proved ideal training for Kennedy's need for high-visibility performance clothes that were appealing to American tastes. Observing that "we are on the threshold of a new American elegance thanks to Mrs. Kennedy's beauty, naturalness, understatement, exposure, and symbolism," Cassini generated a

succession of crisp, elegant designs interpreted in a striking array of luxurious silks and opulent brocades.[4] For three years, Mrs. Kennedy's signature style was synonymous with the "American look," distinguished by its refined sophistication and exquisite taste. According to a *Life* magazine article published the day of John F. Kennedy's inauguration, Jacqueline Kennedy's "sophisticated simplicity" had been attracting the admiration of both young and more mature women since the primaries. Jackie-inspired fashions, such as sleeveless and collarless shifts, were already for sale in stores across the country. Her trademark pillbox hats were selling for $35 to $70 at the New York salon of high-end milliner Mr. John, while Bloomingdale's and Orbach's department stores offered customers the chance to buy complete "Jackie" ensembles for as little as $68.68.[5]

Following Mrs. Kennedy's lead, the wardrobes of fashionable New Yorkers combined French couture and their copies, as well as clothes by American designers. The wealthiest of New Yorkers went to Paris, where they bought custom designs from the

houses of Christian Dior, Hubert de Givenchy, and Nina Ricci, among others. These designers acquired their training during apprenticeships with couture masters. Their rarified designs were customized to the bodies of individual clients and defined by costly fabrics, hand workmanship, and intricate details.

Another outcome of Mrs. Kennedy's French couture-centric aesthetic of the early 1960s was the proliferation of the "Paris copy." It lured every economic stratum of the American public, which had been dazzled by Parisian couture since its inception in the middle of the nineteenth century, into department stores with the promise of costly looks for a fraction of the price. New York department stores, from Fifth Avenue's high-end Bonwit Teller to 34th Street's moderately priced Orbach's, featured line-for-line copies licensed by the couture houses as well as more loosely interpreted knock-offs. In both cases, these clothes, in contrast to their Paris originals, used less costly fabrics, fewer linings, and less labor-intensive methods of construction and detailing. Machine-stitched button holes

replaced the hand-sewn-and-turned ones of the couture, while Americans took advantage of newly introduced technical shortcuts in textile manufacturing, such as bonded fabrics.

New Yorkers also bought from American fashion talent who from the time of World War II had either worked anonymously or had shared credit with Seventh Avenue manufacturers, but who had now opened independent companies under their own names. These U.S. designers went to trade schools, most notably the Parsons School of Design in New York, where they learned not only about fashion, but also about mass-production methods and marketing. Leaders in this group included Norman Norell, Vera Maxwell, and Ben Zuckerman. Their clothes were specifically created for the active lifestyles and conservative pocketbooks of Americans. Prioritizing practicality, functionality, and high quality, the garments they created were sleek, timeless, masterfully crafted, and, according to *Vogue*, "made for women who drive cars, travel by plane or by jeep, who love to look a little bit pampered and more than a little elegant by night." American

designers, *Vogue* asserted, "concentrate their considerable charms and talents on pure, uncluttered lines."[6]

Mirroring the youth and elegance of Jacqueline Kennedy, American fashion of the early 1960s took a turn toward a new style: a simpler, more natural aesthetic that allowed for greater ease of movement and could be achieved at lower cost. The First Lady's influence opened the door to far greater transformations to come throughout the course of the ensuing decade.

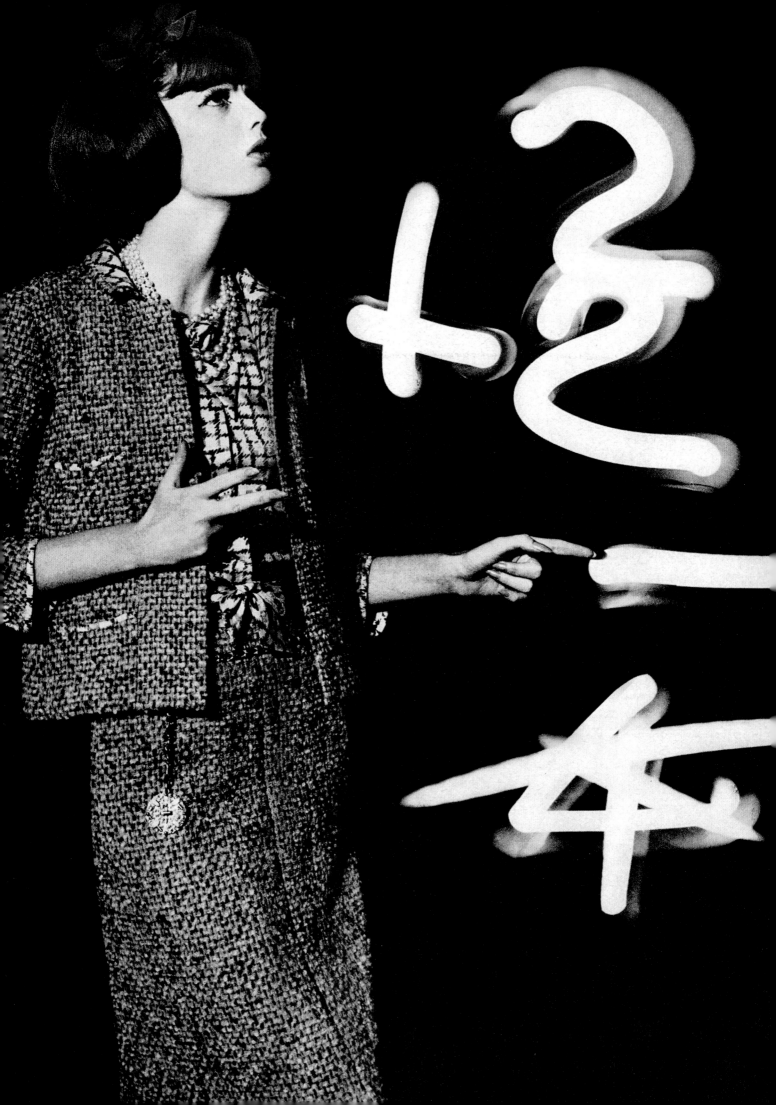

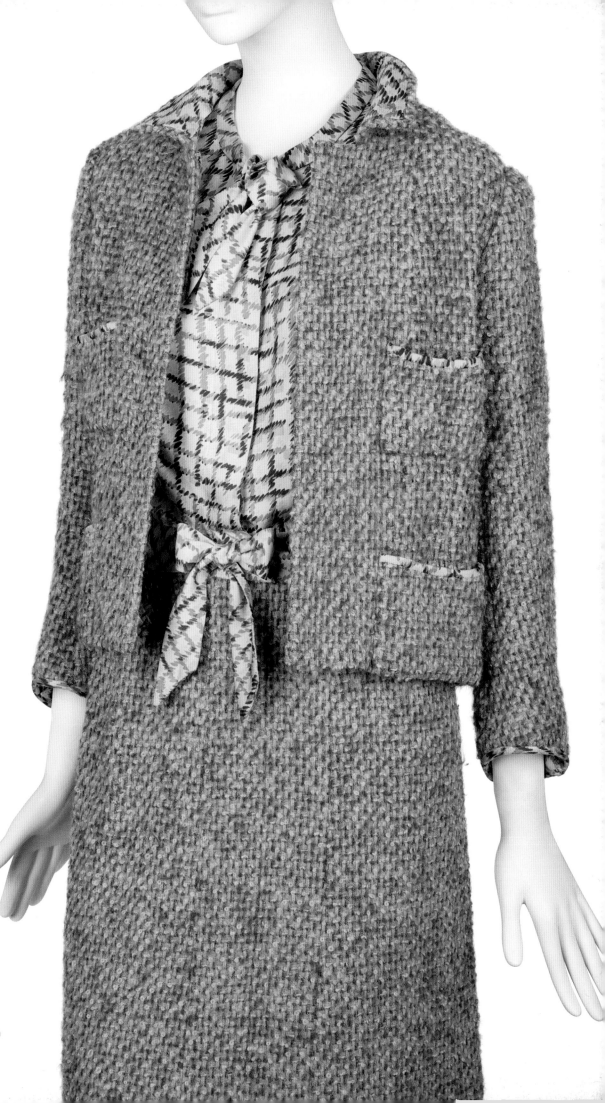

Opposite: Chanel suit
published in Jessica
Daves's "Paris: Yes-s
and No-s in the
Spring Collections,"
*Vogue*, March 1962.

**Chanel**
—————
Suit of Linton fancy
wool tweed, Spring
1962.

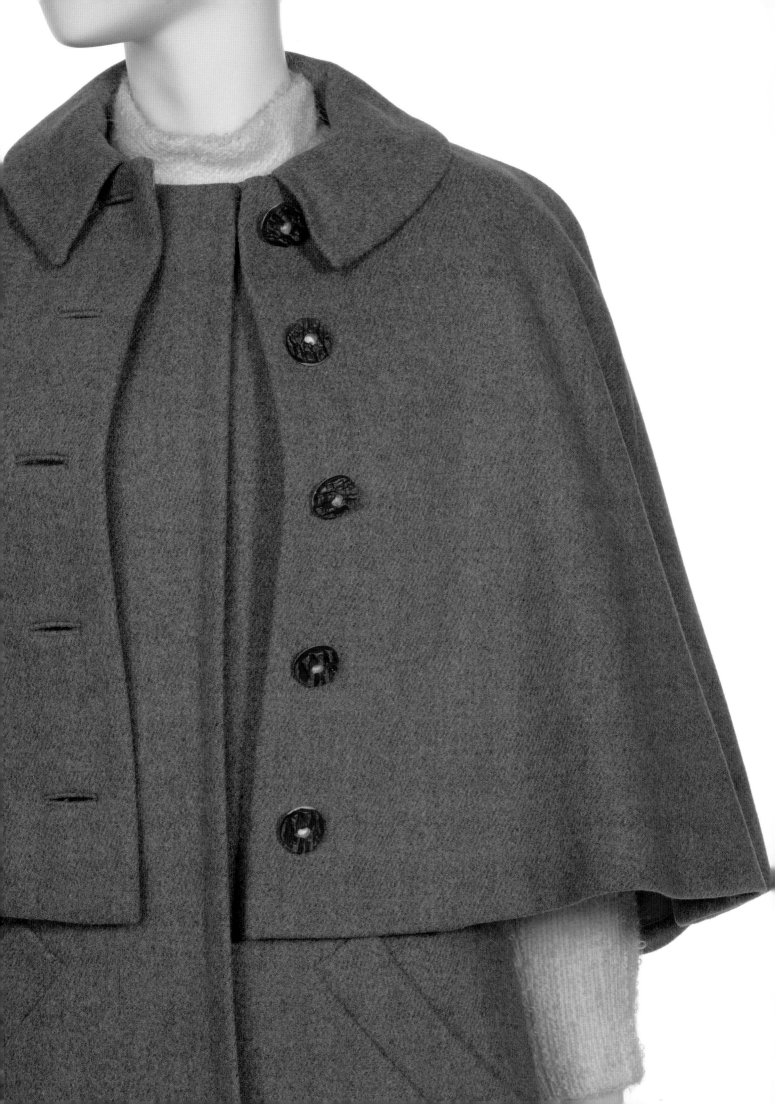

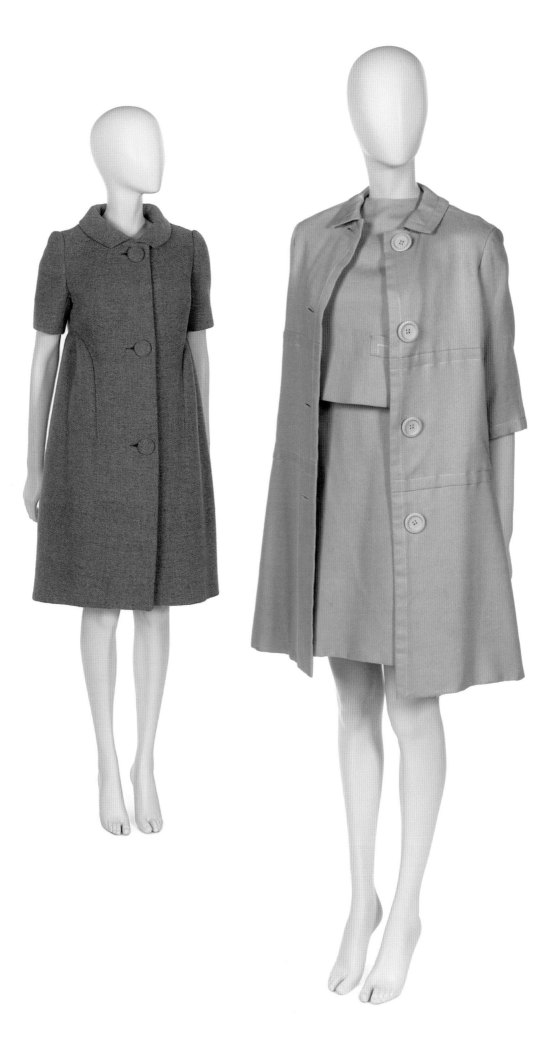

**Vera Maxwell**

Day ensemble
comprising cape
and coat of Scottish
"Ghillie" cloth and
dress of wool bouclé,
1961.

**Nina Ricci, retailed
by Nan Duskin**

Short-sleeved coat
of Moreau wool tweed,
1960.

**Marc Bohan
for the House of
Christian Dior**

"Vie en Rose"
afternoon ensemble
consisting of coat
and dress of linen,
Spring/Summer
1961. Jacqueline
Kennedy owned an
apricot version
of this ensemble.

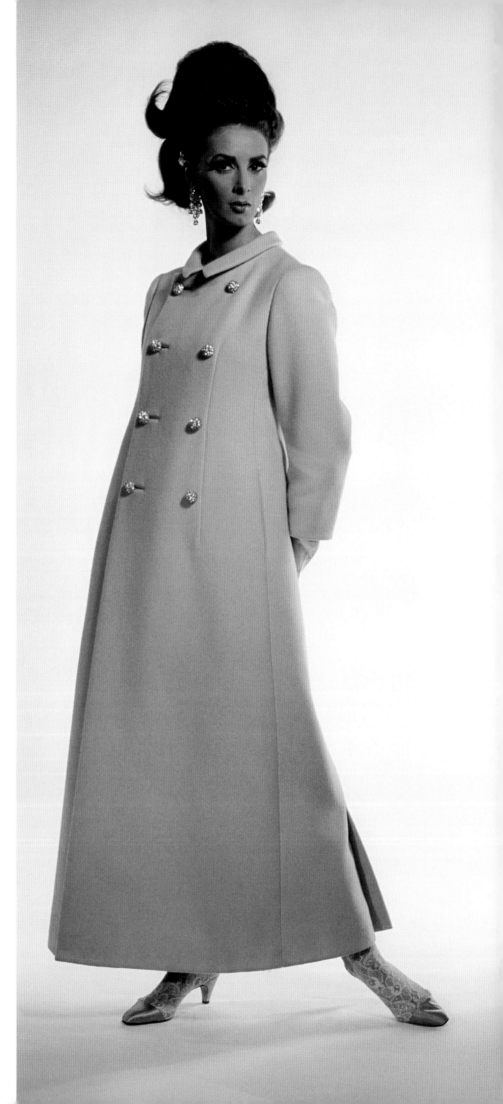

Ben Zuckerman
coat published in
"American Style: The
Regency Pales . . .
The Narrow Look . . .
New Charm from
the Tailor's Hand . . .
More and More
Legginess," *Vogue*,
September 1964.
David Bailey.

**Ben Zuckerman**
—
Evening coat of
wool broadcloth with
jeweled buttons, 1964.

**Yves Saint Laurent
for the House
of Christian Dior**
—
Suit of wool compris-
ing skirt and jacket
with sleeveless blouse,
Autumn/Winter 1960.

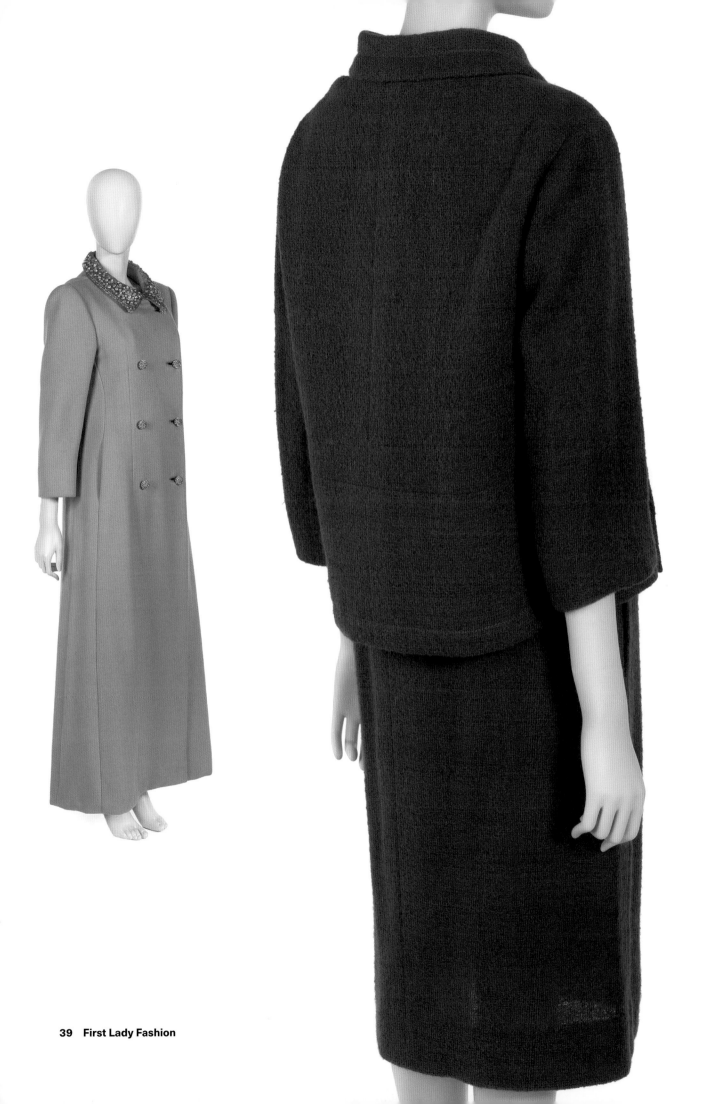

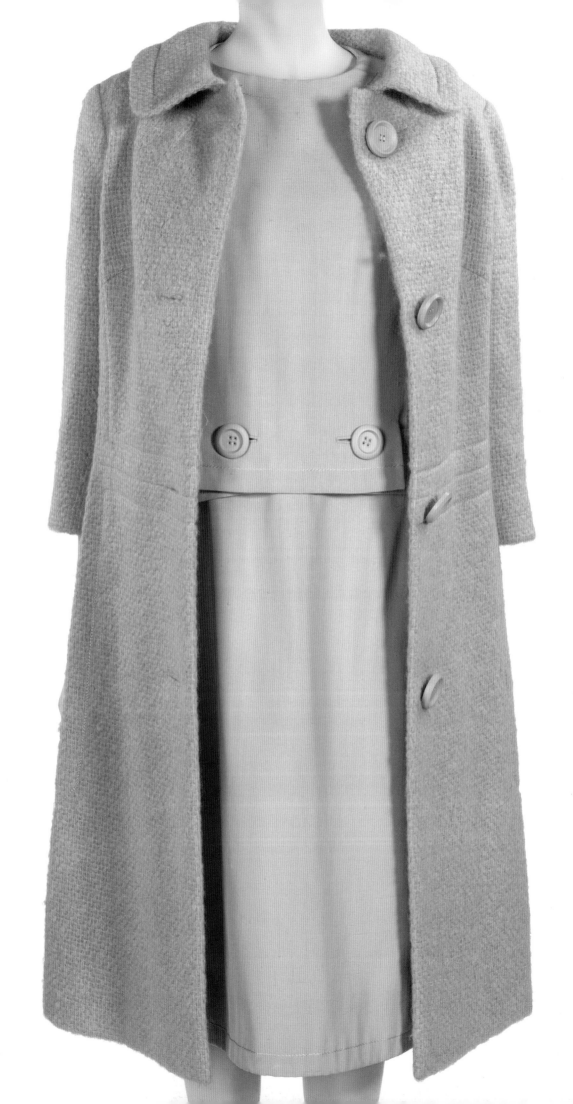

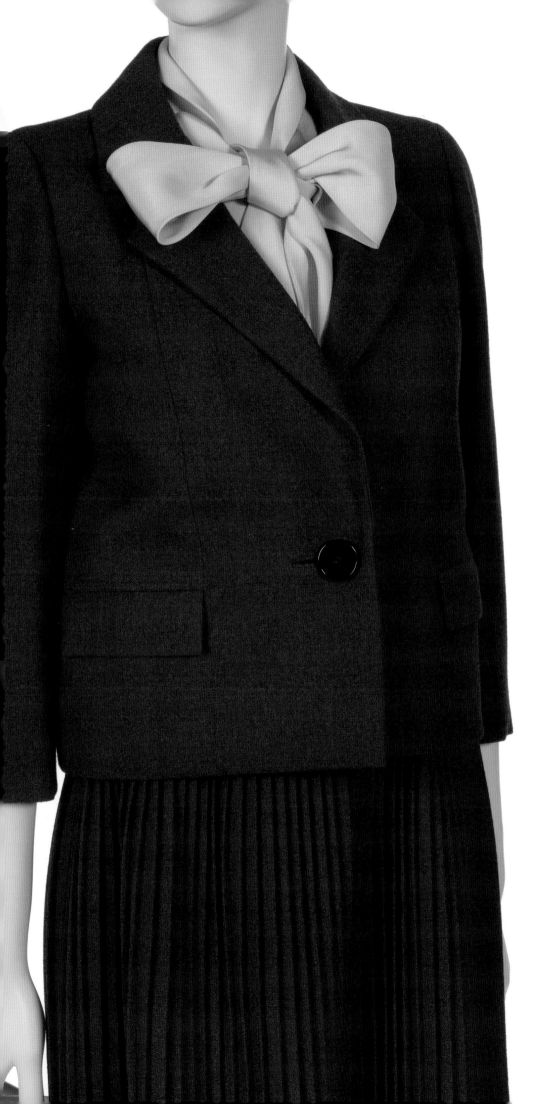

**Marc Bohan
for the House of
Christian Dior**

Coat of wool and
dress of slubbed silk,
Spring/Summer 1962.

**Norman Norell**

Day ensemble
comprising jacket and
skirt of wool flannel
and blouse of silk,
1960.

**Oleg Cassini**

Sleeveless evening
ensemble with midi
overblouse and skirt
of linen/silk blend,
1960s.

**Mainbocher**

Evening ensemble
comprising jacket of
cashmere, blouse
of cordonnet machine
lace and crepe,
and full-length skirt
of cashmere,
Fall/Winter 1964.

**Anne Klein for
The Country Clothes
Shop, retailed
by Lord & Taylor**

Ensemble comprising
wool jumper with
synthetic poult de
soie blouse and tie,
early 1960s.

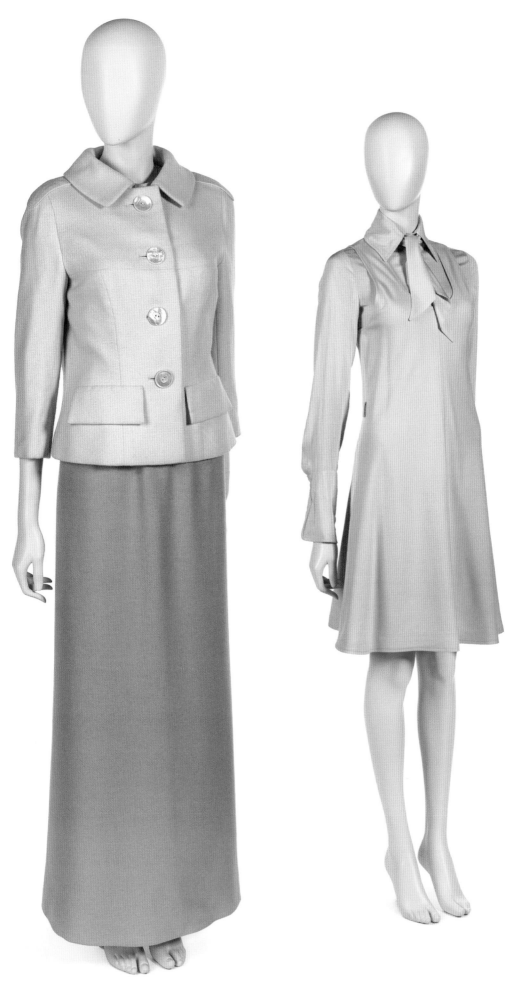

Audrey Hepburn
modeling Givenchy
ensemble, published in
"Givenchy/Hepburn,"
*Vogue,* November 1,
1964.

**Hubert de Givenchy**

Evening ensemble
comprising coat of
chenille lace embroi-
dered with beads
and rhinestones and
dress of satin, 1964.

**Hubert de Givenchy**

Ensemble comprising
ball gown of silk faille
and stole of silk crepe
trimmed with ostrich
feathers, 1964.

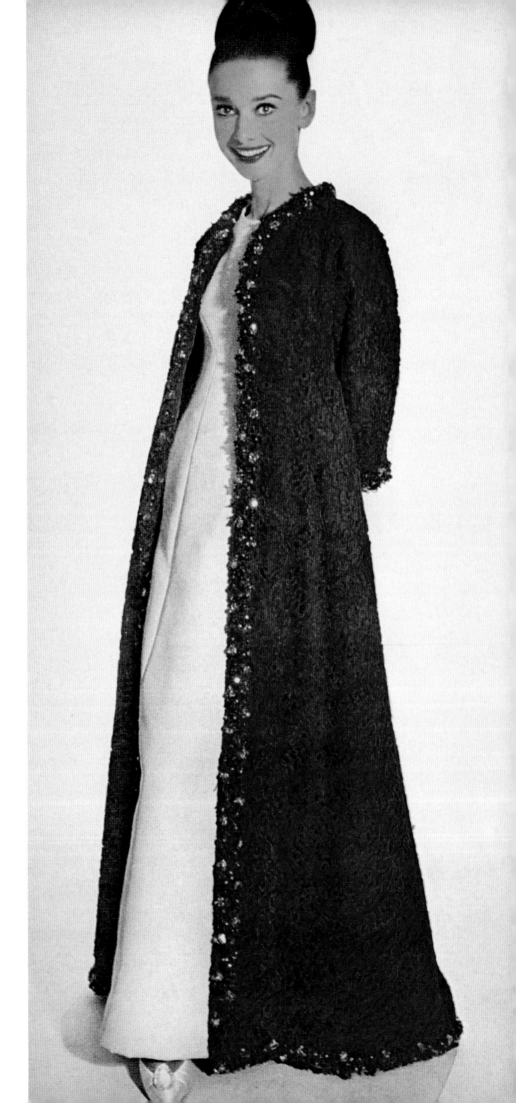

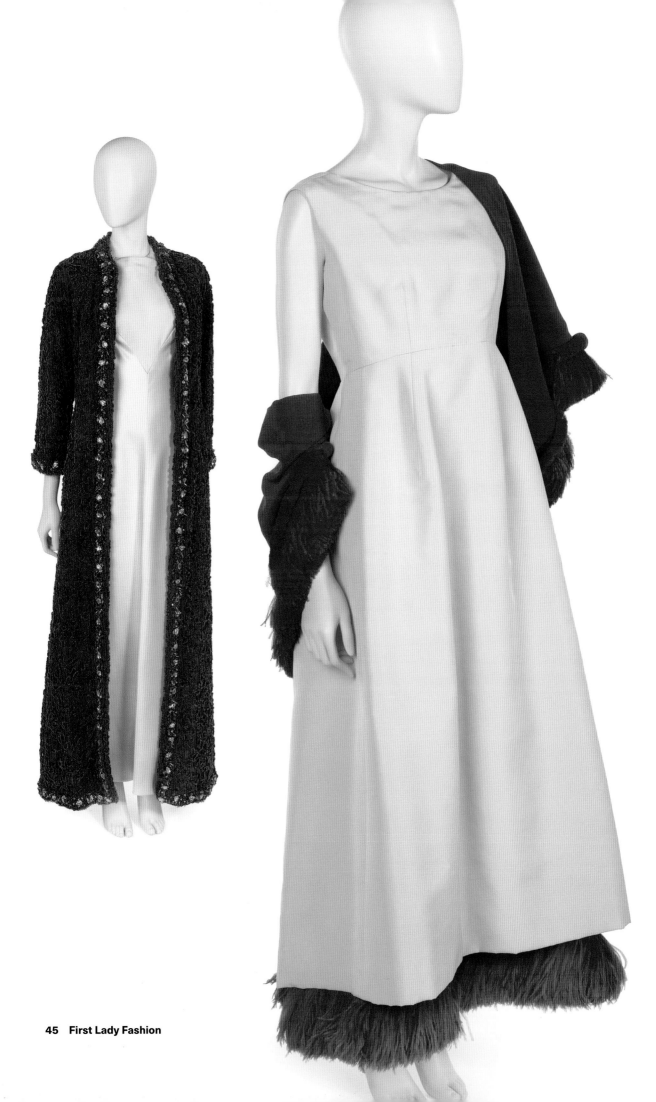

**Mainbocher**

Evening dress in
metallic matelassé,
Fall/Winter 1963.

**Ann Lowe,
retailed by Saks
Fifth Avenue**

Debutante gown
of poult-de-soie with
silver bugle beads
and iridescent
sequins, 1962.

**Sarmi**

Evening dress
of silk embroidered
with beads and
satin, 1961. Worn to
the inaugural ball in
honor of President
John F. Kennedy in
Washington, D.C.,
on January 20, 1961.

**Attributed to Oscar
de la Renta for
Jane Derby, retailed
by Nan Duskin**

Evening dress
in Spanish cotton
lace with bowed
sash, ca. 1963.

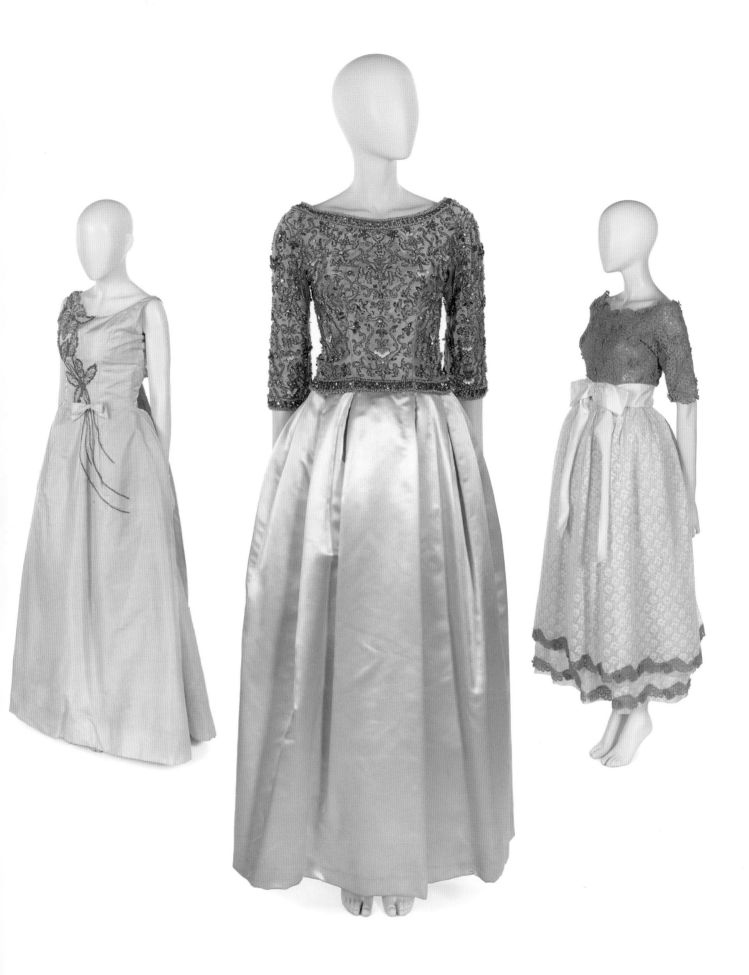

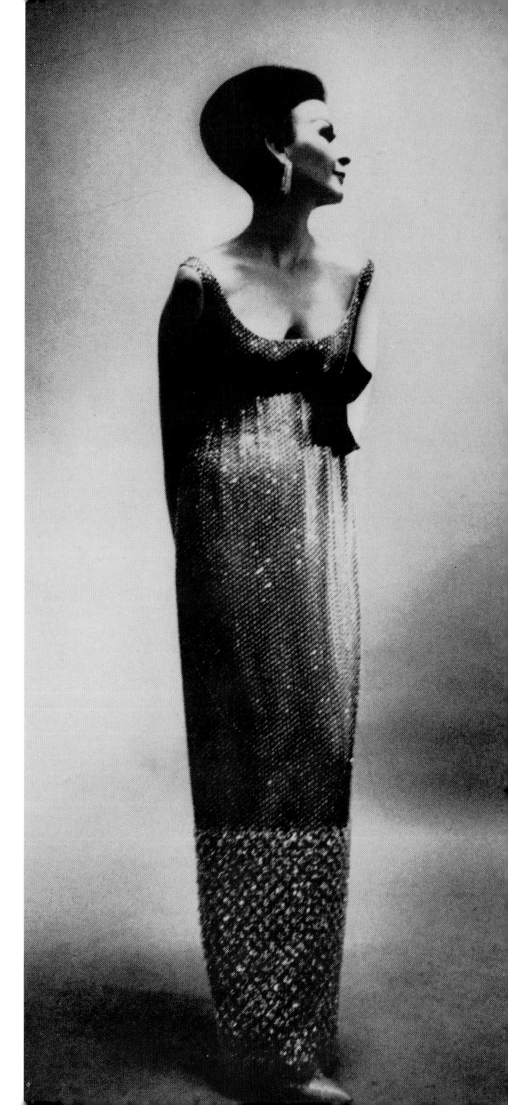

"Tissue-of-Diamonds
Dress," designed
by Norman Norell,
published in Gloria
Guinness, "A Woman's
Best Friend is Not a
Diamond," *Harper's
Bazaar,* October 1963.

**Norman Norell**

"Tissue-of-Diamonds
Dress" of silk net
studded with crystal
brilliants over silk
charmeuse,
Fall/Winter 1963.

**Yves Saint Laurent
for the House
of Christian Dior**

Ensemble comprising
dress and jacket of
silk gazar, Fall/Winter
1960.

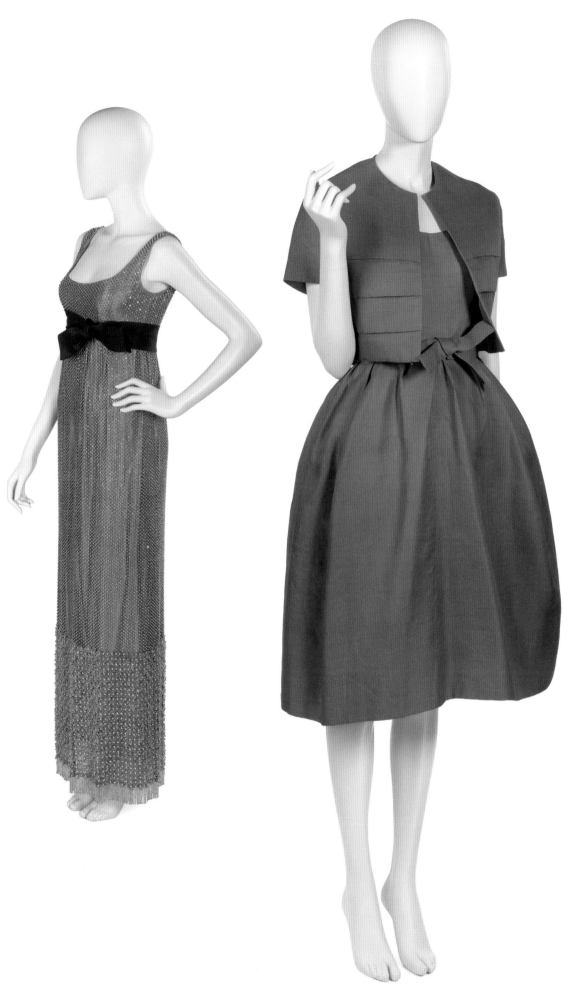

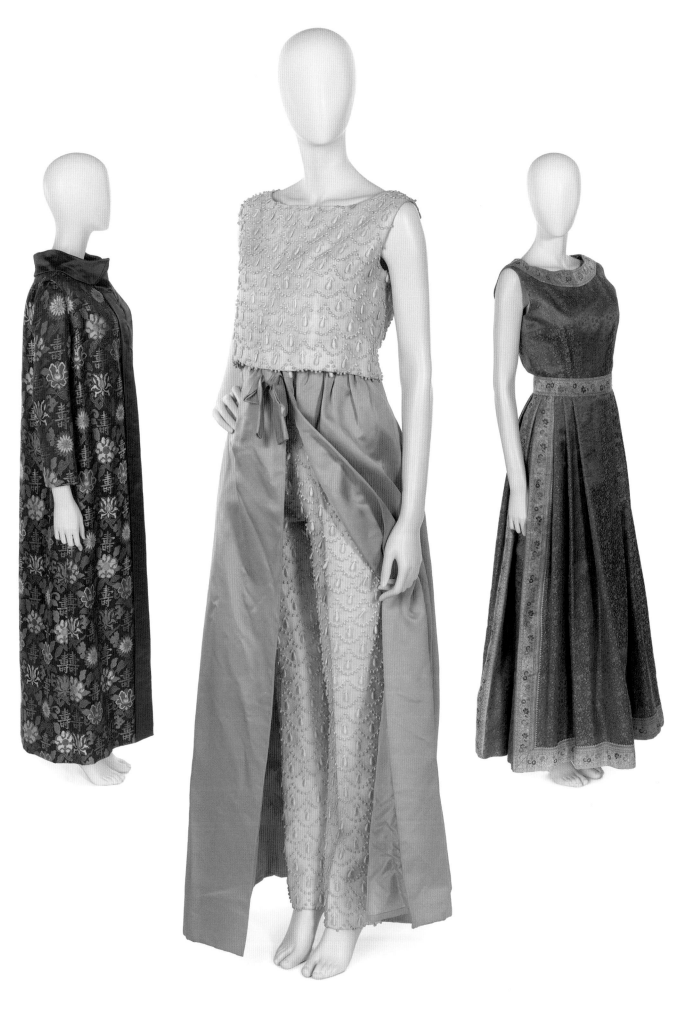

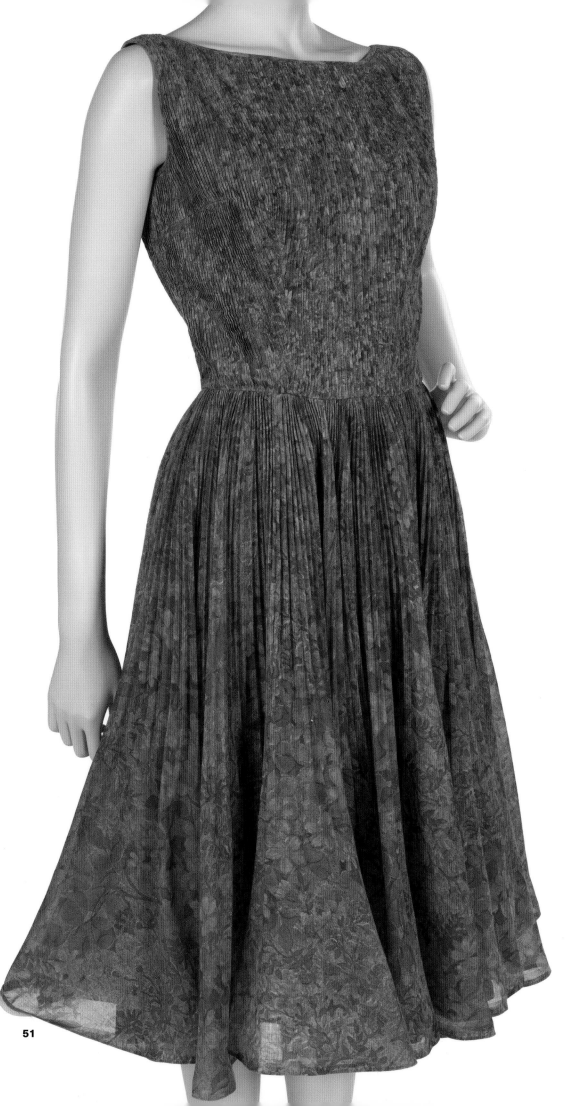

**Unattributed**

Evening coat of silk satin brocaded with metallic Chinese characters and stylized floral motifs, 1960–64.

**André Courrèges**

Ensemble comprising top and narrow trousers of organdy covered with embroidery and long satin split evening skirt, ca. 1963.

**Cez and Bez, New York**

Evening dress and belt of Indian-style floral brocade on silk ground, 1963.

**Nick Savage for Mollie Parnis**

Day dress of printed polyester, 1962–63.

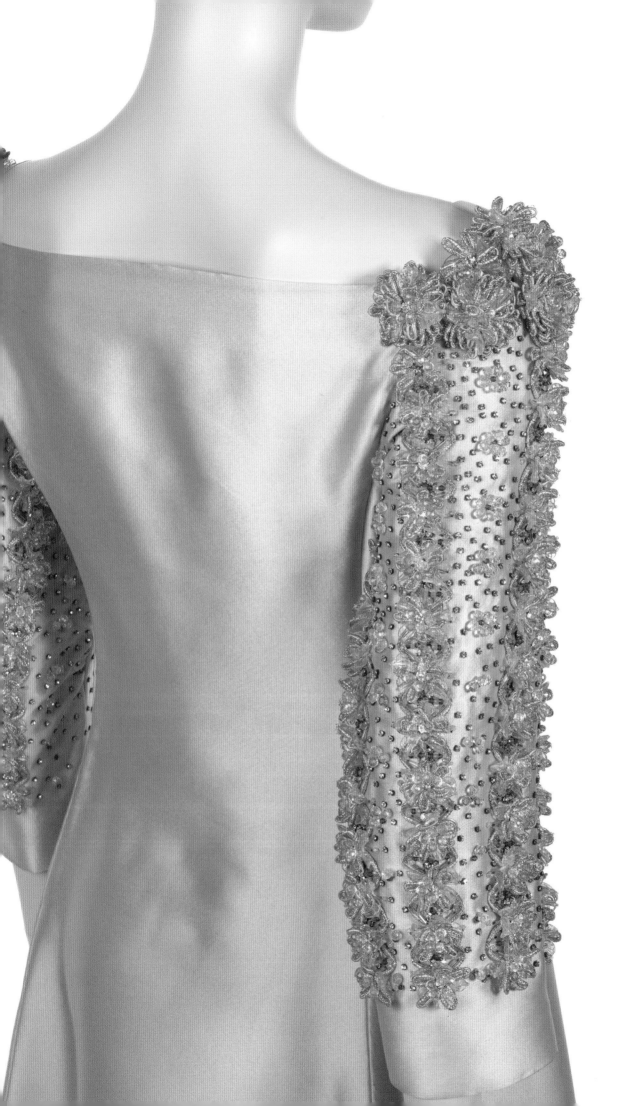

**Antonio Castillo, retailed by Bergdorf Goodman**

Evening dress of silk twill with rhinestone and crystal bead, floral-embellished sleeves, Fall/Winter 1964.

**Norman Norell**

Evening dress of jersey with applied sequins, ca. 1960–62.

**Pauline Trigère**

Dress and stole of silk brocaded with stylized floral motif, 1961–62.

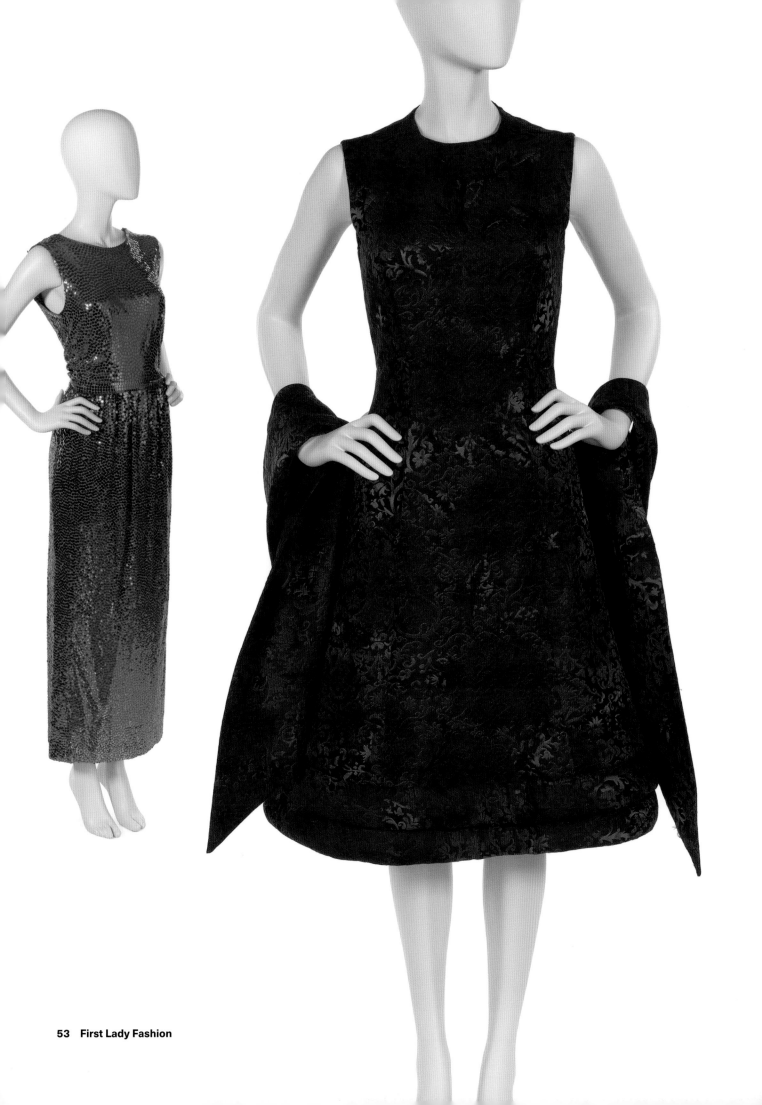

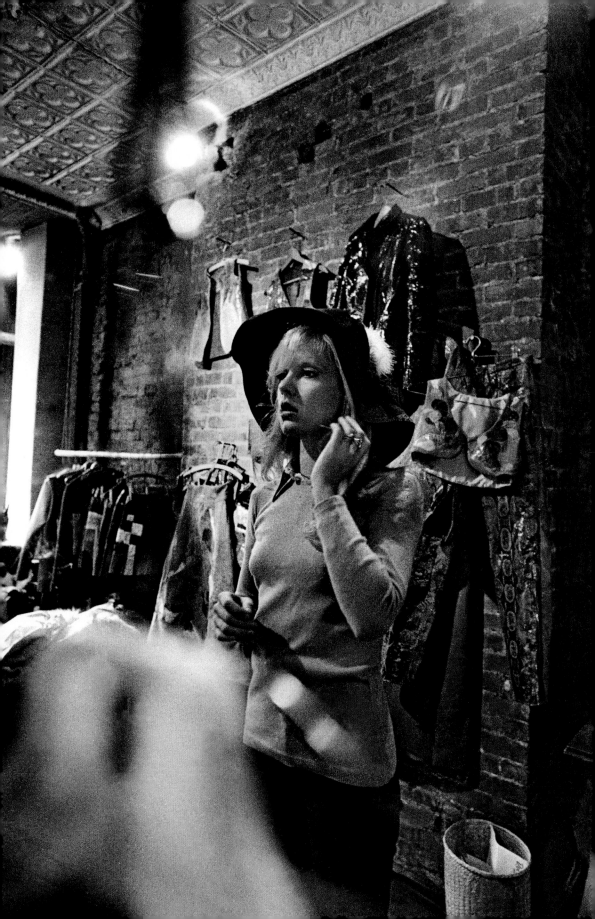

**Hazel Clark**

# Fashioning the 1960s in New York

## A Whole New Way of Shopping

"Personally," 1960s marketing master Paul Young noted, "I've always thought anybody who takes fashion seriously is ridiculous. I mean they're just clothes. Therefore they should be fun, and nothing about wearing them should be taken seriously."[1] This irreverent philosophy shaped not only Young's view of fashion, but also his approach to retailing, most notably in his founding of the archetypical Manhattan boutique Paraphernalia. "People would walk into the store dressed in their straight clothes," Young asserted. "They'd buy something and put it on . . . before heading directly to a party. They were buying something to wear tonight and more or less throw away tomorrow. We priced our clothes with that in mind."[2]

Focusing on young consumers, boutiques like Paraphernalia celebrated fashion novelty and innovation. Selling low-priced merchandise, from flirty dresses to playful shoes and jewelry, that turned over rapidly, these small, independent shops offered consumers the promise of finding something new on every visit—and in an atmosphere that often seemed like a fun dance party, with pop music blasting all day and late into the night. Boutique shopping represented radical changes in the ways fashionable clothes were designed, made, marketed, and displayed—a shift that shattered the traditional fashion retail order that had been in place since the end of the nineteenth century.

The boutique concept—introduced in 1955 with designer Mary Quant's Bazaar in London—offered a new style of fashion shopping. Before

French singer Sylvie Vartan shopping in New York, March 1970. Here she poses in the Dakota Transit shop on Ninth Street.

boutiques, people purchased their clothes at department stores, with each store targeted to a specific demographic, and their neighborhood specialty shops. While the concept of the fashion boutique was not new (in 1933 Lucien Lelong had opened one in his Parisian couture house to sell his "*éditions*"), Quant's boutique and those that followed, like Paraphernalia, added a new shopping option to the fashion retail marketplace. In contrast to practices at large, corporate department stores, boutique owners stamped each store's merchandise, interiors, and displays with their individual creative personalities and nurtured informal and personal relationships between their clientele, their sales staff, and themselves. Even the names of these stores—Paraphernalia, Bazaar, Abracadabra—signaled a less formal way of shopping. Boutiques soon lured the young and hip away from department stores and specialty shops. By the late 1960s, even the most tradition-bound department stores acknowledged the influence of boutiques and created their own versions on their sales floors.

Many boutiques had opened in Manhattan by the mid-1960s, creating a distinctive fusion of fashion, commerce, and art that made New York City the hub of America's boutique culture. The shops became renowned and widely covered in both the fashion and mainstream press. The Teeny Weeny boutique at 73rd Street and Madison Avenue, opened by socialite Joan "Tiger" Morse, was well known for selling "mini dresses and other fashion oddities that used primarily man-made fabrications" to fashion- and art-savvy clients that included Andy Warhol's set.[3] Others included Splendiferous on Third Avenue at 75th Street; Abracadabra at 243 East 60th Street, which *Interior Design* magazine described as evoking "the flashing world of the circus midway"; and Serendipity 3, an ice cream parlor-turned-fashion emporium on the Upper East Side.[4] East of Greenwich Village, Limbo and its neighbor Dakota Transit catered to a more countercultural clientele.

Of the boutiques that made New York City the center of 1960s fashion, Paraphernalia was most influential in establishing not only British-born Mod style (best represented by the aesthetic of the ultra-thin, 16-year-old model Twiggy), but also the phenomenon of boutique shopping in the United States. Young aimed to create clothes that were inexpensive (with nothing costing more than $99, the price of a round-trip flight to Puerto Rico) and short lived, many made out of disposable materials that could be tossed out when the next new thing showed up. He also sought out young

American talent. Betsey Johnson (later to have her own label) joined Paraphernalia from the art department of *Mademoiselle*; Joel Schumacher, a Parsons School of Design alumnus, was creating window displays at Henri Bendel in Midtown.[5] The interior of Paraphernalia, designed by architect Ulrich Franzen, was sleek and futuristic, featuring curved steel and chrome-and-white walls. The clothes, all bearing Paraphernalia's label, showcased novel garment materials. Some were made from plastic, paper, or vinyl; others glowed in the dark or reflected light; there were even some that grew when watered. Betsey Johnson packaged neon-colored, nylon bikinis crunched up in a tennis-ball can and also designed a silver motorcycle jacket.

As Paraphernalia's young and hip clientele demonstrated, Mod fashions were not for the old or dowdy, but were rather intended for a "chick elite."[6] Skirt lengths were short and getting shorter, sized to youthful bodies. The diminutive became a metaphor for youth, and the epithet "mini" was ubiquitous. Small clothes (the miniskirt), products (the mini car), fashion models (Twiggy, Pattie Boyd, Jean Shrimpton), and pop musicians (the British group Small Faces and singer Millie Small) were fashionable in Britain, and America followed its lead. Paraphernalia's daytime crowd, for instance, frequented fashionable nightclubs such as Max's Kansas City, and Edie Sedgwick, famous as a member of Andy Warhol's Factory, became the fitting model—and glamorous icon—for Paraphernalia's clothes.

As department stores took note of this new retailing phenomenon, they created in-house boutiques to attract and hold on to younger shoppers. Bergdorf Goodman opened Bigi and gave its milliner, Halston, his own boutique, both aimed at its upscale, couture clientele—in contrast to Paraphernalia's younger and less wealthy Mods. Similarly, Bonwit Teller created its S'fari Room, where imported designs could be found alongside the creations of new American designers such as Giorgio di Sant'Angelo.[7] Young American and European designers were also featured at Bendel's, on West 57th Street just off Fifth Avenue. Bendel's became a leader of modern fashion in 1960s New York under Geraldine Stutz, who became the company's president in 1957 (a rare position for a woman at the time).[8] Stutz thrust Bendel's into the forefront of retailing trends as she revamped the store according to her own vision: "I knew instinctively that we must be the kind of store that I myself would like to shop in and that it must be a cozy, intimate place with friendly, personal service to cater to

Geraldine Stutz,
president of Henri
Bendel, within
her Street of
Shops, ca. 1967.

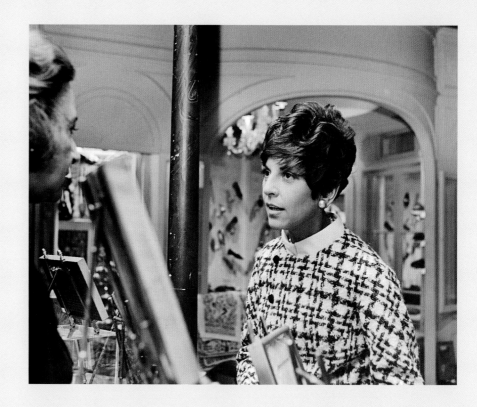

sophisticated, small-sized women who love clothes."[9] Stutz brought in young American designers and the latest styles from Britain and Europe, carrying sizes no larger than a current-day size 8. These designers' creations became known as "Dog Whistle Fashion"—"clothes with a pitch so high and special only the thinnest and most sophisticated women would hear their call."[10] Stutz was adamant about her female advantage over her male competitors in creating a woman's store, modeled after her own ideas. Bendel's success in Stutz's era proved her right.[11]

One of Stutz's major retail innovations was Bendel's "Street of Shops," which established the template for New York's boutique culture when it opened in 1959. The design by architect and display artist Howard McKim Glazebrook transformed the store's narrow, cavernous first floor into what looked and felt like an urban Main Street with connecting alleyways lined with a series of small boutiques, creating spaces that provided intimate shopping experiences within the larger store. Stutz was championed as the first merchant to install boutiques in a large specialty store, and the Street of Shops was hailed by the fashion media as New York's "super-boutique," positioning Bendel's as a leader in New York City's retail transition.[12] Balancing the store's "inherently good taste," according to Stutz, with the experience of shopping in the renegade East Village, Stutz created an identity for Bendel's that was more daring than department stores, yet more refined than independent boutiques.[13] The visual merchandising of fantastical décor and theatrical displays—some windows were designed by future Hollywood film director Joel Schumacher—also set the store apart by creating a constantly changing environment that drew customers to its Midtown location.[14]

**58**

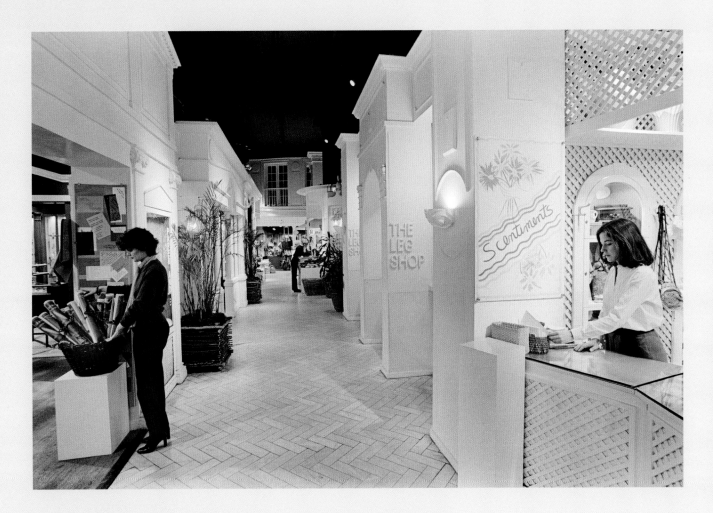

In 1967 Bendel's further expanded the boutique-within-the-store
concept by opening a small space exclusively for British designer Jean
Muir. This was the first of Bendel's many in-store boutiques for individ-
ual designers, including the French Sonia Rykiel in 1969 and New Yorker
Stephen Burrows in 1970. Later, Ralph Lauren, Perry Ellis, and other
designers were given their own dedicated spaces. Bendel's Street of Shops
and its in-store boutiques reflected the store's commitment to constant
innovation to maintain the sense of modernity (and luxury) that was
essential to the store's continued success in this period, as well as to its
influence on both independent boutiques and those in department stores.

Like independent boutiques, Bendel's brand derived in part from
its commitment to supporting—and selling—exclusive designs that could

Limbo, at 24 St. Mark's Place, with its diverse stocking policy ranging from vintage velvets to World War I uniforms, published in "Living—Shopping— Easy in 'East Village' Boutiques," *New York Times*, December 8, 1965.

only be purchased there. While working with Seventh Avenue designers to develop pieces exclusively for Bendel's, Geraldine Stutz also sent buyers to pursue what was then an under-tapped European ready-to-wear market.[15] This was a radical move—Bendel's fashion base had traditionally been focused on couture, and no other New York store at the time was targeting new young designers from Europe. Store buyer Jean Rosenberg was sent on her first buying excursion to Italy in 1959, tasked with procuring anything she liked that was new and exciting.[16] Scouring Italy, Paris, and London throughout the 1960s, Rosenberg introduced new European and British designers to New York and America, including Krizia, Chloé, Sonia Rykiel, Jean Muir, Jean Charles de Castelbajac, Emmanuelle Khanh, and Zandra Rhodes. Many were showcased in exclusive boutiques within Bendel's, and some continued to sell at the store for the next twenty years, thereby creating a market for their fashions and enhancing Bendel's boutique-like approach to merchandising and marketing.

As stores like Bendel's were incorporating boutiques into their retail offerings, new freestanding boutiques featuring Mod and other cutting-edge fashions were springing up around Manhattan, especially in the 1950s and 1960s, between Second and Sixth Avenues, as well as in Greenwich Village.[17] Uptowners headed south to the Lower East Side, seeking what was different, amusing, and cheap, a trend reported by the *New York Times* in December 1965.[18] So popular was the area around St. Marks Place that it gained its own name, the East Village. There the retail atmosphere was laid back, with shops that did not open until the afternoon and that served as gathering places for neighbors, pets, and family members. Made-to-measure clothing was available alongside second-hand shops, some businesses did alterations, and others stocked designer fashions such as Rudi Gernreich's dresses that retailed for a moderate $45 to $50. The *Times* article featured a photograph of Mod young women at Limbo, located at 24 St. Mark's Place, described in the caption as "a men's shop where girls look for pea jackets (retailing used at $8.50), bell-bottoms and corduroys."[19]

At the time, St. Mark's Place was attracting an eclectic group of people. Limbo's owner, Martin (Marty) Freedman, recalled that many underground, emerging, and well-known musicians, actors, and writers— including Abby Hoffman, Jimi Hendrix, Timothy Leary, Sly Stone, Jerry Rubin, John Lennon, and Yoko Ono—became regulars at his shop.[20]

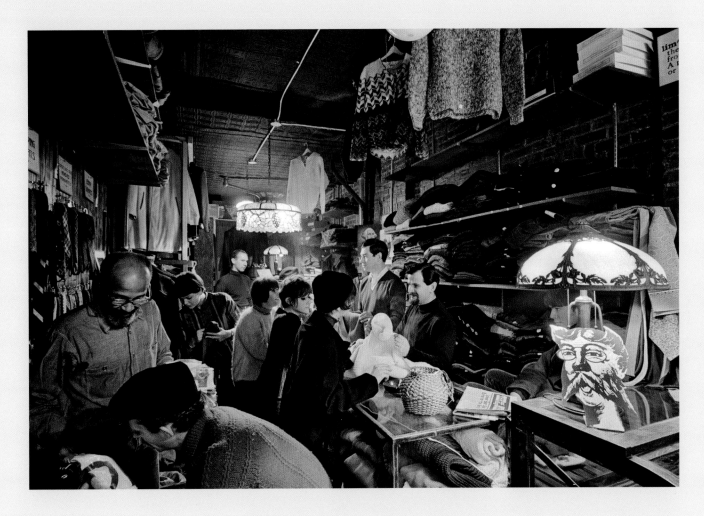

Freedman's shop was not just a Mod boutique, featuring instead a counterculture aesthetic that anticipated late-1960s trends by carrying items of clothing with their own genealogies rather than designer labels. Freedman described sourcing the merchandise:

> We would go rag picking each morning. Every day was an adventure: We'd tear open bales and out spilled clothing made fifty years earlier but worn. We found uniforms from the First World War and unworn clothing from the '20s that would have made a flapper flip. We visited old factories that made costumes for Yiddish theaters, where we picked up endless varieties of men's and women's clothing and accessories. Everything was cheap. Our biggest expense was dry cleaning. We would buy silk Hawaiian shirts for 25 cents, used Levis for 10 cents a pound (or 15 cents apiece), Navy pea coats for $2.00, wool 13-button Navy trousers for 50 cents, silk and velvet dresses for $1.00.[21]

After cleaning the vintage garments, Freedman and his staff would mark them for sale and expect to sell everything in less than a week. They sourced army surplus items from Britain, which also sold out quickly. Success gave them confidence to experiment. With rented sewing machines and free scraps of leather from factories' cutting-room floors, they employed local "hippie geniuses" to embellish jeans and jackets, which

Dakota Transit
workroom, in a
building adjacent to
the store on Second
Avenue at Ninth
Street, ca. 1970.

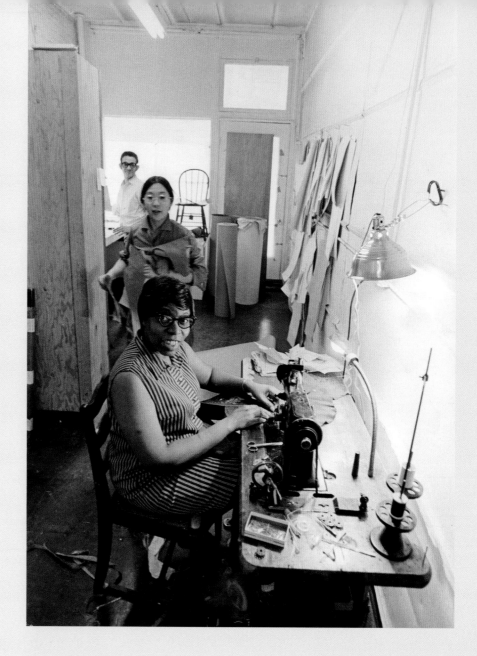

were sold to "Ford models, weekend hippies, and, of course, established garment center companies who promptly knocked off our designs."[22]

For a few years in the mid-1960s, Limbo was the center of alternative fashion retail in New York, but it was not the only one of its kind. Nearby, Andrea Aranow opened her boutique Dakota Transit in 1969. After moving to New York from Massachusetts, where she had made garments from suede purchased from shoe-trade jobbers in Boston, Aranow rented a St. Mark's Place storefront as a workshop. She hadn't planned a business, but finished pieces hanging in the window soon attracted attention and clients. One of the first and most famous was Jimi Hendrix, who ordered a suit made of snakeskin, a material Aranow had discovered in New York and used as colorful patchwork appliques on her suede garments. Hendrix was one of a number of rock musicians who wore Aranow's custom-made outfits for their performances, which were often attended by audience members also garbed in Aranow's clothing. Dakota Transit's location around the block from the Fillmore East music venue ensured a steady stream of clients and visitors: reporters from fashion magazines (*Vogue*

and *Harper's Bazaar*), celebrities (Jackie Kennedy visited but did not purchase), and "Tiger" Morse of Teeny Weeny boutique. Attracted by the low rents and the counterculture community, neighboring small independent shops included a store run by a friend of Jimi Hendrix that sold clothes, textiles, and accessories from Morocco, the Middle East, and Asia. Dakota Transit's second shop in Midtown, however, was not a success,[23] indicating that, like London's Carnaby Street, location was important to the success of 1960s boutiques in New York City. Boutiques were not just shops, but rather they made their neighborhoods—the East Village, Midtown—into places to see and to be seen.

Many boutiques founded in the 1960s were short lived. Dakota Transit closed in 1974. Limbo continued until 1975 when the building was sold, later housing the famous Punk emporium, Trash and Vaudeville. Paraphernalia had an even shorter life, losing its original identity by the late 1960s, as it diffused the brand's originality by franchising it—by 1968 four Paraphernalia stores had opened in Manhattan, one in Southampton, and 44 more across the United States.[24] The chain finally closed in the late 1980s.[25] Bendel's remained under the leadership of Geraldine Stutz until the store was sold to The Limited in 1985; Stutz left the following year.[26]

It seems fitting that Paraphernalia and other boutiques imploded by the end of the decade, signaling not just the end of Mod, but also that significant changes in fashion were already under way. The hippie aesthetic of the West Coast had reached the East Coast, taking over style leadership from the British Mods. As Caroline Rennolds Milbank has described, "By 1968 the groovy set had discovered new places to shop: antique clothing stores, army-navy outlets, and ethnic emporiums."[27] Yet the boutique concept remained enormously influential. It had provided a new shopping context for a younger and distinctly modern fashion consumer, facilitating a range of different "looks" at various price points. Moreover, it had made shopping for clothes fun and had provided individuals with more opportunities for putting together their own styles. It had, in short, changed the face of fashion shopping.

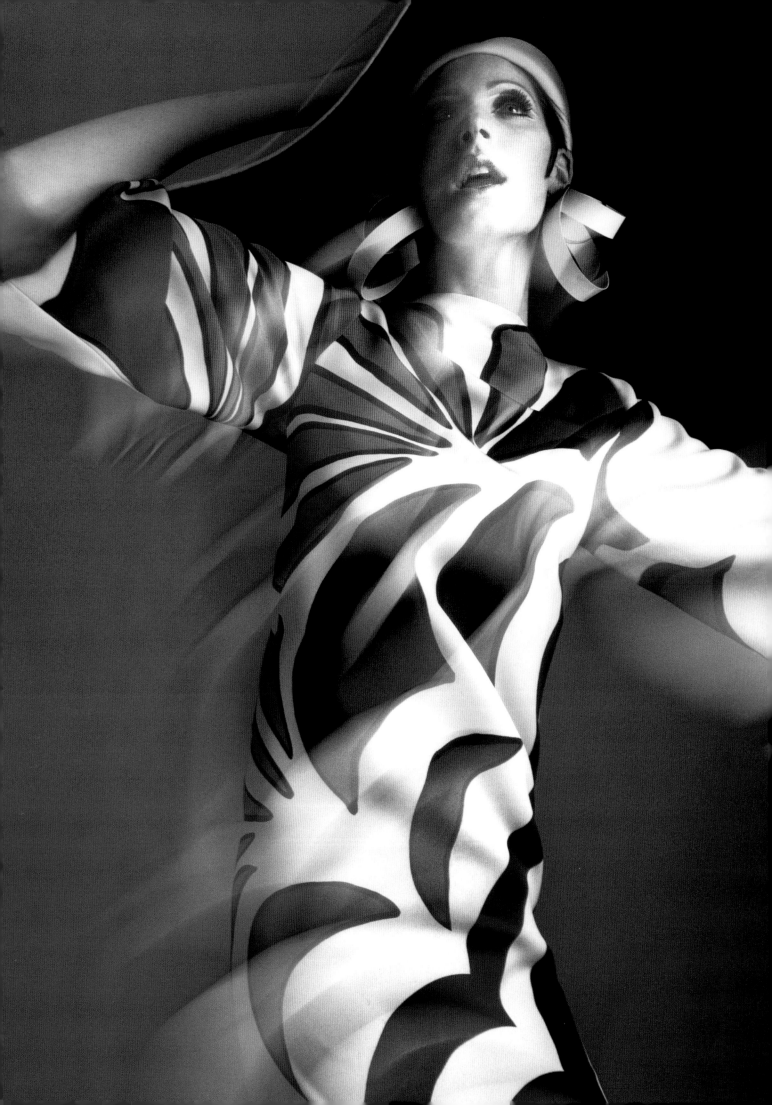

**Phyllis Magidson**

# Youthquake
## 1964–1966

In her January 1965 lead article, *Vogue* editor Diana Vreeland declared a "Youthquake," a term of her own invention that predicted a new era for American fashion: "The year's in its youth, the youth in its year. Under 24 and over 90,000,000 strong in the U.S. alone. More dreamers. More doers. Here. Now. Youthquake 1965."[1]

Vreeland issued her statement in the middle of a period marked by discernible change in clothing styles, manifesting a desire for the woman of fashion to be "completely modern— sexy, romantic without a trace of nostalgia."[2] What this meant for women's dress was a shift to fashions that showcased young and fit bodies in the form of miniskirts and dresses of shape-skimming silhouettes made possible by innovations in fabrics such as vinyls, polyesters, and knits. Clothing no longer relied upon body-shaping undergarments. In 1964 California designer Rudi Gernreich, who a few years earlier had ventured east to open a Seventh Avenue showroom for his body-conscious knitwear designs, introduced a natural-fitting, ultra-sheer brassiere that he dubbed the "No Bra" bra, which

permitted the upper body to move freely without visible means of support.

The era's maverick spirit of fashion experimentation energized Seventh Avenue veterans, such as Pauline Trigère and Norman Norell, as well as new Seventh Avenue designers just establishing their own labels. The leaders of the latter cadre were design modernist Geoffrey Beene and fashion iconoclast Gernreich. Beene established his own label in 1963 after working as a designer for Seventh Avenue's Teal Traina of Traina Inc., which had been launched in 1959 following the dissolution of the Traina-Norell manufacturing partnership. Beene's trail-blazing design philosophy expanded upon the traditional American fashion vocabulary by "aiding the process of the modernization of clothes on a couture level . . . taking limitations off fabrics . . . making the humblest fabric as rich as the richest . . . recognizing the symbiotic relationship between comfort and style."[3] During this era, Beene transformed his color palette from muted and sedate to bold and vibrant, verging on fluorescent. This youthful palette characterized his evening gown of resist-dyed silk

chiffon, a creation for which he won his first Coty American Fashion Critics' Award in 1964.

Adding to the era's dynamic mix were audacious newcomers who had not apprenticed on Seventh Avenue, including Betsey Johnson and Deanna Littell. Many of these designers had only vocational training in sewing and clothing construction, skills like draping and pattern-drafting, and they applied their artistic enthusiasm to little-nothing dresses, invigorating America's reputation for easy dressing with their technically naïve approaches toward design. Concept-driven rather than structurally sophisticated, their creations frequently relied on spontaneous intuitive techniques such as wrap-and-tie and on-the-body draping rather than on flat patterns and toiles—designs inspired by raw talent rather than technical skill.

Whether a seasoned denizen of Seventh Avenue or an aspiring neophyte, New York fashion designers drew inspiration from surprising and non-traditional sources, frequently reflecting contemporary trends in art. *Life* magazine's February 26, 1965, coverage of "Pop" dresses emblazoned with Andy Warhol's soup cans was followed by the April 16, 1965, issue showcasing a colorful array of visually disorienting dresses shot within the Museum of Modern Art's exhibition *The Responsive Eye*. *Life*'s "It's OP from Toe to Top" fashion feature, with "OP" meaning "optical art," featured designs by Geoffrey Beene and Pauline Trigère, both working in a startlingly technicolor palette. Transposing the kaleidoscopic colors and rhythmic effects of visual artists Victor Vasarely and Bridget Riley (who protested that her art was "sold to hang on a wall, not on a girl"), Beene's and Trigère's fashions resonated with the vitality of contemporary art motifs.[4] Concurrently, both fashion newcomer Betsey Johnson and Andy Warhol were fascinated by reflective materials; Warhol decorated his studio, the Factory, with mirrors, tin foil, and silver paint, while Johnson designed a silvery shift for Warhol superstar Edie Sedgwick.

In addition to homegrown talent, this New York moment was defined by an infiltration of British Mod musical and theatrical performers, as well as designers, hairstylists, and makeup artists—all chiseling away at Britain's longstanding reputation as a seat of cultural and fashion conservatism. Originally derived from the word modernist and used to represent a preference for jazz and the anti-establishment fashion stance of a male-dominated, London-based clique, Mod came to encompass a broad range of cultural and lifestyle preferences starting in the mid-1950s. Mod style was embodied by the Beatles—who took New York by storm in February 1964—and was characterized by slim, custom-tailored suits, pointed-toed boots, and forward-combed, long, shaggy hair.

In the world of fashion design, the British invasion was epitomized by London's Mary Quant. Having launched her original Kings Road boutique, Bazaar, in 1955, with a follow-up location in Knightsbridge the following year, Quant next targeted the United States for potential business affiliations. Scouted by junior J.C. Penney buyer Paul Young, who was charged by the company to search Europe for new talent, Quant was hired in 1962 as a London-based premier designer for Penney's "Young International

Designer Collection." In 1963 she came with her husband to New York, where she intended to infiltrate Seventh Avenue's fashion structure. Quant herself was a walking advertisement for a distinctive London Mod look that united fresh, simply cut clothing, patterned white stockings, baby doll shoes, and pale face makeup with darkly defined eyes and carefree hair. She acquired her iconic wedge-bob from British hairstylist Vidal Sassoon, who revolutionized the hair industry by foregoing rollers and hair spray in favor of virtuosic precision cutting and who opened his own New York salon in 1965.

During her visit, Quant showed her collections to New York's industry-defining publication *Women's Wear Daily*, which raved, "These Britishers have a massive onslaught of talent, charm, and mint-new ideas. English chic is fiercely NOW . . . by the young for the young." Quant and her work were also featured in Diana Vreeland's "Youthquake" issue. Quant was also the leader of the most daring retail experiment of the mid-1960s: Madison Avenue's Paraphernalia boutique. Showcasing the maverick designs of

an obscure creative team, the shop offered accessibly priced clothing made up in non-traditional, space-age materials and intended for short-term wear. Paraphernalia's futuristic clothing was real, not conceptual, and was available for immediate purchase. Its seductive fare featured works in neon and see-through vinyl, armor-linked metal and plastic plaques, and wet-look synthetics, all in the name of fashion iconoclasm. The boutique's unique retail environment showcased the experimental creations of a hand-picked team selected by Paul Young, who had moved on from his earlier affiliation with Penney's. The team comprised Betsey Johnson ("the hottest property off Seventh Avenue and a one-woman rival to the Kings Road and Carnaby Street"); Parsons-trained Deanna Littell; Joel Schumacher; Carol Friedland; and anchored by Mary Quant. [5]

Paraphernalia was launched with a spectacular September 1965 opening party. *Vogue* later recounted, "The clothes racks had nothing for sale, but the boutique was jammed. There were the prettiest girls; the best dancers; the super New York swingers; the

police (smiling)—and later on Senator Edward M. Kennedy . . . lots of guests wore clothes the shop is now selling." [6] A vital blend of late-hour hangout for New York's beautiful people, where one could try on, purchase, and walk out wearing the day's cutting-edge fashion, Paraphernalia was more than a store; it was a symbol of the free-spirited, Youthquake ethos of the mid-1960s.

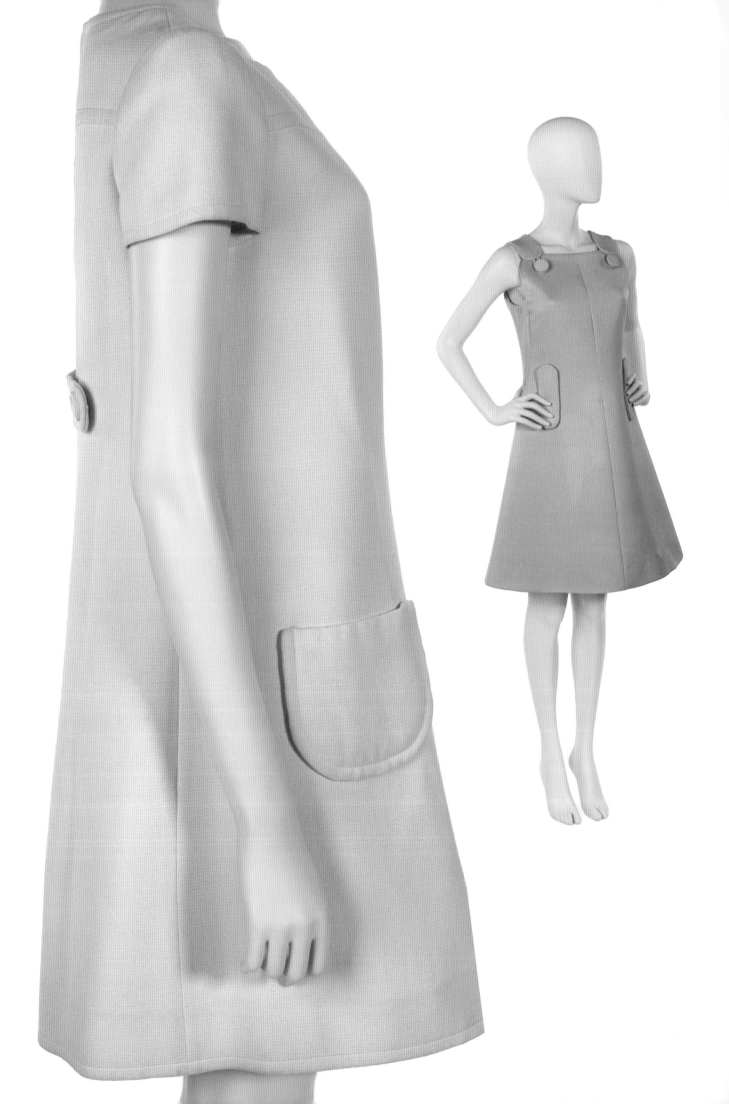

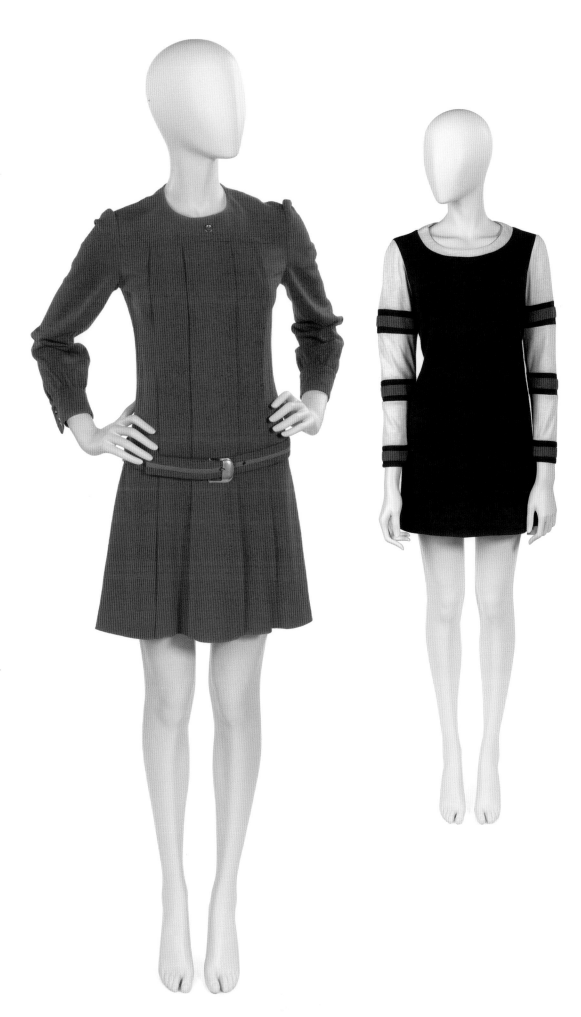

**André Courrèges**

Day dress of patterned wool twill, welt seams, mid-1960s.

**André Courrèges**

Dress of wool gabardine, decorative welt applied panels over slit pockets echoing wide shoulder staps, mid-1960s.

**Mary Quant, designed for J.C. Penney Co.**

Dress of pleated wool jersey with ribbon-applied self-fabric belt, 1967.

**Mary Quant, designed for J.C. Penney Co.**

Ensemble comprising wool jersey mini dress and matching "knickers," 1967.

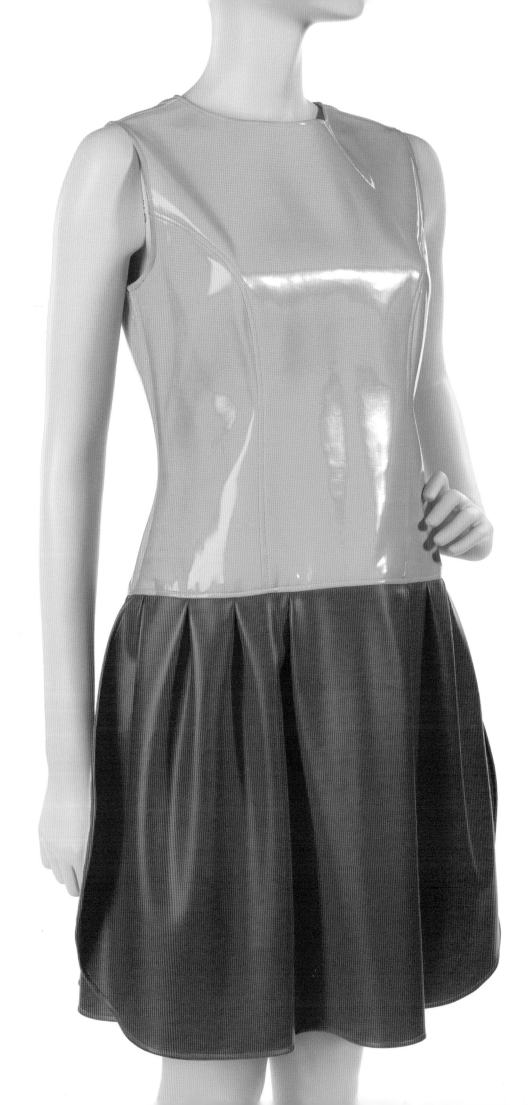

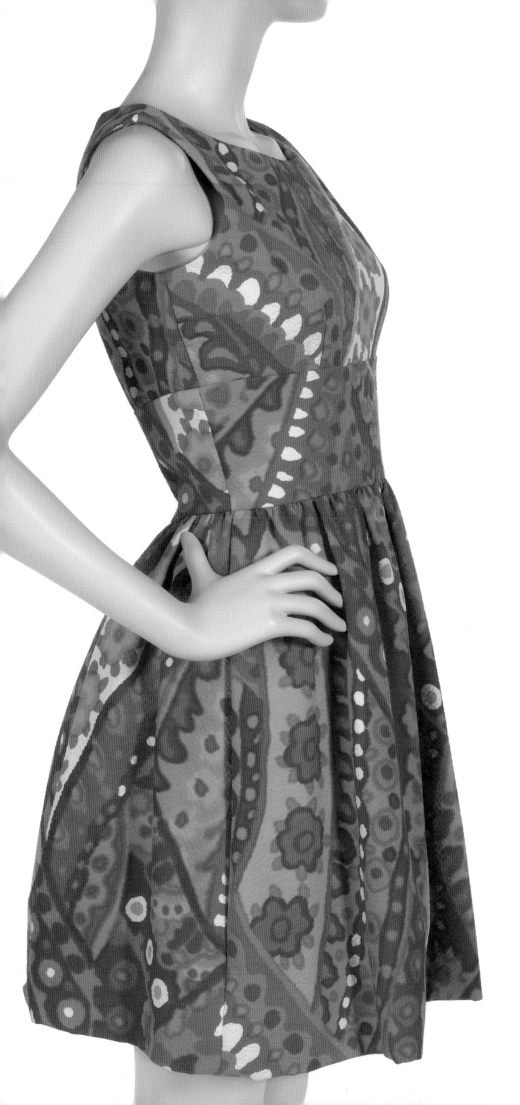

**Tiger Morse
(attributed)**

Dress of vinyl,
ca. 1965.

**Chester Weinberg,
retailed by
Henri Bendel**

Day dress of printed
cotton cloque,
1964–65.

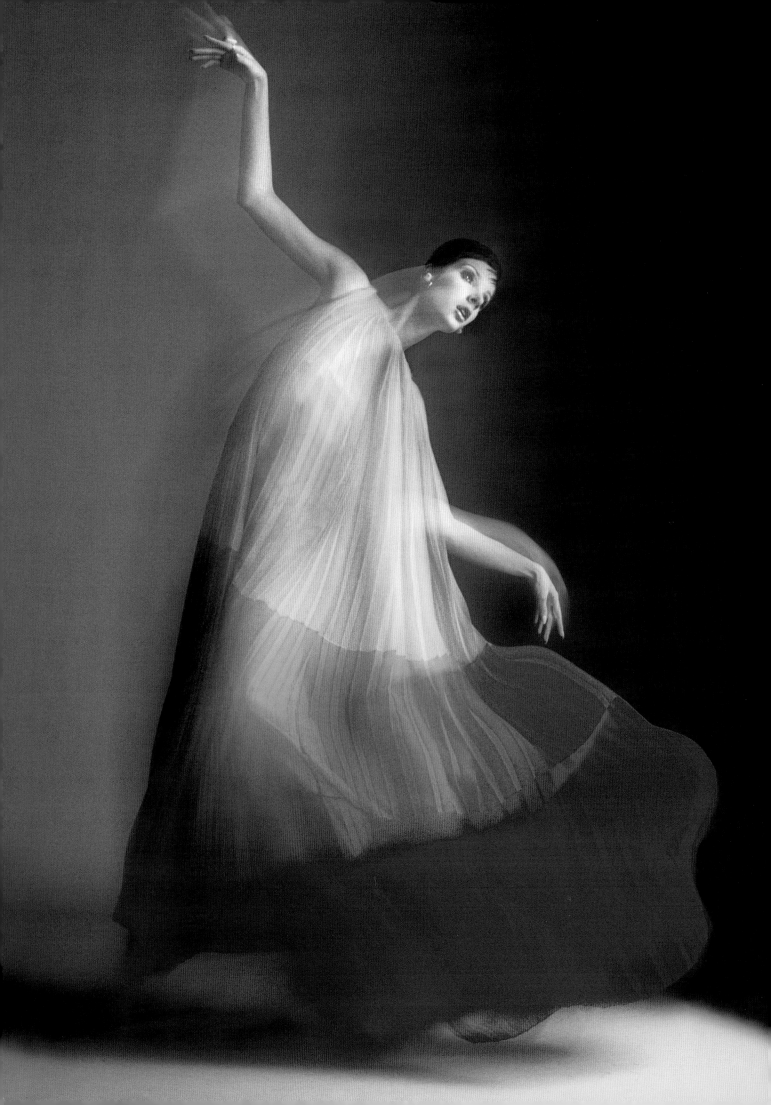

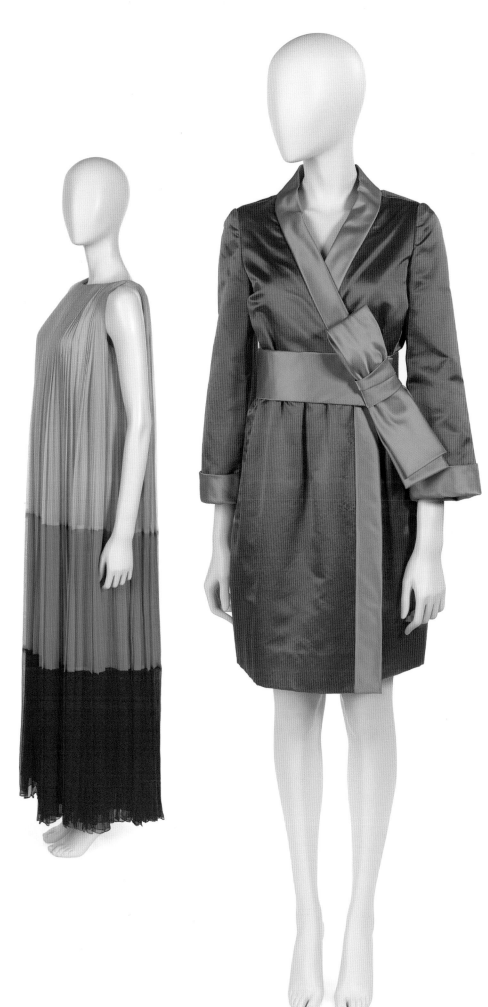

Opposite: Diana
Newman models a
Sarmi dress in full
motion to reveal its
voluminous skirt, 1967.
© Neal Baar, outtake
from photoshoot
for *Harper's Bazaar*,
March 1967.

**Sarmi**
———
Evening dress of silk
chiffon, mid-1960s.

**Deanna Littell
for Bendel's Studio,
retailed by
Henri Bendel**
———
Evening kimono
dress of contrasting
satin, 1967.

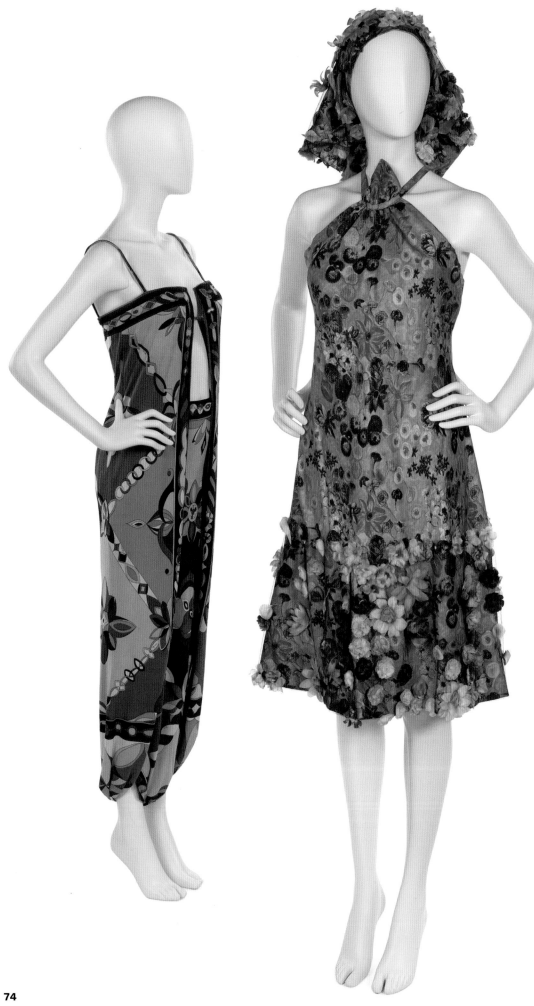

**Emilio Pucci,
retailed by Saks
Fifth Avenue**

Evening jumpsuit
of "Rombi" silk knit
jersey, 1966.

**Pauline Trigère,
retailed by
Lord & Taylor**

Cocktail dress with
matching scarf and
briefs of silk, ca. 1965.

**Pauline Trigère**

Ensemble comprising
cocktail dress and
stole of chiffon
with applied ostrich
feathers, 1966.

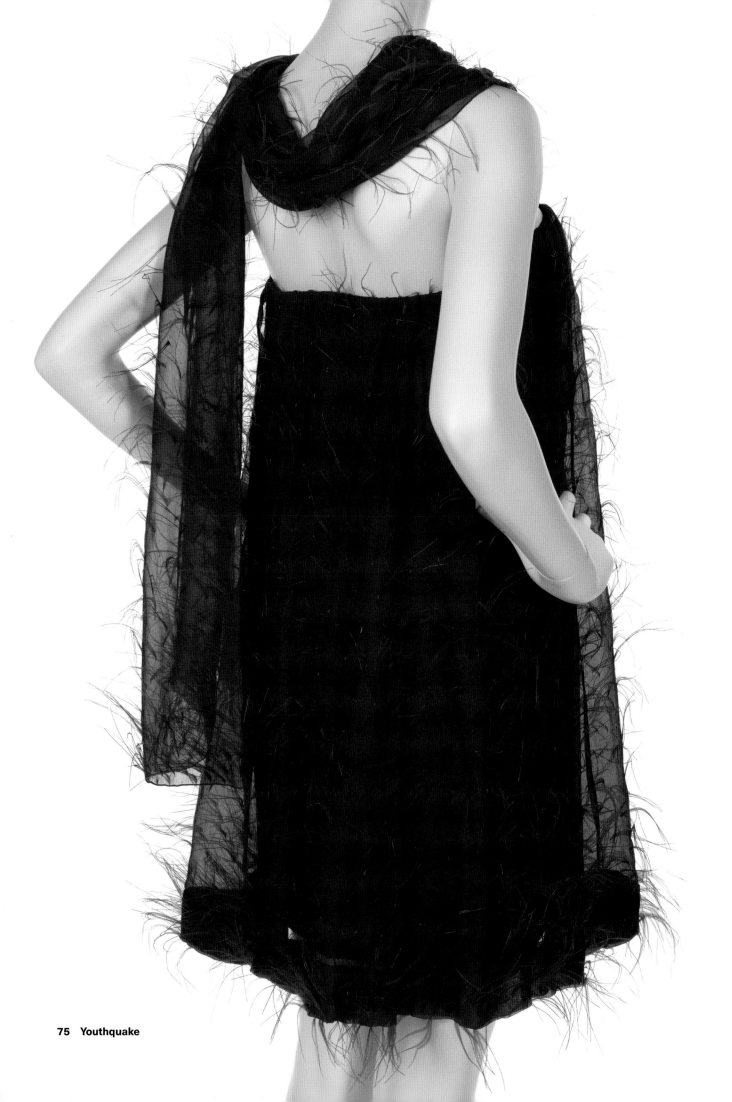

André Courrèges utilized architectural seams and clean lines in his "space age" designs for the modern woman. Image published in "Paris 1964: Vogue's First Report on the Spring Collections," *Vogue*, March 1, 1964.

**André Courrèges**

Ensemble comprising coat of wool flannel and dress of worsted double wool gabardine twill, 1964.

**André Courrèges for Samuel Roberts**

Ensemble comprising coat and dress of tattersal plaid wool gabardine, mid-1960s.

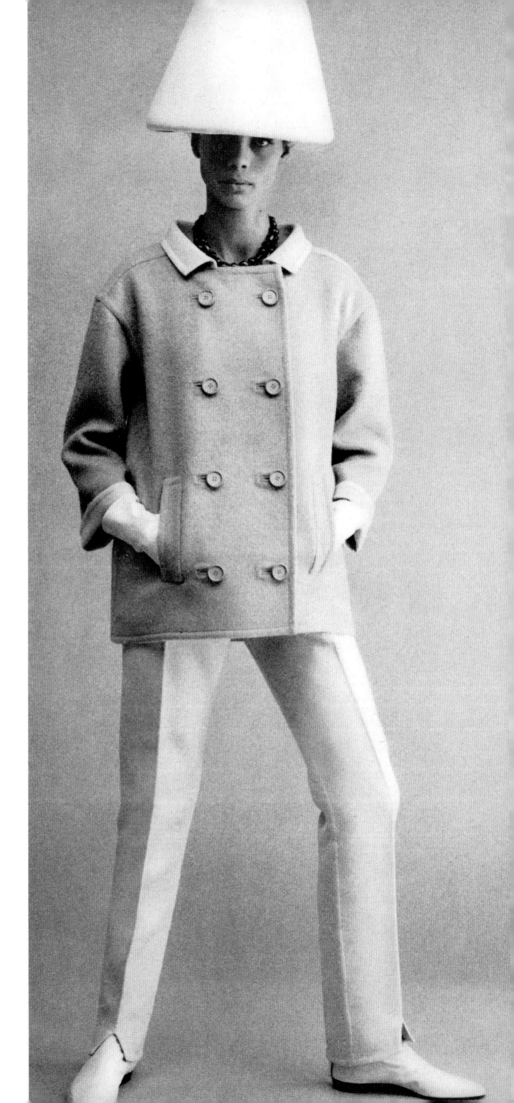

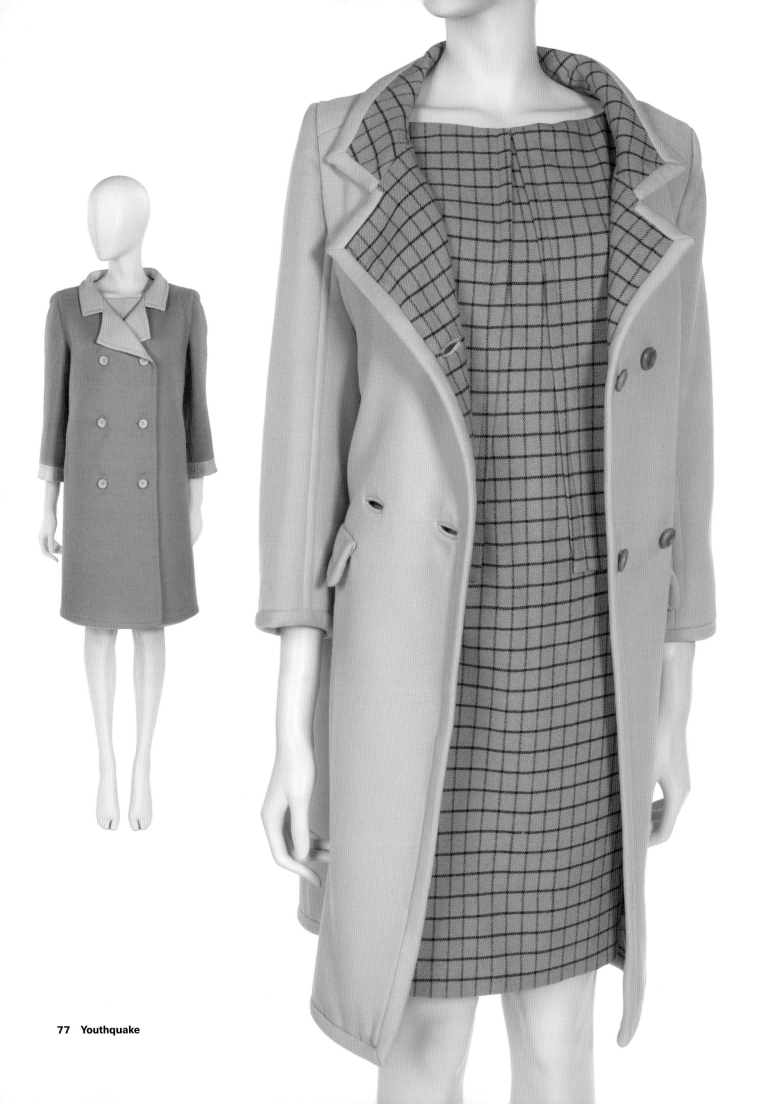

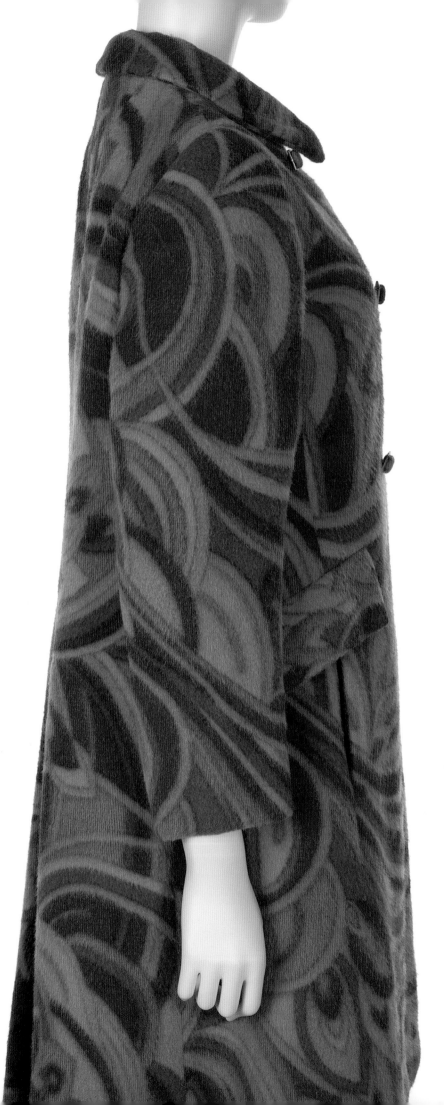

Opposite: Model Marissa Schiaparelli Berenson, granddaughter of couturière Elsa Schiaparelli, wearing a Bill Blass coat in an editorial feature published published in *Vogue*, August 15, 1967.

**Bill Blass for Maurice Rentner, retailed by Saks Fifth Avenue**

Coat of foliate printed mohair and synthetic pile, 1967.

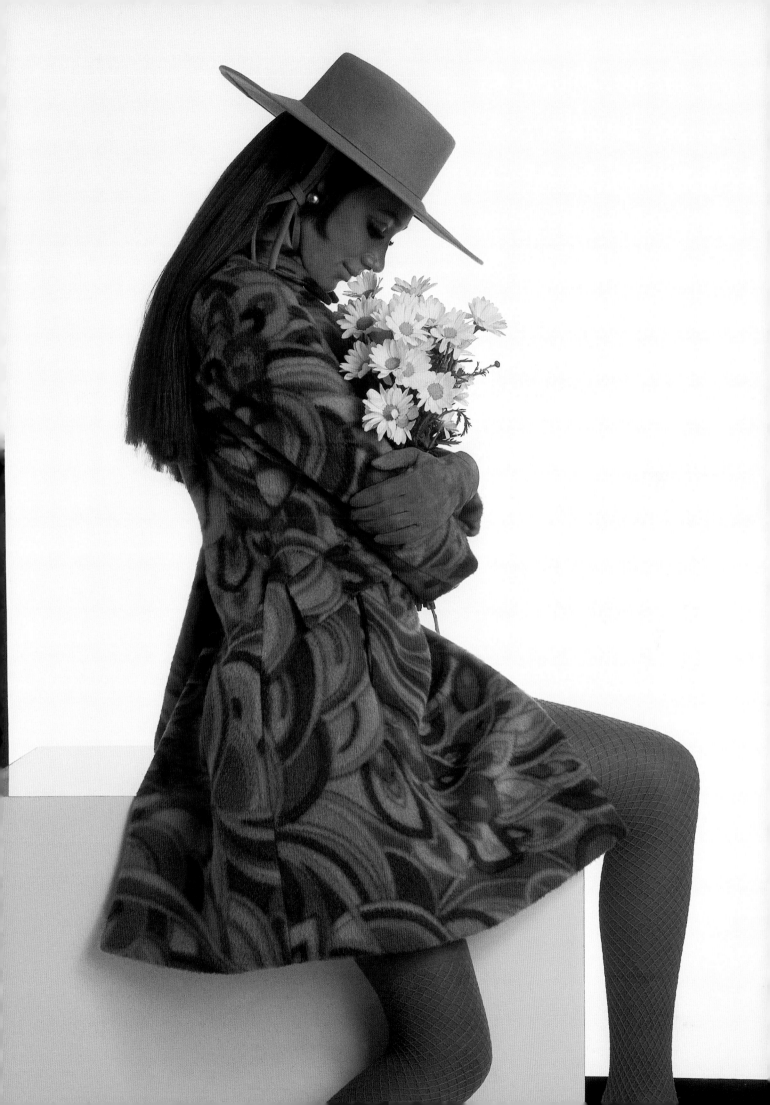

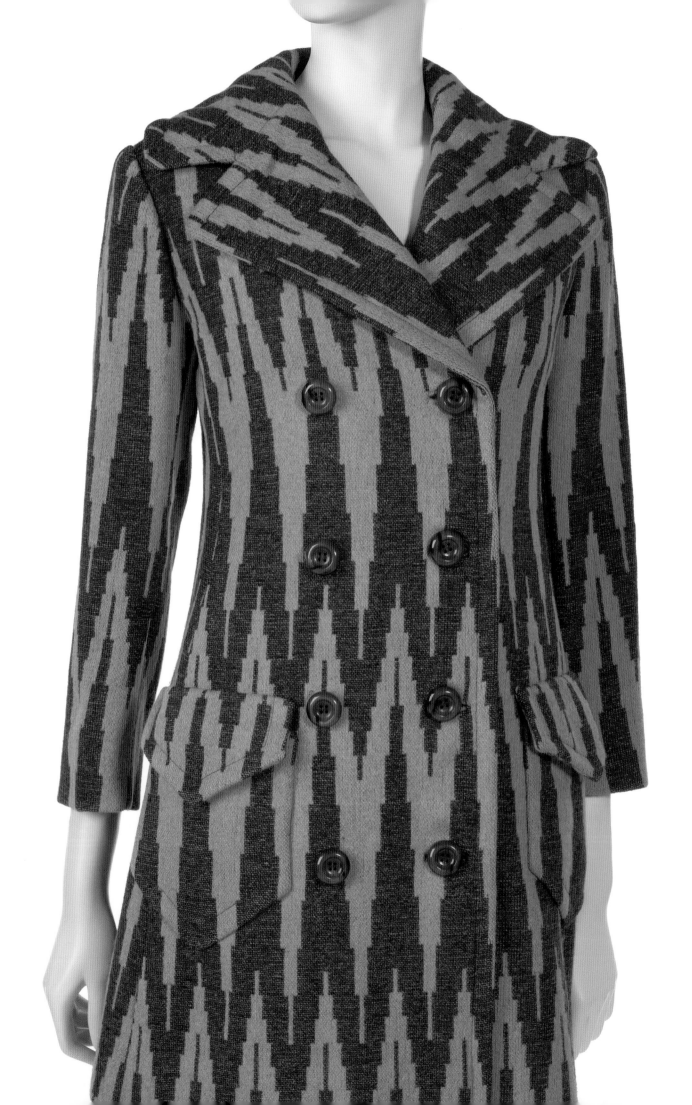

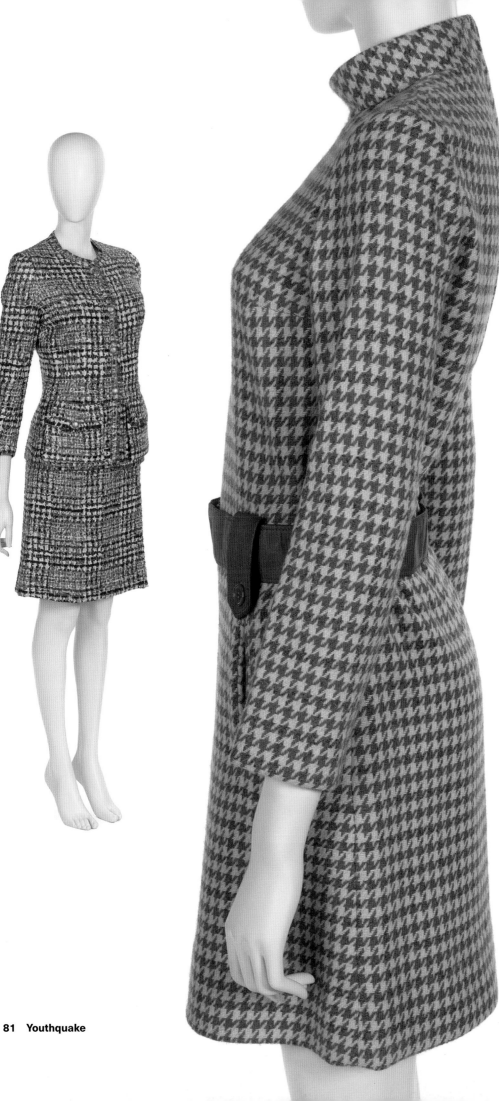

**Donald Brooks**

Suit comprising jacket and skirt of wool with woven ziggurat motif, 1965–67.

**Chanel (attributed)**

Day ensemble comprising dress and jacket of silk and Linton wool tweed, 1965.

**Anne Klein for Mallory, retailed by Franklin Simon**

Day ensemble comprising coordinating suede coat (not shown) and hounds-tooth wool dress, mid-1960s.

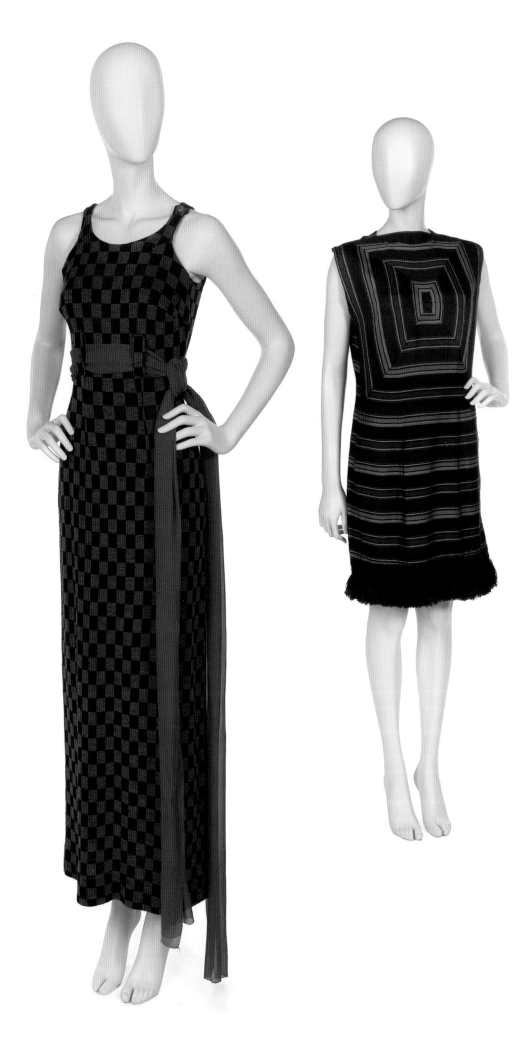

**Rudi Gernreich
for Westwood
Knitting Mills**

Dress of wool knit with
silk chiffon sash, 1955.

**Ruby Bailey**

"Bullseye" day dress
of linen woven with
horizontal stripes and
decorative cotton
fringe hem, 1965–67.

**Norman Norell**

Dress of net studded
with rhinestones
over silk crepe, 1965.
Designed for Lauren
Becall to wear in her
role in *Cactus Flower*
(1965 Broadway
production).

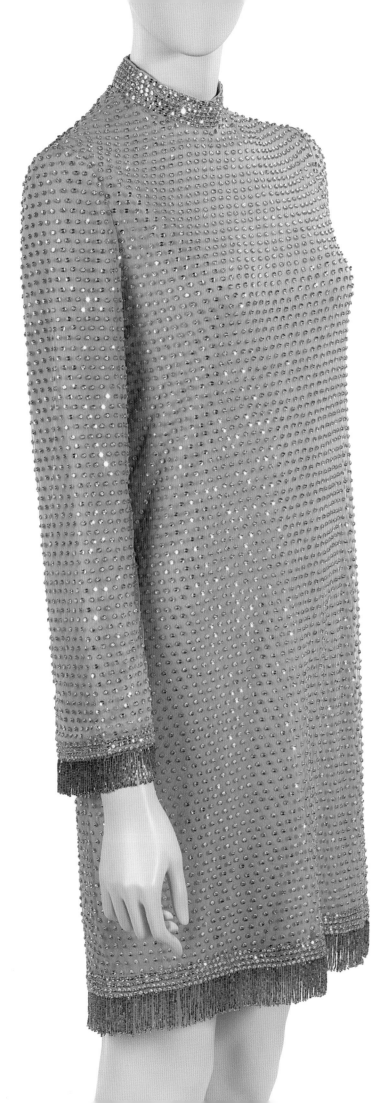

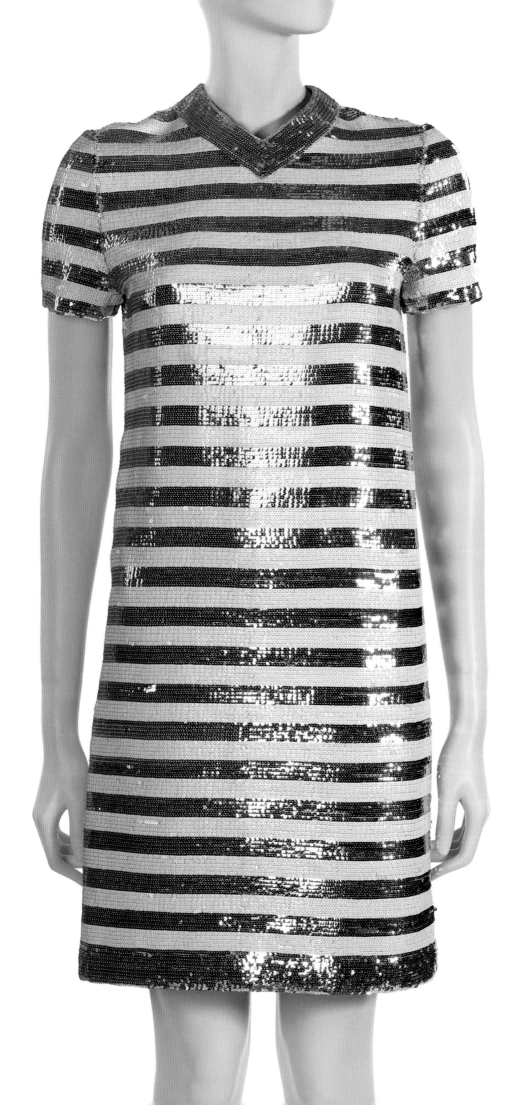

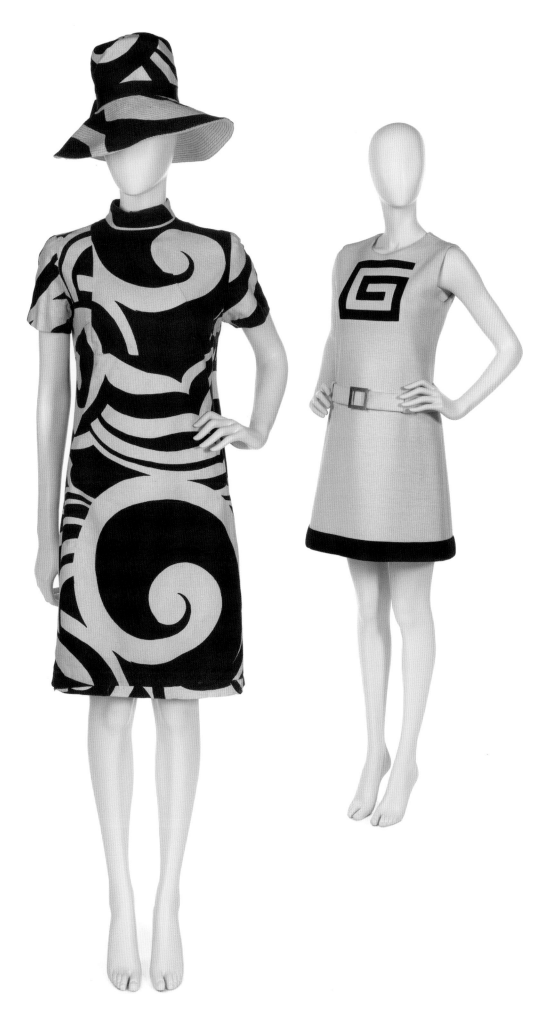

**Yves Saint Laurent (attributed), retailed by Bonwit Teller**

Cocktail dress of alternating sequin bands on wool ground, 1966.

**Ruby Bailey**

"Swirl" dress and hat of crash linen printed in swirls and arabesques, 1965–67.

**Pierre Cardin**

Dress of wool jersey with self-fabric belt, 1967.

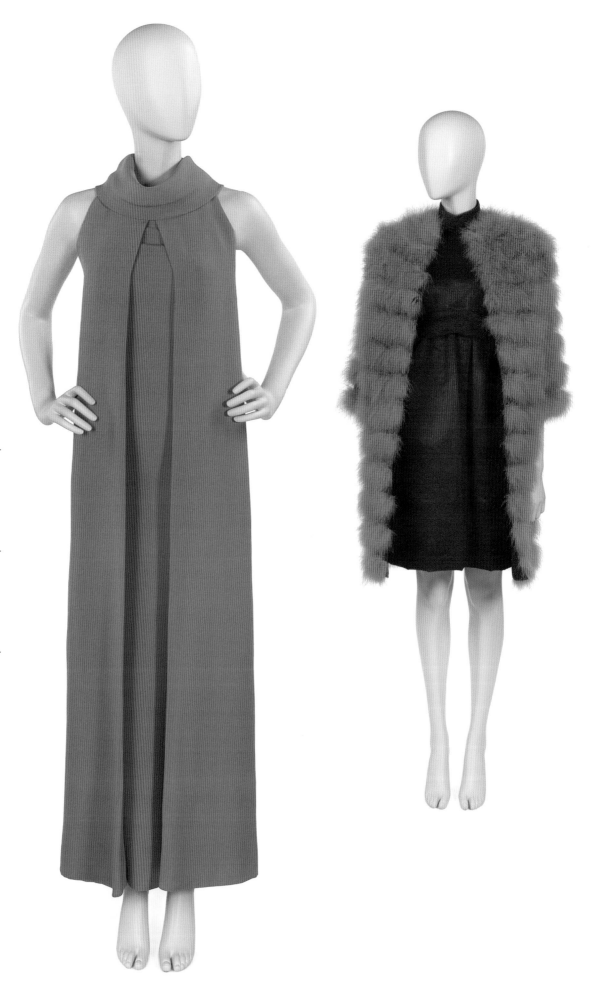

**Jean Patou**

Evening dress of silk crepe with floating panels, 1967.

**Geoffrey Beene, retailed by Henri Bendel**

Evening ensemble comprising evening dress of satin and "fluff"coat of marabou, 1967.

**Galanos**

Evening ensemble comprising wool jersey poncho over one-shouldered gown, 1966.

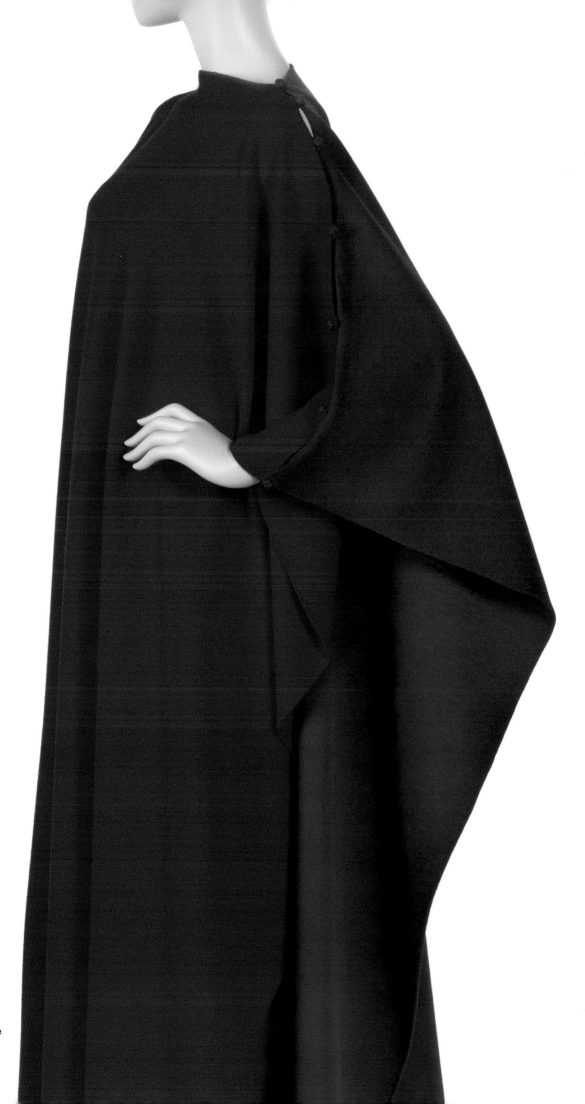

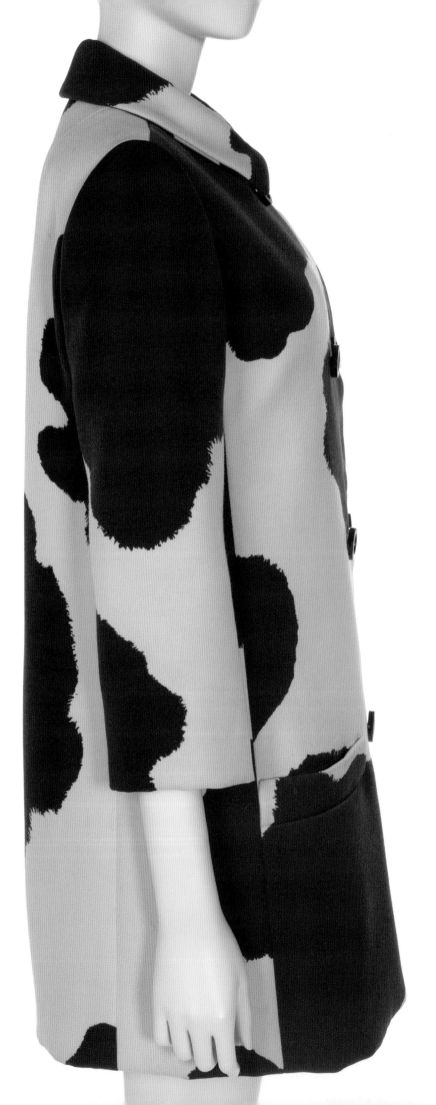

**Donald Brooks**

Coat of pony-print wool gabardine, 1965–67.

**Geoffrey Beene, retailed by Lord & Taylor**

Dress of cotton cloque with patent leather belt, mid-1960s.

**Geoffrey Beene, retailed by Lord & Taylor**

Dinner dress of worsted wool crepe with ostrich feathers, ca. 1967.

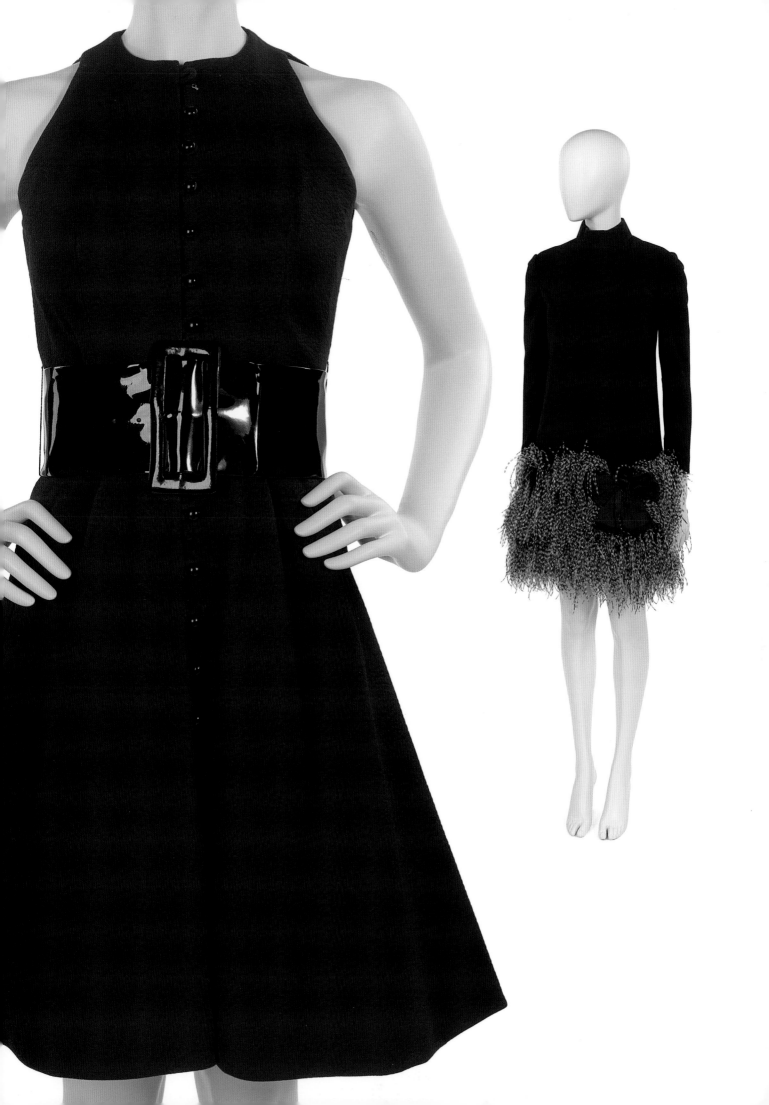

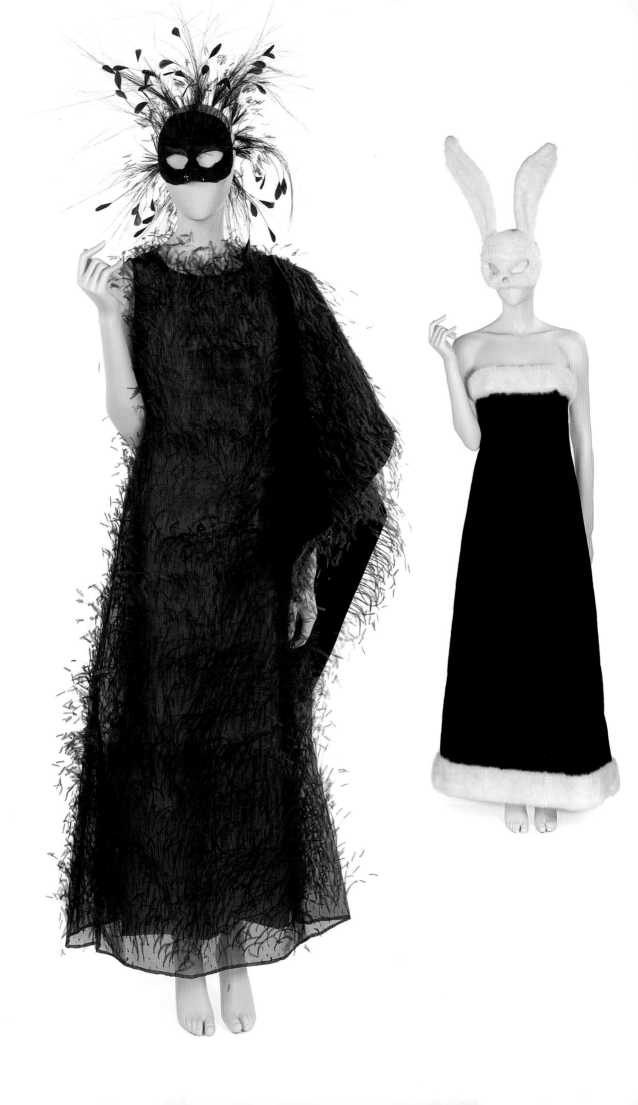

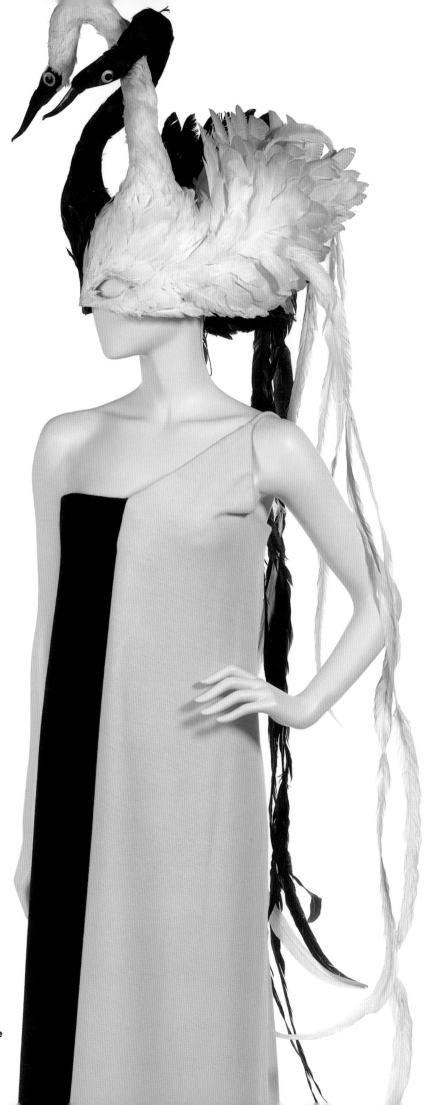

On the evening of November 28, 1966, Truman Capote hosted 540 politicians, scientists, artists, writers, composers, tycoons, and other luminaries at a Black and White fancy dress ball honoring *Washington Post* publisher Katharine Graham. Held in the grand ballroom of the Plaza Hotel, the event was hailed as "the party of the century" and "the biggest and most glorious bash ever" by *Life* magazine.

### Halston

Evening dress and stole of feathers on organza, 1966. Worn to the Black and White Ball.

### Halston

Strapless evening dress of velvet and bunny mask in mink and satin, 1966. Worn to the Black and White Ball.

### James Galanos (dress)/Bill Cunningham (mask)

Evening dress of double-knit wool jersey and mask of coq feathers in shape of intertwining swans, 1966. Worn to the Black and White Ball.

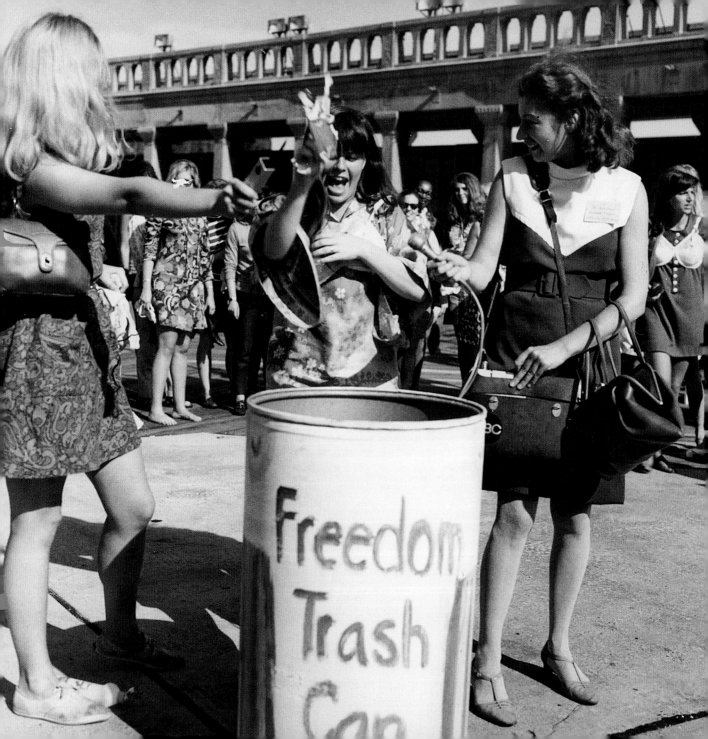

**Sarah Gordon**

# Liberating Fashion

## Feminism and Women's Clothing in the 1960s

A 1966 photograph of the British model Twiggy shows her sitting in front of what appears to be a toy shop, holding a balloon. She sits knock-kneed, her Mary-Jane-shod feet pigeon-toed, her eyes enormous with false eyelashes. Her floral-patterned dress has no waistline and the hem is at mid-thigh. A photograph taken four years later shows women wearing similar short skirts marching down Fifth Avenue in feminist solidarity. More than 10,000 women marched that day, demanding legal abortion, equal opportunities in education and employment, and equal rights in their own relationships.[1] While both photos portray women in miniskirts, they represent "before" and "after." Twiggy was a symbol of the "Youthquake," young women who rejected their mothers' girdles and suits and embraced mini dresses and pants. But because they didn't have many alternative models, they frequently ended up looking like little girls. A few years later, engagement with anti-establishment movements offered alternative identities. In its opposition to a profoundly sexist society, the women's liberation movement offered a new version of femininity— a version that was reflected in the clothing women wore.

Women's clothing changed dramatically during the 1960s, and feminism changed the way people thought about themselves, their relationships, and the society around them. These parallel changes—in fashion and in the wider cultural arena—influenced each other. The miniskirt began as youthful revolt against the traditional ideas of the 1950s, but, as that same generation of women became engaged in issues of gender equality and social justice, they embraced the "No Bra" bra, minis, pants, and other new styles of the period as symbols of modernity and explicit political statements.

After the Depression and World War II, the desire to return to "normal life" included a return to traditional roles and opportunities. Women

Women protesting at the Miss America pageant in Atlantic City, 1968.

who had worked at "men's" jobs were urged to "go home and raise a family." This nostalgia for "normalcy" in gender relations was reflected in fashion. Ultra-feminine designs accompanied gendered segregation of occupations and expectations. Strong-shouldered, practical styles from the 1940s, influenced by war work and fabric rationing, were replaced by Christian Dior's "New Look" of full skirts with narrow, corseted waists. The fashions of the 1950s featured hourglass silhouettes accompanied by stockings, high heels, hats, and gloves. Women's bodies were molded by tight girdles and pointed bras. Even waistless "sack" dresses were made with restrictive hems, constricting movement as much as the form-fitting skirts and suits.

But real life wasn't what was depicted in *Life* magazine. Women continued to work, channeled by sex-segregated, help-wanted ads to secretarial, waitressing, teaching, and other feminized "pink collar" jobs that paid less than "male" jobs. Even if they held the same job as men, women's wages were consistently lower, plus women faced sexual harassment, a "second shift" of housework, and difficulty finding child care.[2] In 1961 President John F. Kennedy created the Interdepartmental Commission on the Status of Women, and he signed the Equal Pay Act in 1963 to address some of these challenges. As the federal government was looking at women's work and wages, skirts began to creep above the knee. Exactly who started the trend depends on who tells the story, but British Mod designer Mary Quant is frequently credited with naming shorter skirts "minis." Quant designed a distinctly different silhouette for the new generation, drawing attention to legs and away from breasts, waists, and hips. By the mid-1960s, minis were ubiquitous.

The miniskirt offered women more than a new look—it meant a new way of moving. In minis and the flat or low-heeled shoes worn with them, they could take longer strides. The mini also meant more comfortable, less restrictive underwear, and because short skirts would expose garters, Quant marketed tights. One fan, writer Elizabeth Kendall, described the feeling of wearing tights as "a kicking of legs, a leaping in the street . . . They were motion!"[3] The evolution away from form-fitting designs to A-line shifts also meant less pressure (no pun intended!) to squeeze into an hourglass shape. Kendall also admired Marimekko's brightly patterned shifts that "were cut like primitive paper-doll frocks, which meant *no girdles were necessary.*"[4]

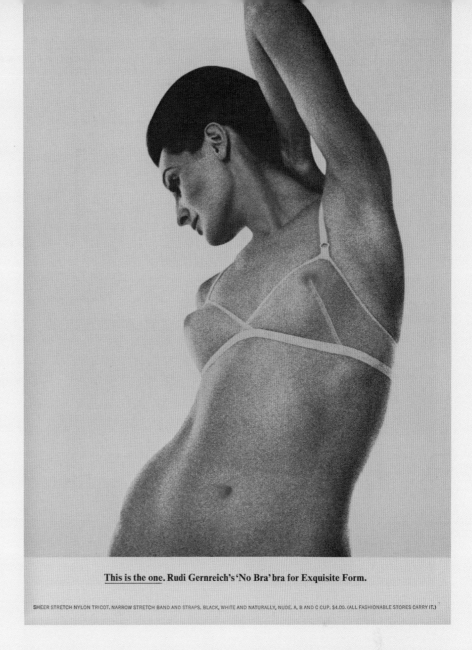

**This is the one. Rudi Gernreich's 'No Bra' bra for Exquisite Form.**

SHEER STRETCH NYLON TRICOT. NARROW STRETCH BAND AND STRAPS. BLACK, WHITE AND NATURALLY, NUDE. A, B AND C CUP. $4.00. (ALL FASHIONABLE STORES CARRY IT.)

The comparison to doll dresses was not coincidental—the mini was
a deliberate move away from styles worn by the mothers of this genera-
tion, an escape from hyper-feminine silhouettes and high heels. Actress
Ali McGraw recalled how her Betsey Johnson miniskirt made her feel
"*so* different from the depressing society ladies," and *Rags* magazine
observed that "the mini was *us against them*, youth against older people
whose values they had grown to mistrust more and more."[5] Mary Quant
believed that "growing up was a debilitating thing," and many of her
styles were deliberately childlike.[6] Models posed pigeon-toed, and shoes
sported Mary-Jane straps. Some mini dresses were actually called "baby
doll" dresses. Celebrity models Edie Sedgwick and Twiggy popularized
the "gamine" look with their short haircuts and elaborately made-up eyes.

Ironically, the childlike aspect of the miniskirt was sometimes used
to mock the women who were pursuing change. Many women involved
with the "New Left" anti-war and social justice movements felt marginal-
ized by sexism within their organizations. A 1967 newsletter produced by
Students for a Democratic Society (SDS), for instance, included a cartoon

showing a doe-eyed, childlike woman, dressed in a polka-dotted baby-doll dress with puffed sleeves, bow tie, and matching panties, holding a sign that read, "We want our rights and we want them now!"

Another interpretation of the mini's popularity was that it offered a new and liberating femininity. Emanuel Ungaro claimed that "the liberation must progress" and stated that his miniskirts encouraged movement for women who "have become so strong and so independent."[7] It wasn't just designers eager to sell their products who loved the new style. Historian and artist Carole Turbin felt empowered by "a knit mini dress with wide orange and yellow horizontal stripes, which showed off my long legs," and writer Margo Jefferson adored her knock-off Rudi Gernreich mini dress because it made her feel fabulous.[8]

Quant associated her designs directly with new choices for women, relating them with modernity, freedom, and the invention of the birth control pill:

> Women had been building to this [new freedom] for a long time, but before the pill there couldn't really be a true emancipation. It's very clear in the look . . . a rather childlike exhilaration: Wow!—look at me!—isn't it lovely? At last, at last![9]

"The pill," available beginning in 1960, revolutionized women's sexual relationships. While early oral contraceptives were not without downsides—serious side effects, reduction in hormone levels, and health risks—they did, as Quant noted, emancipate women. And miniskirts represented that emancipation. A fundamental change had been wrought, and it had become possible to pursue lives that included intimate relationships without unwanted pregnancies.

Not all feminists associated miniskirts with social change, however. The members of the National Organization for Women (NOW), formed in 1966 by Betty Friedan and a diverse group of colleagues to focus on employment inequalities, wore clothing that reflected their goals of working *within* the political system. NOW emphasized policy changes—such as maternity leave, contraception, education, and equal employment laws—rather than revolutionary shifts in gender roles. They therefore dressed to be accepted by the establishment they sought to influence. A photograph of NOW's 1966 organizing conference shows members wearing conventional suits and dresses and low heels, and journalist Anselma Dell'Olio

recalled the conservatively dressed crowd sporting "full makeup, tailored suits, and hats" at NOW's first meeting in an Upper East Side townhouse in Manhattan.[10]

Female members of SDS and similar organizations formed their own groups and engaged in what they called "consciousness raising," which focused on recognizing ingrained patterns of sexism. Participants were encouraged to see that their experiences were part of larger social patterns—that "the personal was political." It was these women who coined the term "Women's Liberation," began talking about "gender" as being socially created, and used the word "sexism" to describe deep-seated cultural biases against women.

Consciousness raising changed the way many women understood their own lives, and they then took steps to change the culture around them through organizations, protests, and legal challenges. The Boston Women's Health Collective published the wildly popular *Our Bodies, Ourselves* to answer women's health questions ignored by male doctors, and the Chicago Women's Liberation Union trained women to perform safe clandestine abortions. University students demanded female professors and equal access to degree programs. NOW petitioned the Equal Employment Opportunity Commission to end sex-segregated help-wanted ads, and activists "liberated" all-male institutions like McSorley's Ale House and cat-called male pedestrians on Wall Street. And a Rutgers University law professor named Ruth Bader Ginsburg argued before the Supreme Court that discrimination based on sex violated the Constitution.

One symbol of overt sexism that became a target was the beauty pageant. The group Redstockings, who believed women "won't get anything by being nice girls," protested the 1968 Miss America contest in Atlantic

City, claiming the pageant epitomized how "men are judged by their actions, women by appearance" and served "to enslave us all the more in high-heeled, low-status roles."[11] Redstockings staged a demonstration on the boardwalk, unfurled a banner in the pageant hall, spoke only with female reporters, and crowned a live sheep. Their protest made television and print news, which featured the pageant winner together with the demonstration. What garnered the most attention was Redstockings' "Freedom Trash Can," into which they threw "instruments of female torture" such as high heels, bras, garter belts, girdles, false eyelashes, and copies of *Playboy* and *Good Housekeeping*. The press reported that Redstockings set fire to the items in the can although, in fact, nothing was actually burned, as fires were not permitted on the boardwalk.

The Atlantic City protest represented a rejection of the way women were *supposed* to be and prodded more women to consider their clothing in a political light. It was not difficult to associate stiff, pointed bras and constricting girdles with women's oppression. Elizabeth Kendall recalled how her bra and girdle made her feel like she'd been punched in the stomach and implied that her natural shape was shameful.[12] She was not alone. After the pageant, Redstockings received letters with testimonials like, "I've been waiting all my life for something like this to come along."[13] A year later, *Women's Wear Daily* quoted a college student saying, "I find bras uncomfortable. Half the girls I know don't need them anyway. Besides, I think that clothes look better without them."[14]

Comfort in clothing was central to reclaiming women's bodies for themselves. British design team Marion Foale and Sally Tuffin believed that "clothes *had* to be comfortable. That was the main requirement."[15] Comfort began with textiles: the new stretch fabrics pleased consumers, manufacturers (DuPont's worldwide earnings from Lycra grew from $6.3 million in 1964 to $30 million in 1969), and designers, who embraced the new materials.[16] In addition to stretch jersey, they used leather, denim, paper, and new synthetics like nylon and vinyl that offered attention-getting colors and textures. The colors were memorable—my mother, Suzanne Gordon, a science teacher, recalled a "beautiful lime green coat," and her friend Tara Gordon fondly remembered "bell bottoms . . . made of satin—some were pink and one pair was green with yellow and orange stripes vertically going up my leg."[17]

Those spectacular bell bottoms signified another important social phenomenon. While miniskirts got most of the attention, the

mainstreaming of pants for women may have been the more dramatic and enduring change. (Carole Turbin's father, William Turbin, born in 1909, believed that "women wearing pants" was the greatest change during his lifetime.[18]) Women had worn pants in casual or work settings for years, but because they were not considered "good" clothes, they did not threaten the status quo. While college students frequently wore jeans, many colleges banned women from wearing pants in classrooms or the library.[19] *Women's Wear Daily* observed in 1960 that "trousers have remained restricted to the areas of casual, sports and home wear." The article was illustrated with images of Norman Norell's suits with tailored long shorts, which it claimed were "the way pants can stride into everyday life, look correct, and not shatter any standards of femininity."[20] It was high praise to remain unthreatening.

Pants graduated from work and play wear to "grownup" options for women *only* when those standards began to change. Trousers were firmly associated with masculinity and male power and, until that power was questioned, women in trousers could not be not taken seriously. In 1962 couturier Yves Saint Laurent designed trousers intended for "weekends or night," but waited several years before creating a collection of trousers "for everything, for restaurants, for life."[21] Tuffin recalled that when she and her partner first made a suit with pants instead of a skirt they "fell about laughing" because it seemed so outré.[22] But their customers welcomed this new way of dressing—their pantsuits sold out at the opening of the Paraphernalia boutique in 1965.

Leftist women considered pants to be tools in their campaign for equal rights. Socialist feminists wore men's jeans with an explicit intent, arguing that since gender differences were socially determined, dressing in a more gender-neutral way "would not only contribute to eliminating male dominance but also class and race inequality."[23] Saint Laurent explained that he'd been inspired by young women protesters wearing pants and that his ready-to-wear trousers intended "for everything" sold best because that (younger) customer was "more adapted to the life of today, more receptive to change."[24]

Feminism did not mean dressing in one specific way—women were able to choose styles from "severe to sexy showoff."[25] Moreover, one individual could enjoy a style for multiple reasons. For instance, Turbin appreciated pants as a symbol of gender equity *and* because they showcased women's curves. Tara Gordon loved her peasant blouse, saying, "I was very, very

interested in what I wore reflecting my 'sexual freedom' and my contemporary style."[26] Both women were involved in feminist causes, and part of the freedom they sought was to dress and move as they pleased.

That freedom of dress was sometimes constrained in the workplace, however. While feminists sought greater educational and employment opportunities, their jobs often required traditional clothing. Many employers insisted that women wear skirts to work. When Turbin wore a favorite pantsuit to her job at the relatively liberal Ethical Culture Society, she was told she had to wear a skirt, and Tara Gordon chose to work in publishing *because* her employer let her wear jeans. Even members of Congress came up against dress codes. An avowed feminist and peace and civil rights activist, New York Representative Bella Abzug, like the members of NOW, dressed according to the rules in order to be taken seriously. Abzug, however, had the chutzpah to take ownership of those rules and create a trademark look. She explained her hats as a political choice:

> *In those days professional women wore hats—and gloves, so I put on gloves and a hat. And every time I went anywhere for business, with the hat and gloves, they knew I was there for business . . . When I ran for Congress and got to Washington, they made such a fuss about the hat instead of what was under it that I didn't know whether they wanted me to take it off or keep it on. I decided that they wanted me to take it off, which made me determined to keep it on.[27]*

In 1970 *Rags* decried dress codes that restricted women's choices:

> *As women become freer and more expressive in their dress, management has lately dragged out an old patchwork of Puritanical no-no's and stitched them together with diplomatic lingo.[28]*

The article described a booklet for Bank of America employees that offered examples of "good" and "bad" outfits. Approved skirts were no higher than 1.5 inches above the knee, which *Rags* described as "square examples of anal-fastidious middle America." Even less management-friendly than short skirts were a "psychedelic Afro bouffant" and a "hippie chick" outfit with a peace sign necklace.[29] It is no surprise that the Bank of America deemed Afros or hippie looks unacceptable. Dress codes were a way for the establishment to maintain control, and countercultural looks were, by definition, a challenge to that status quo.

Activist Bella
Abzug, ca. 1970.

Rules that rejected Afros were an attempt to force women of color to conform to white standards of appearance. Women of color faced a pervasive combination of racism and sexism, and the changes they sought, along with how they chose to dress and wear their hair, connected to their own experiences. Women in the Young Lords, a nationalist Puerto Rican group, focused on supporting their community and protesting the forced sterilization of women in Puerto Rico while dealing with sexism within their organization. Radical black feminists saw patriarchy as intersecting with racism, capitalism, and compulsory heterosexuality. Given the long history of black women caring for white children, many black women believed *their* liberation lay in staying home to raise their families, arguing that mothering was valuable work.

Just as they had a different view of the power structure, women of color reevaluated their appearance in different ways than did white feminists. The Civil Rights movement was a movement for inclusion, and protesters intentionally wore their best clothing. By the late 1960s, however, nationalist groups promoted natural hair and African designs. Margo Jefferson, who grew up in an elite black community, recalled that "suddenly, people like us were denouncing war and imperialism, discarding the strategic protocol of civil rights for the combat aggression of Black Power."[30] Jefferson stopped straightening her hair and began to wear an Afro, African-print dresses, and dramatic earrings. When Sherry Suttles arrived at Barnard College in 1965, she wore ironed dresses and pressed her hair straight; by 1967 she was choosing braids or an Afro and wore jeans and beaded necklaces from the Ivory Coast. Suttles commented that "fitting in with her white colleagues was no longer her priority." Instead, she adopted the look of "black, politically active New Yorkers."[31]

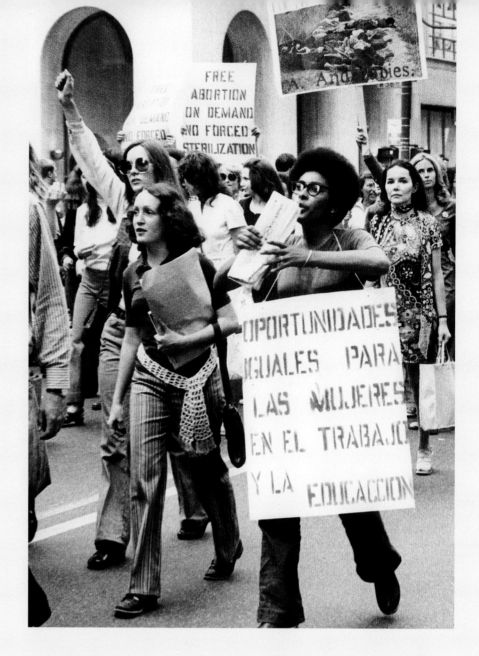

Women's Strike for Equality on Fifth Avenue, August 26, 1970.

A series of fashion shows in New York that featured the Grandassa models and African fabrics and designs gave rise to the phrase "Black is Beautiful."[32] The shows began as countercultural events, but within a short time, magazines spotted fashion trends and a broader audience and ran spreads on non-Western fashions. The message was powerful: a 1968 issue of *Sepia* magazine featured photos of Iris Carter, noting that she was "as proud of her race as she is of her pretty hair" in an article about how black college women were style influencers for their generation.[33] Just as the Miss America protest had engaged women who hated the restrictive clothing they were expected to wear, African-inspired looks resonated with young black women who valued their own heritage.

By the end of the decade, new ideas about gender, class, and racial equality were percolating through American culture. On August 26, 1970, more than 10,000 people marched down Fifth Avenue in support of women's equality. Marchers demanded childcare, abortion rights, the end to the Vietnam War, and equal opportunities in education and employment. Photos show women and men of all ages and ethnicities, as well as a

great variety of outfits—from miniskirts to jeans to Pucci-style dresses. At one point, a heckler derided marchers as "bra-less traitors," demonstrating to what degree people now connected clothing choices and politics.[34]

The turning point in the relationship between feminism and fashion occurred when women reconsidered their clothing as a political choice. New styles were an integral part of the process of redefining gender roles. Designer Michael Fish, who suggested that men start wearing skirts, observed in the late 1960s, "You have to think differently before you can dress differently. By changing their clothes, people risk changing their whole lives, and they are frightened."[35] While some people clung to older ideas, the younger generation believed that the fight for women's rights had "dynamite revolutionary potential."[36] Their clothing choices offered one form of revolution. A *Rags* writer claimed that "fashion which does not serve the people is bullshit."[37] Or, as another woman put it, "it felt wonderful to be able to wear anything."[38]

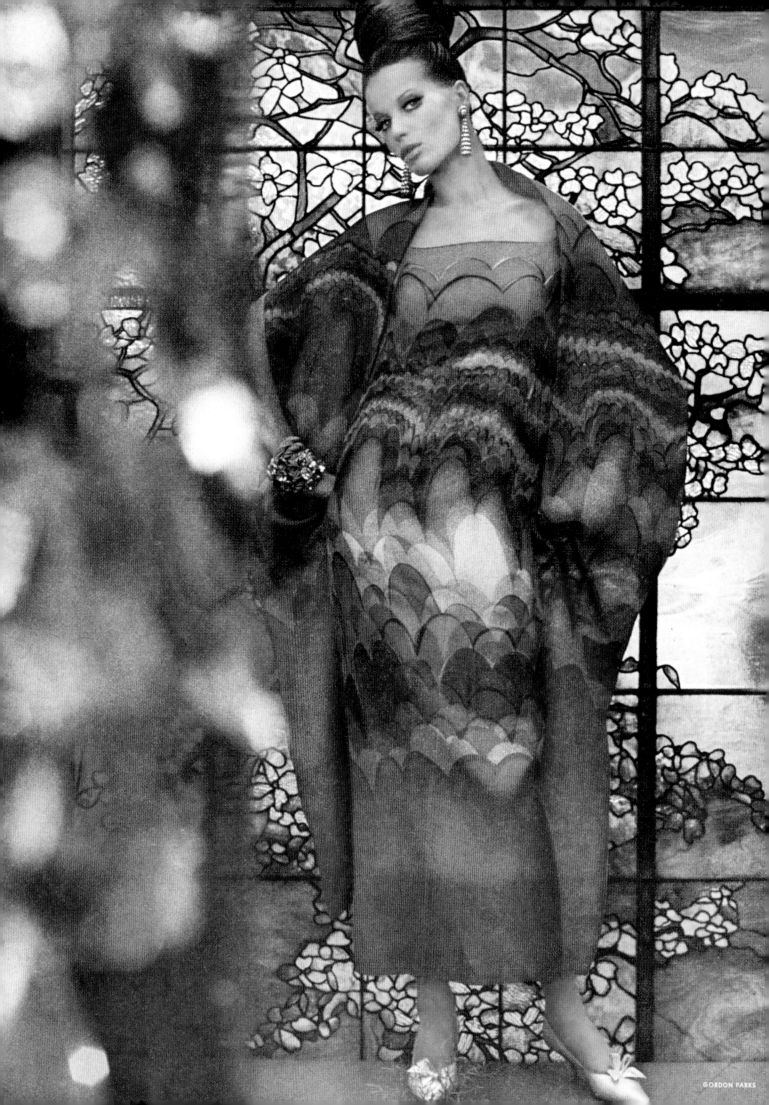

GORDON PARKS

**Phyllis Magidson**

# New Bohemia
## 1967–1969

Pauline Trigère dress and stole, publsihed in "Art Nouveau—Flowering Again in America," *Vogue,* March 1, 1965.

"New Bohemia—its long, long hair still flowing—has moved forward to infiltrate the Establishment," wrote cultural critic John Gruen in the August 1967 issue of *Vogue*. "The underground . . . has surfaced in all its many-pronged, gaudy, shocking, often brilliant, often disquieting glory, by relentlessly following its initial and basic premise: the re-examination of every area of experience and the complete rejection of all preconceived ideas of what life and art are all about."[1]

Gruen's assertion of the wholesale rejection of preconceived ideas involved literature (Allen Ginsberg), theory (Marshall McLuhan), and theater (the Electric Circus). His article also signaled radical transformations in fashion. The cross-pollination between fashion, art, and culture informed and altered the look of mainstream attire, accessories, hair, and makeup. In contrast to earlier in the decade, these elements fused into a non-naturalistic, highly theatrical look. This clothing was meant to be worn, to "be-in"—a reference to a 1967 Central Park Vietnam War protest—to hike in, party in, and ultimately, to dispose of or leave at the home of a

friend. From patterned shift dresses to boldly striped caftan jumpsuits, these items represented the drive to create and dress on one's own terms—a tendency that was typical of the decade's DIY attitude. Fashionable high-society women, for the first time, looked to counterculture icons, like rock star Janis Joplin, for inspiration.

Veteran New York designers such as Pauline Trigère, Chester Weinberg, and Norman Norell, among many others in the ready-to-wear design and manufacturing workrooms of Seventh Avenue, accelerated the momentum of the Youthquake movement. Their clothes featured bold colors in garish combinations like chrome yellow and neon pink, as well as hypnotic psychedelic patterns, none of which had ever been considered flattering or appropriate by fashion insiders. They also used unexpected materials, like paper, and broadly interpreted both the already frequently referenced Op Art movement and the newly embraced Art Nouveau.

In addition to Op Art patterns, ethnic Indian and Middle Eastern textiles and motifs heavily influenced late 1960s New York fashion designers,

who borrowed from these design vocabularies to create fantasy caftans, kurtas, and harem pants. On Seventh Avenue, the post-Youthquake transformation of Geoffrey Beene's designs, from simple to exotic, represented the new trends as he embraced the iconoclastic look of the New Bohemia. He introduced his Beene Bazaar line in the spring of 1969, deliberately combining wildly mismatched floral and paisley patterned patchwork pieces to evoke a thrift-store aesthetic.

Beene also added Indian bells, gold metallic textiles and braids, and Op Art patterning to his creative palette. Saks Fifth Avenue brought in printed gauze and spangled silk dresses from India, adding to the explosively hued Emilio Pucci resort pieces that carried its store-exclusive label. Even legendary couture ateliers in Paris, like Dior, adopted the beguiling excesses of exoticism, romanticism, and theatrical fantasy that were eagerly bought by wealthy New Yorkers. Also influential was traditional clothing associated with the American West (denim, fringe, leather, suede, and beadwork) and military dress, which Seventh Avenue designers, such as Bill Blass,

adapted from the wardrobes of young people who bought uniforms in thrift shops and Army/Navy stores. No one represented the eclectic aesthetic like Laura Johnson. As wife of Saks Fifth Avenue Chairman of the Board and CEO Allan Raymond Johnson, she dressed from New York collections, acquiring a resist-dyed gown from Geoffrey Beene's first Coty-winning collection, James Galanos's striking red-and-green evening ensemble, and Pauline Trigère's 1969 floral evening pajama. Concurrently, she infused her wardrobe with an international flair by adding a full-length vinyl dress from André Courrèges's boutique collection and myriad Saks-labeled boldly patterned dresses and cat suits by Emilio Pucci. As recounted by Johnson, her husband would not permit her to wear any garment after she'd been photographed in it: consequently, everything she wore intentionally invited the photographer's lens to ensure unlimited additions to her wardrobe.

Once the trends toward pattern and ethnic and historical sources became integral to the New Bohemia fashion aesthetic, they

were incorporated in the design of accessories, hair, and makeup as well. Jewelry, most notably by David Webb for fine jewelry and Kenneth Jay Lane for costume pieces, looked to sources ranging from Art Deco to China, Mexico, and India. Lane referenced Chinese imagery in creating necklaces, bracelets, and earrings of carved imitation ivory, jade, and coral, while he emulated cannetille filigree in his gilt Indian-style pendants. Makeup, too, became audaciously theatrical in its daytime use of false eyelashes, stylized black eye-liner, and unnaturally pale lipstick, while hair stylists mined cultures and epochs to create fantastical mounds of hair that quoted Kabuki dance-drama and Edwardian romanticism. The use of naturally colored and vividly hued synthetic Dynel wigs and false hair pieces became routine by professional fashion models and theatrical performers, as well as daring civilians.

These years witnessed the escalating public frenzy over trendsetting boutiques that fused fashion and entertainment; although there were examples of such boutiques in cities

across the country, New York housed the largest concentration and most nationally publicized examples.

Inspired by the seemingly instant success and notoriety of the boutique Paraphernalia, Splendiferous and Abracadabra integrated creative interiors, theatrical lighting, and customized rock music soundtracks to create distinctive identities. Marcia Flanders, founder of Abracadabra, recalled the dynamic: "I started meeting these kids who were coming in with their designs. No one would see them. They'd have to stand in line with a bunch of manufacturers and when they finally met somebody, it was always: 'We can't buy from a little kid'. . . That's when I decided that there had to be a store where people like that could sell their work."[2] Another store, Serendipity 3, combined ice cream and fashion, most notably acid-washed-denim caftans and skirts, often made from repurposed men's jeans. Among the most financially successful boutiques of this period was Charivari, opened in 1967 by Selma Weiser, a former department store buyer, on Broadway between 85th and 86th Streets. Intended as a last-minute convenience

shop for the neighborhood, it catered to the Upper West Side's wealthy, progressive demographic that craved an alternative local shopping venue. Weiser appointed her shop with fashionable, moderate- to higher-priced dresses and separates, stocking small quantities of any single item to prevent each look from appearing on multiple women at any given local event. This merchandising tactic allowed for rapid turnover, enabling Weiser to scout out promising, untested design talents and to promote them and their clothing to a local clientele. The shop's runaway success necessitated an expansion, and by 1971, a second Charivari had opened two blocks south at 83rd Street.

All of these aesthetic transformations were met with changes in New York City marketing, as fashionable people transitioned from shopping in department stores to small-scale boutiques, which offered a wider range and a more quickly changing array of clothes, and thrift shops, where vintage clothing was bought at low cost to create eclectic, mix-and-match ensembles. This shift shattered the city's traditional fashion retail

structure, which had been in place for more than a century.

In response to the wild popularity and profitability of these new shopping venues, major New York department stores introduced hip environments to their venerable sales floors. Tradition-bound Bergdorf Goodman opened the teen-oriented Bigi and Bonwit Teller opened its S'fari Room. This upending of the traditional relationship between independent boutiques and established department stores, as large retailers took their cue from small idiosyncratic shops, was just one of the convention-breaking phenomena of the New Bohemian era, which also saw the rise of non-traditional fashion influences and retail strategies. The changes were large and all-encompassing. "To the question, where is the New Bohemia going," John Gruen asked in his *Vogue* essay, "the answer is: Everywhere."[3]

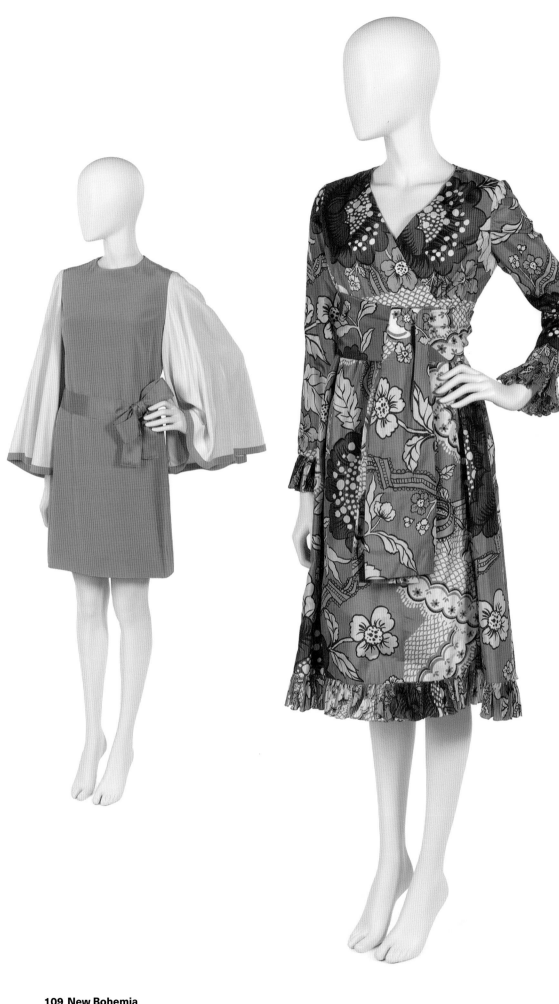

**Unattributed**

Dress with printed
flower motif on sheer
silk ground, 1967–68.

**Attributed to Marc
Bohan for the House
of Christian Dior**

Mini dress of crepe
with crepe sleeves,
ca. 1968.

**Chester Weinberg**

Afternoon dress with
floral motif printed on
taffeta ground, 1968.

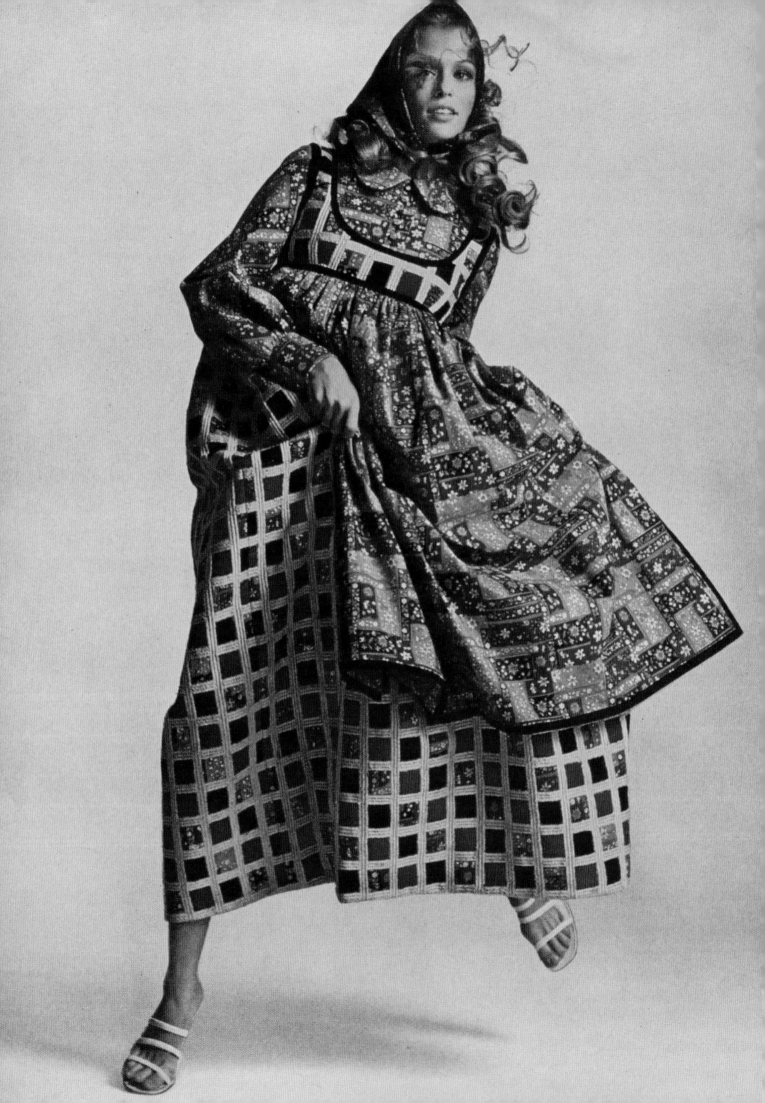

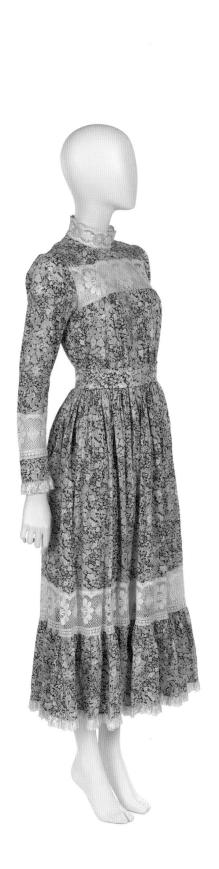

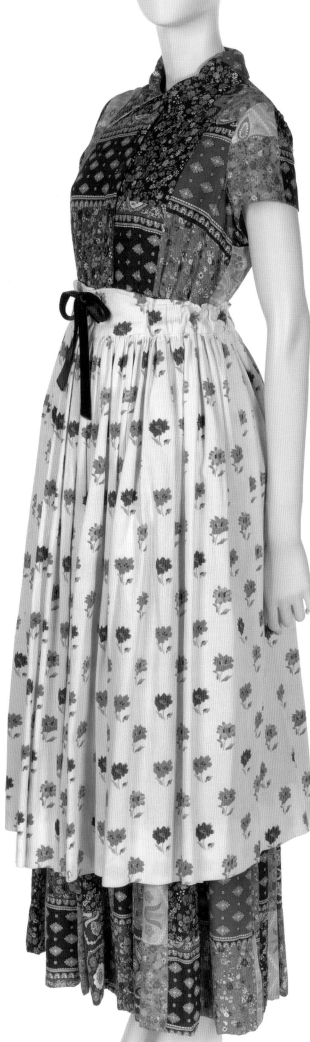

Opposite: Advertisement for the Cotton Producers Institute featuring a variation on Geoffrey Beene's atypical, Bohemian-influenced Fall 1969 Bazaar collection. Published in *Harper's Bazaar*, September 1969.

**Bob Mackie and Ray Aghayan for Elizabeth Arden, New York**

"Prairie dress" of floral printed cotton with linen machine-made wheel lace insertion, ca. 1966–67.

**Geoffrey Beene for Beene Bazaar**

Dress of cotton patchwork with striped and printed overskirt, 1968–69.

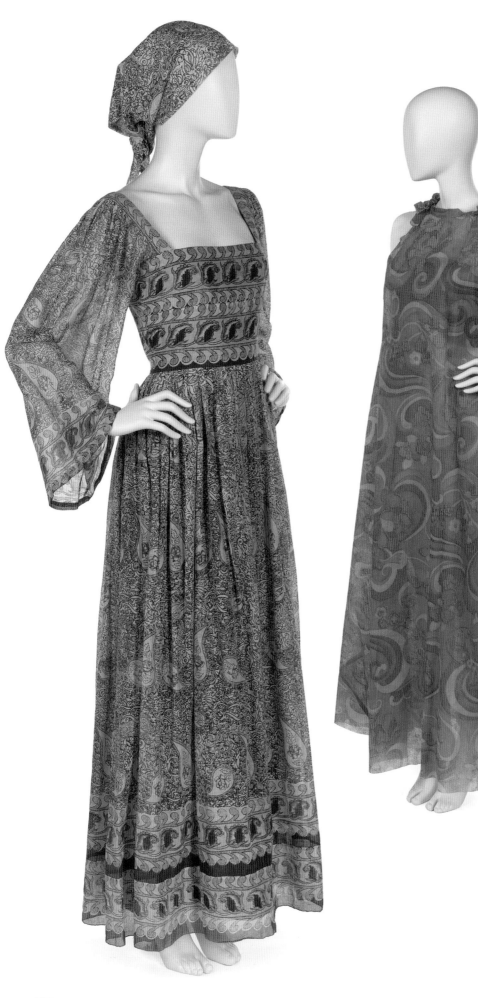

**House of Arts (India), retailed by Saks Fifth Avenue**

Dress with printed pattern on Indian cotton voile and matching head kerchief, late 1960s.

**Fashion by Elin Daggs**

Dress of printed paper, mid 1960s.

**Leo Narducci**

Evening culottes of printed chiffon with ostrich feather collar, 1967.

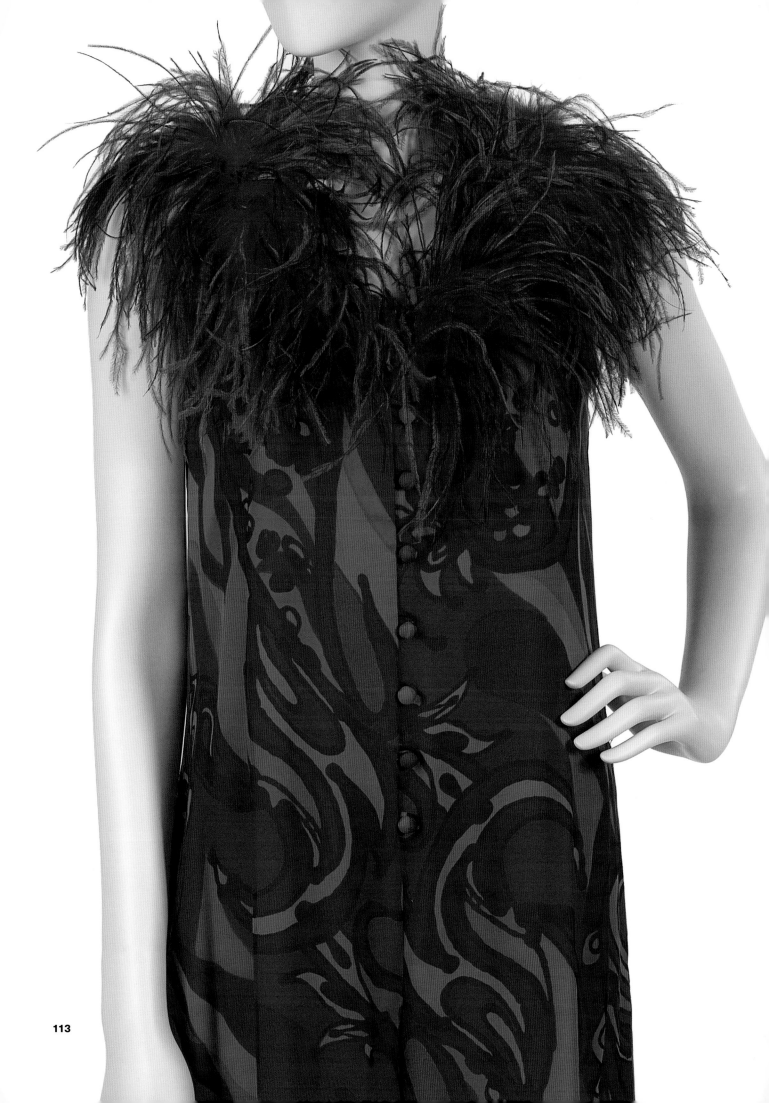

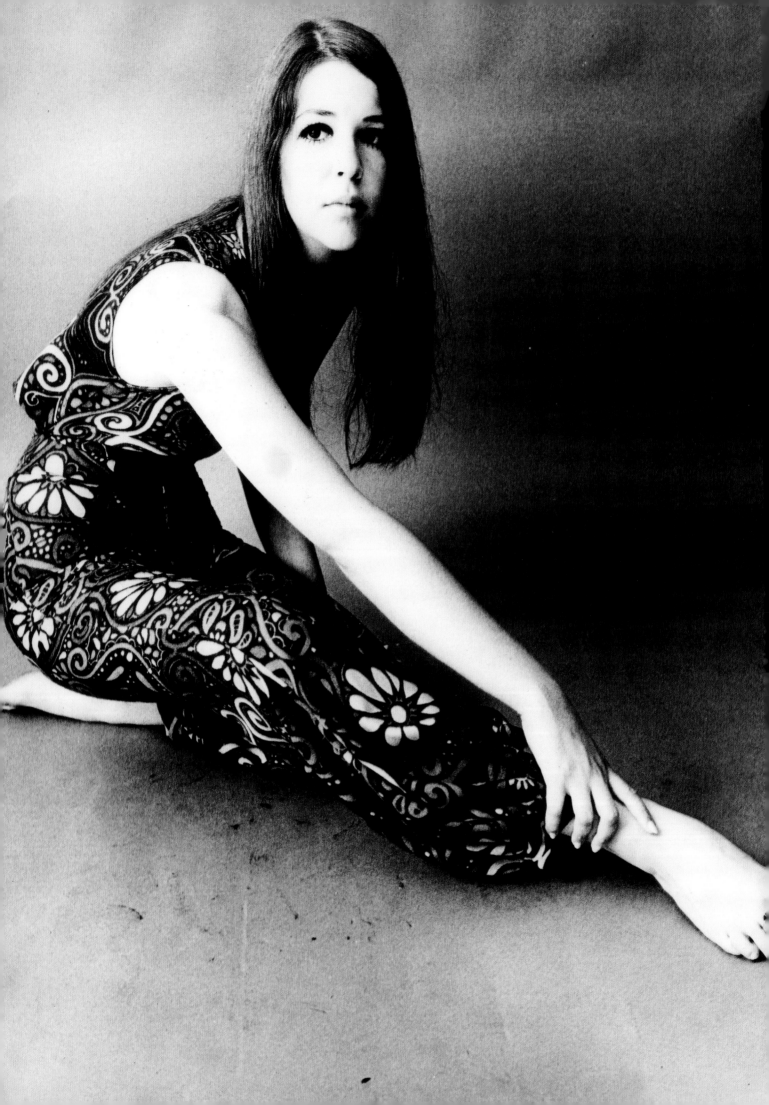

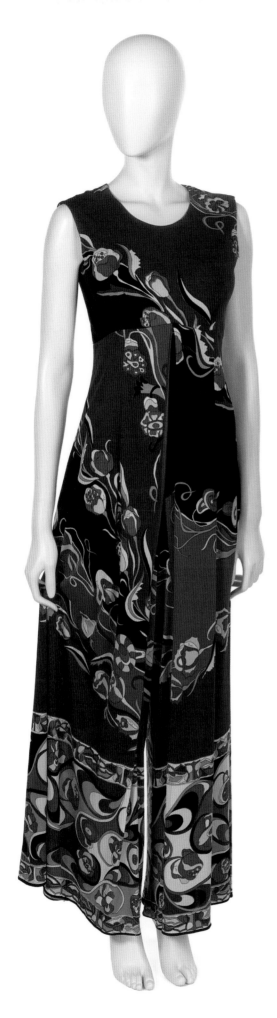
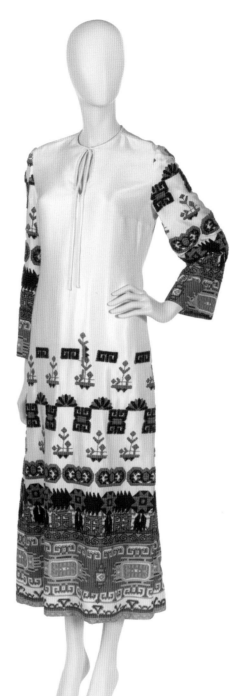

Opposite: Phyllis Magidson, Elizabeth Farran Tozer Curator of Costumes and Textiles, in a harem jumpsuit, 1968.

**Emilio Pucci**

Jumpsuit of printed silk jersey, 1967.

**Mollie Parnis Boutique**

Evening caftan of polyester satin with embroidery in geometric Indian motif, ca. 1970.

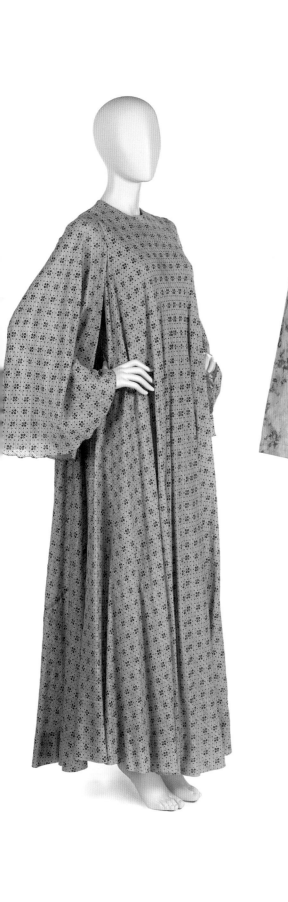

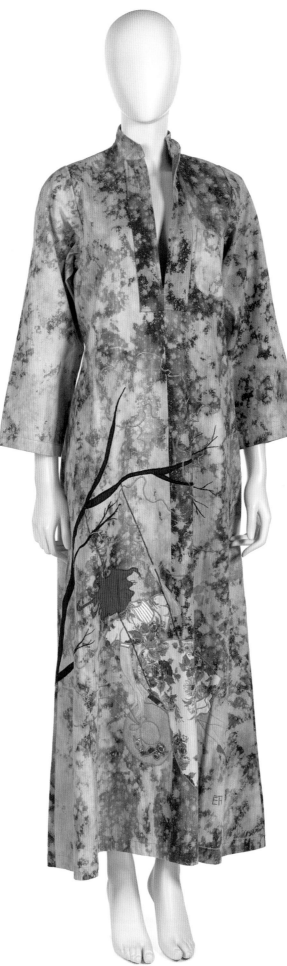

**Mr. John**

Dress of floral printed cotton barrège, early 1970s.

**Ellen Toby Holmes (original embroidery design) for Serendipity**

Caftan of "Cloud"-bleached denim with "Girl on a Swing" appliqué, ca. 1966–67.

**Unattributed**

Caftan of raw silk with soutache trim, 1967. Purchased in Morocco.

**Emilio Pucci**

Dress in floral print on velveteen ground, 1966.

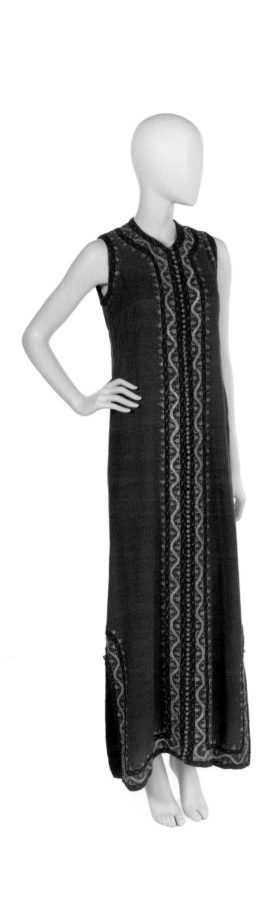
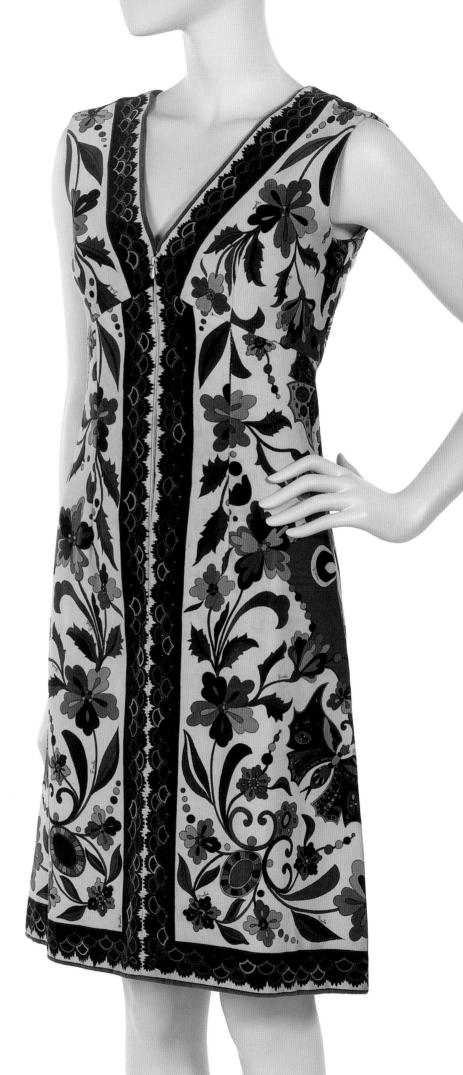

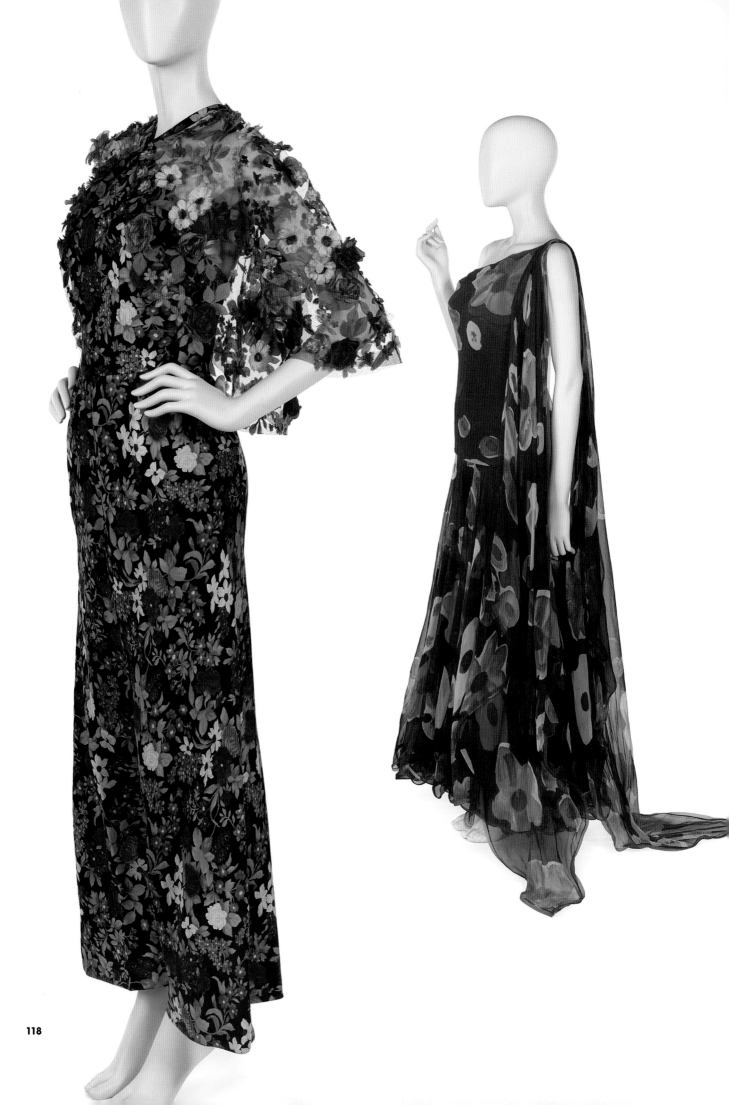

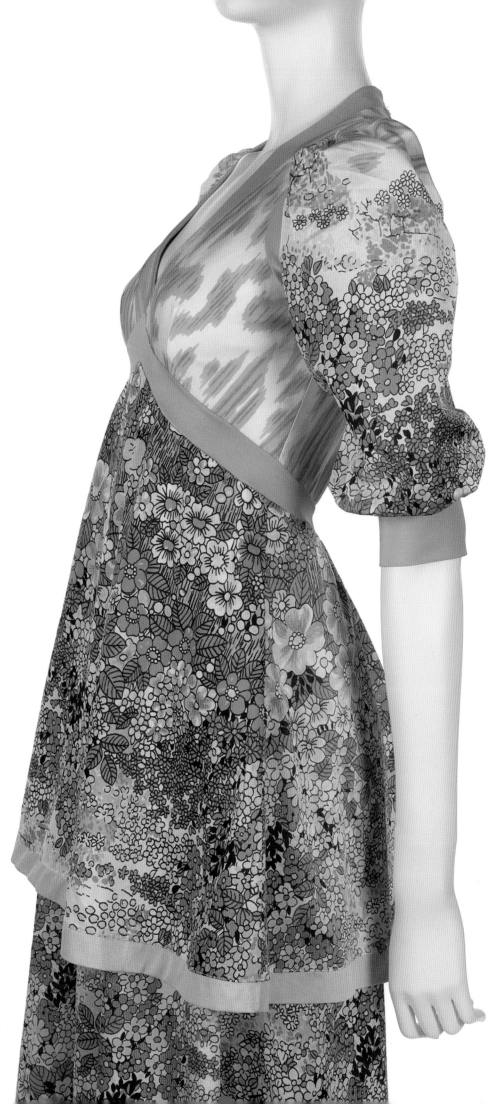

**Pauline Trigère**

Evening pajama
ensemble comprising
one-piece pajama
of floral print on silk
surah ground and
jacket of silk tulle with
applied silk millinery
flowers, ca. 1969.

**Geoffrey Beene**

Evening dress of
resist-dyed plissé silk
chiffon, 1964.

**Giorgio di
Sant'Angelo**

Dress of printed
Qiana jersey, 1972.
Worn by Bernadette
Allen, New York's
Summer Festival
Queen for 1972.

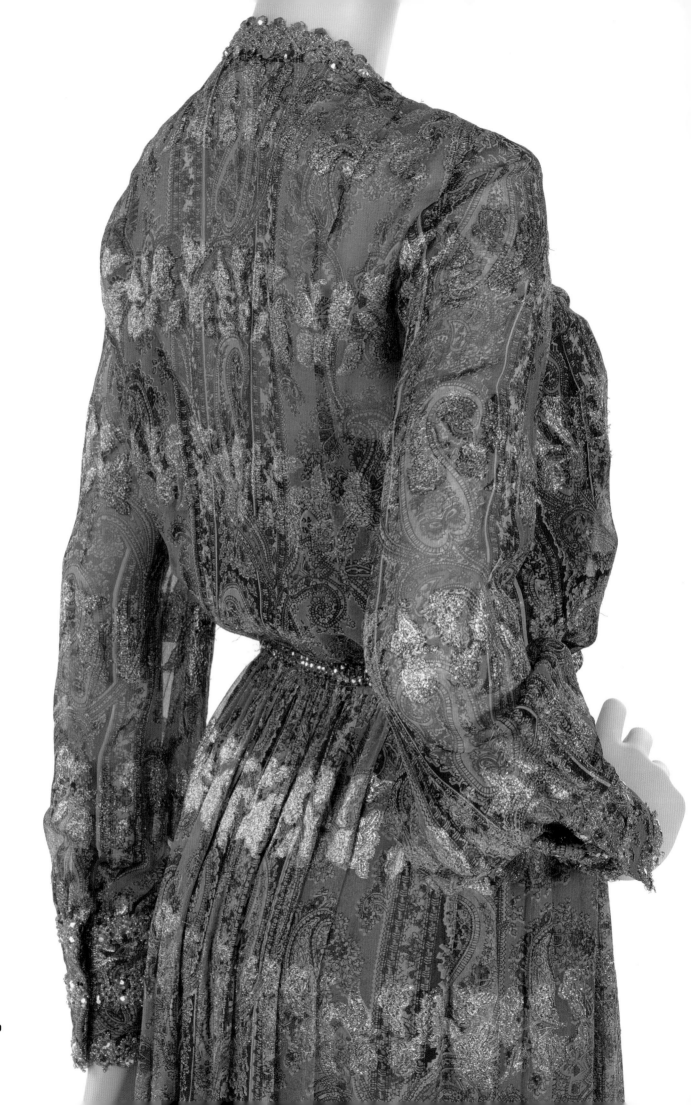

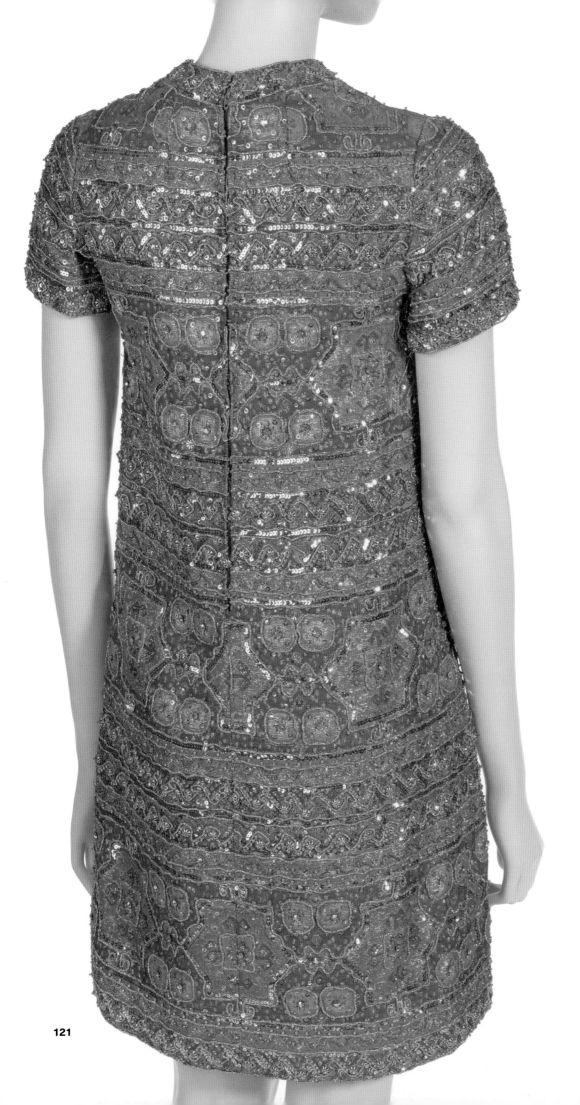

**Bill Blass for Maurice Rentner**

Dress of paisley-printed chiffon and silk crepe slip with braid and rhinestones and belt with rhinestones, ca. 1970.

**Marie McCarthy for Larry Aldrich**

Dress in oriental-patterned, synthetic metallic Ducharne brocade with applied gilt sequins, Fall/Winter 1969.

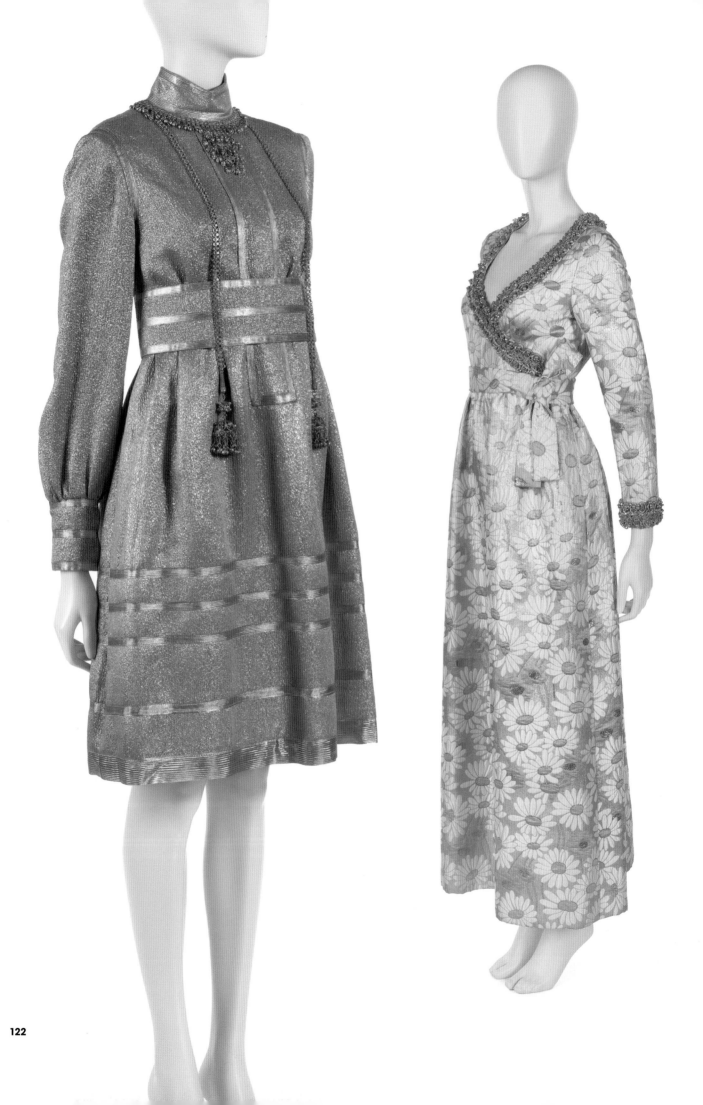

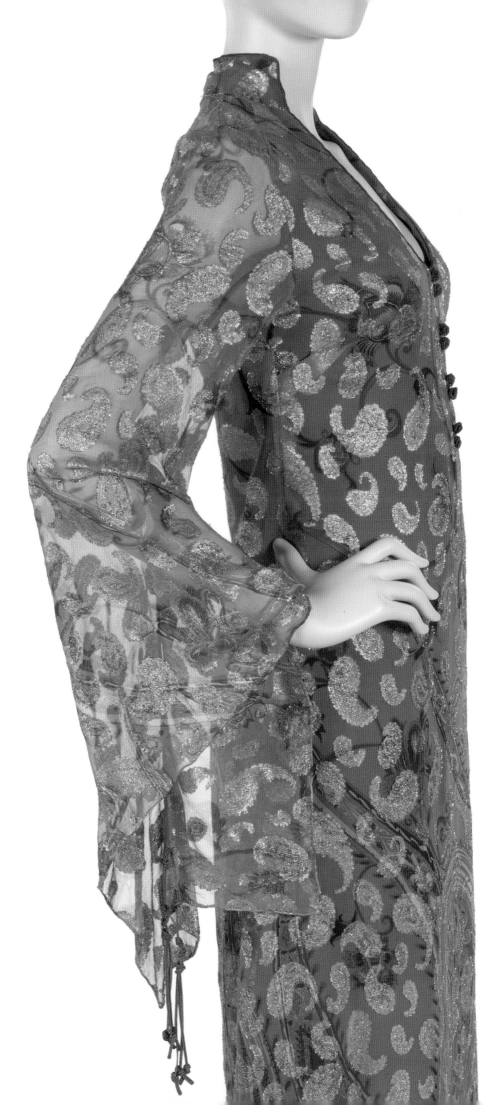

**Geoffrey Beene**

Evening dress of gold lamé with belt and attached necklaces, ca. 1970.

**Oscar de la Renta**

Evening dress of figured gold lamé, 1969. Worn to Academy Awards dinner, 1970.

**Thea Porter**

Evening dress of silk chiffon with metallic allover paisley broche, 1971.

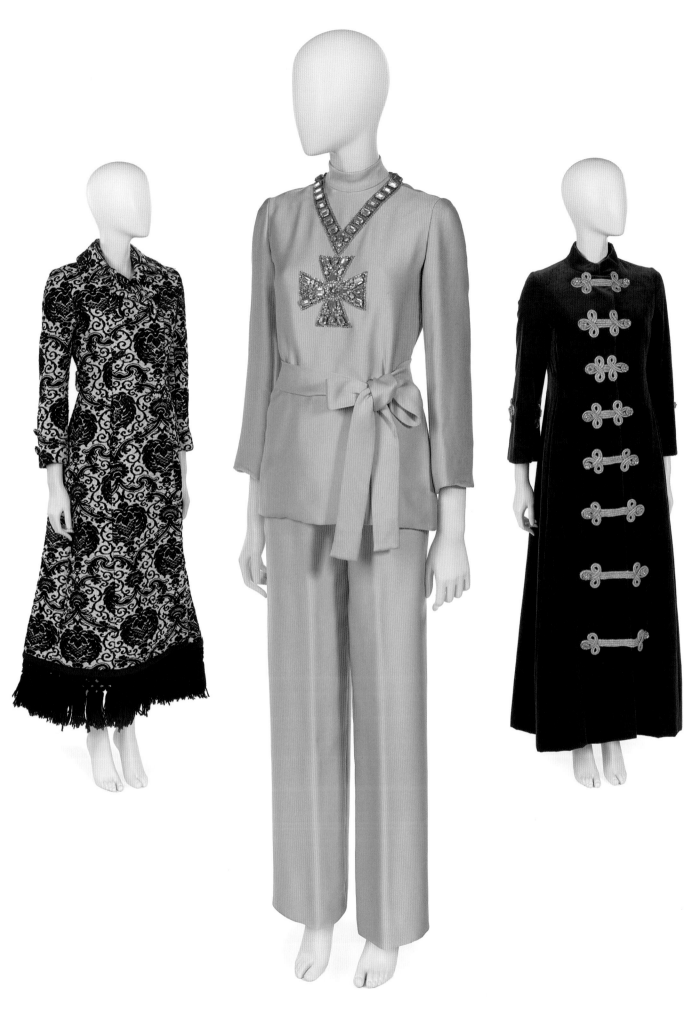

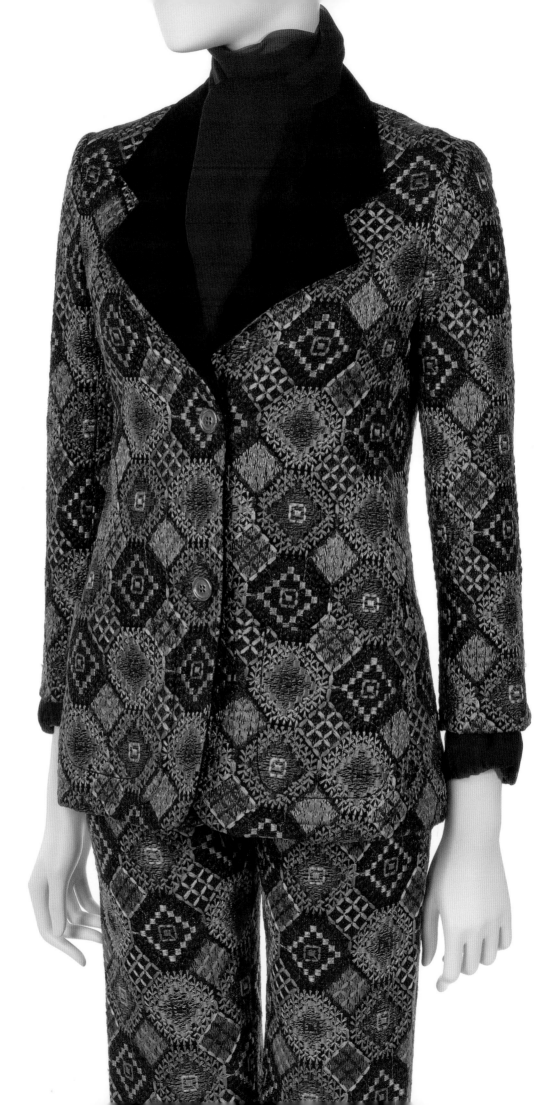

**Adolfo**

Evening coat made
from Spanish wool
manta coverlet, 1960s.

**Norman Norell**

Evening pajamas of
crepe-finished poult-
de-soie with jeweled
Maltese cross, 1968.

**Bill Blass for
Maurice Rentner,
retailed by
Saks Fifth Avenue**

Evening dress of silk
velvet with Lurex braid
closures, ca. 1968.

**James Galanos**

Evening trouser
ensemble with
allover embroidery
in diamond motif
on gauze, ca. 1966.

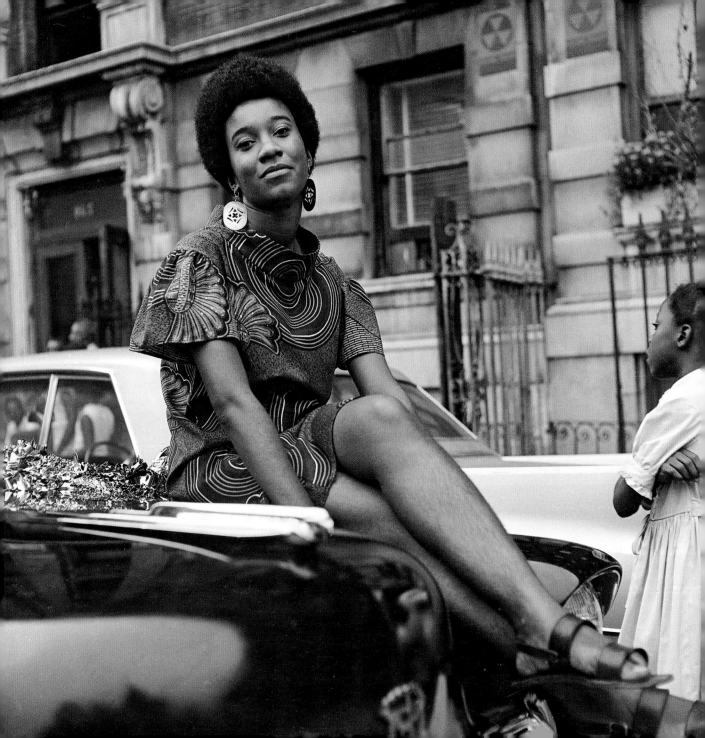

**Kwame S. Brathwaite**
**with photographs by Kwame Brathwaite**

# Fashion and Consciousness

## The Grandassa Models and the "Black is Beautiful" Movement

On January 28, 1962, fashion, music, and politics converged in a ground-breaking showcase called *Naturally '62*, held at Harlem's Purple Manor. Subtitled *The Original African Coiffure and Fashion Extravaganza Designed to Restore Our Racial Pride and Standards*, the presentation sought, according to historian Tanisha C. Ford, to "prove to the world that 'Black is Beautiful' by promoting natural hairstyles and soul fashions as tools of liberation."[1] The event was initiated and organized by my father, photographer Kwame Brathwaite, his older brother, Elombe Brath, and the organization they co-founded with other like-minded artists in 1956: the African Jazz Art Society and Studios, or AJASS. Jazz greats Abbey Lincoln and Max Roach headlined *Naturally '62*, which was initially planned as a one-time event. The first show proved so popular, however, that a second sold-out presentation was held that same night to accommodate the crowd.

*Naturally '62* marked the debut of AJASS's Grandassa Models. The name nodded to Carlos A. Cooks, founder of the African Nationalist Pioneer Movement, who referred to Africa as "Grandassaland." Transcending established cultural and fashion norms, models in the group were darker-skinned and committed to wearing their hair in natural styles and showcasing African-inspired fashion and jewelry. The show featured clothing that was colorful, textured, and versatile, flowing with the same grace and style as the models themselves. The women were chic, stylish, bold, and unapologetic. "By wearing African-inspired garments," Ford has noted, the Grandassa Models "were communicating their support of a liberated Africa and symbolically expressing their hope for black freedom and social, political and cultural independence in the Americas."[2] *Naturally '62* was a pivotal moment in fashion—a cultural statement about embracing one's heritage and self-pride. The message was clear: "Black is Beautiful."

Grandassa model Pat Bardonelle during the Garvey Day Parade, August 17, 1968.

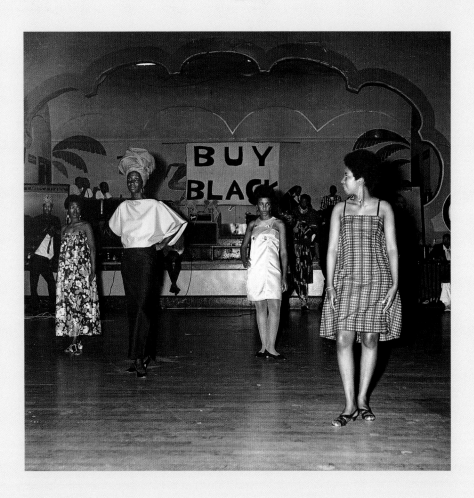

Inspired in part by the writings of political leader and writer Marcus Garvey, Brathwaite, Brath, and AJASS popularized the phrase "Black is Beautiful" through the *Naturally* fashion shows and the Grandassa Models. Traveling nationally for concerts, AJASS members Lincoln and Roach helped spread the "Black is Beautiful" theme and made contacts with other progressive organizations that led to *Naturally* show bookings in other cities. In February 1963, for example, AJASS presented shows at Robert's Show Club in Chicago and Mr. Kelly's in Detroit. "Black is Beautiful" became one of the most important political and cultural ideas of the twentieth century and the Grandassa Models the visual representation of the idea.

Kwame Brathwaite's photographs capture this revolutionary time and were specifically intended to shape American visual discourse. His photographs testify that fashion, as well as artistic and political vision, can effect change in popular culture—and that popular culture can effect change in society at large. Many of the subjects of Brathwaite's carefully crafted photographs invoke the power of objects, such as books, musical instruments, jewelry, headpieces, and artwork. The dress and hairstyles of his subjects emphasize their sense of themselves, while the environs of his subjects convey a community of artist-activists—writers, painters, playwrights, fashion designers, and musicians.

This aesthetic is evident in Brathwaite's photos depicting the marriage of fashion and jazz. Grandassa Models graced album covers for various

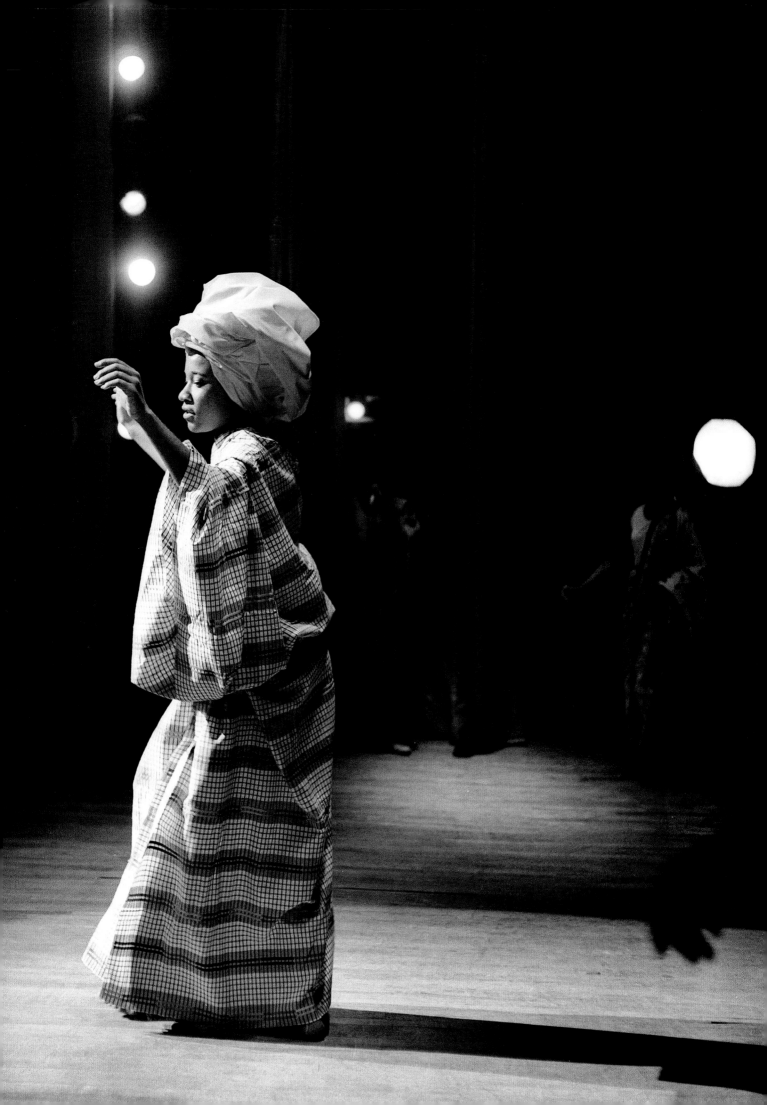

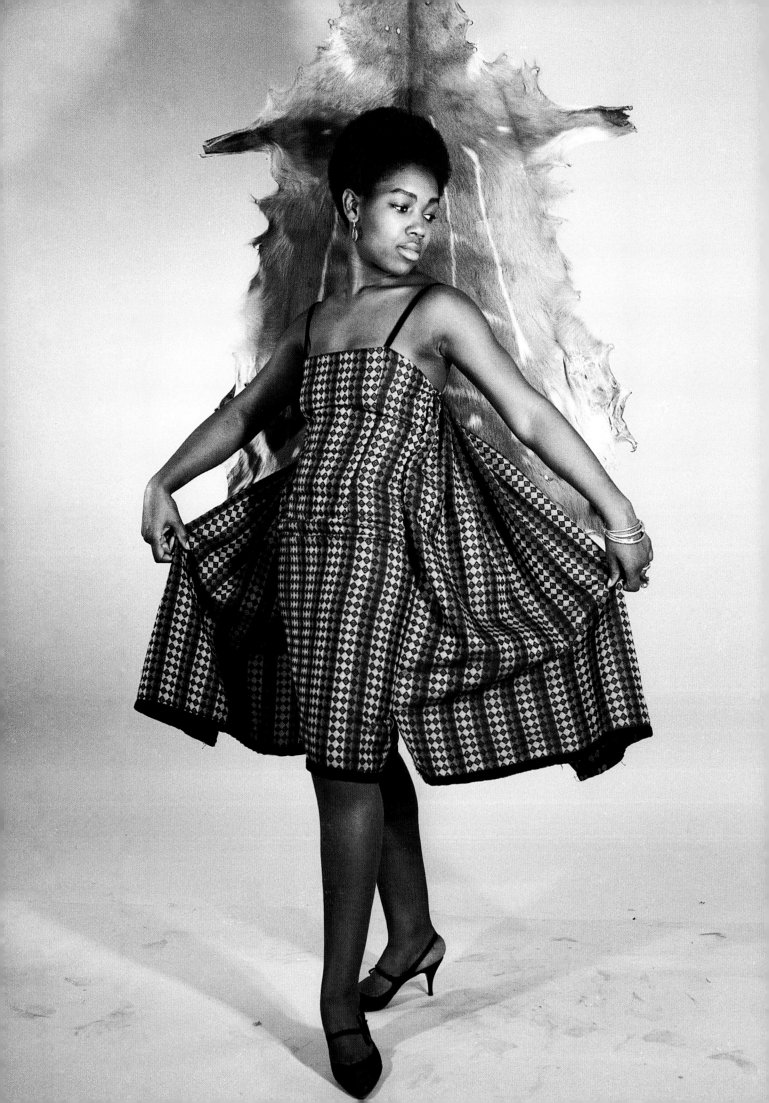

Nomsa Brath at a
photo shoot in the
AJASS studio, ca. 1965.

Photo shoot at a
school for one of
the many modeling
groups who had
begun to embrace
natural hairstyles
in the 1960s.

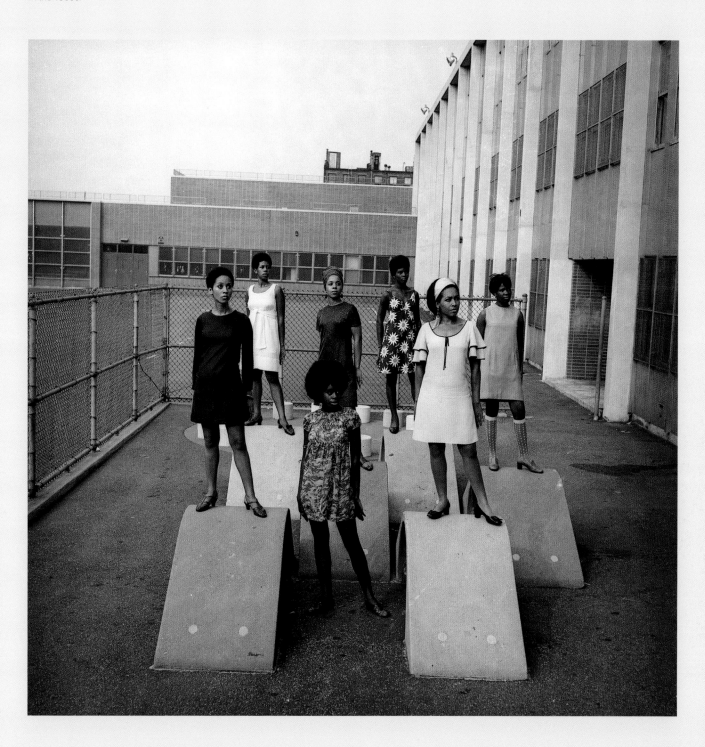

*Naturally '68* photo shoot in the Apollo Theater featuring Grandassa models and AJASS founding members (except the photographer, Kwame Brathwaite), at center from left: Frank Adu, Elombe Brath, and Ernest Baxter.

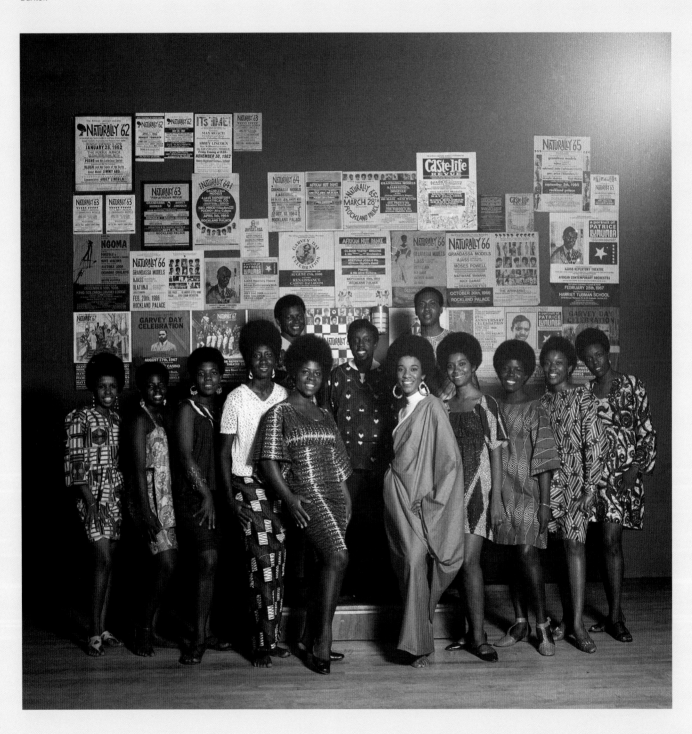

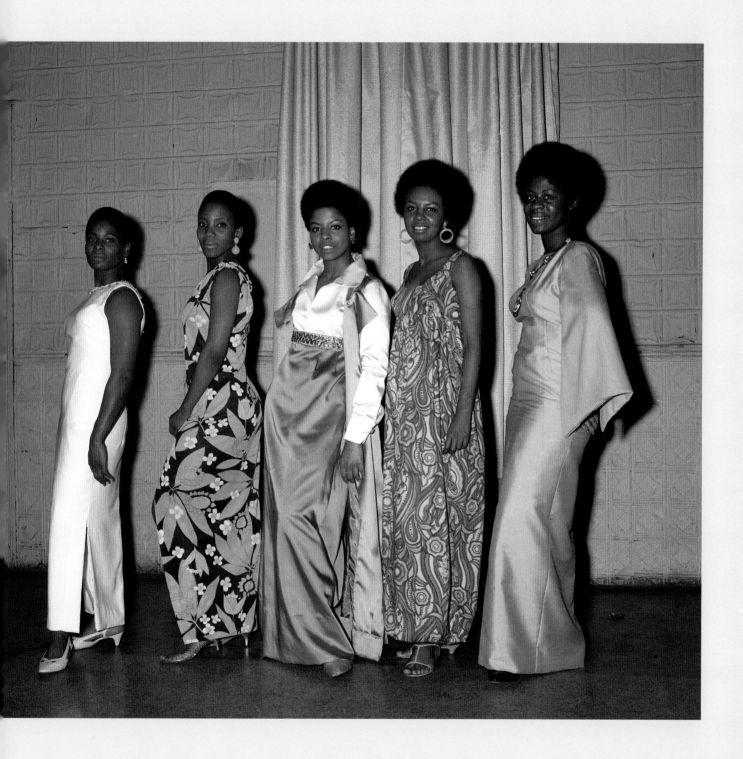

**133 Fashion and Consciousness**

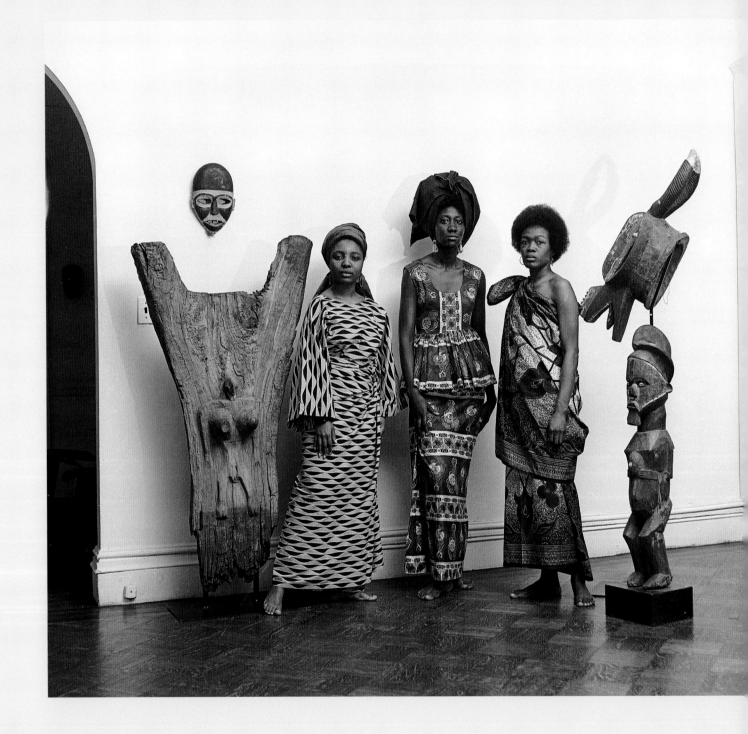

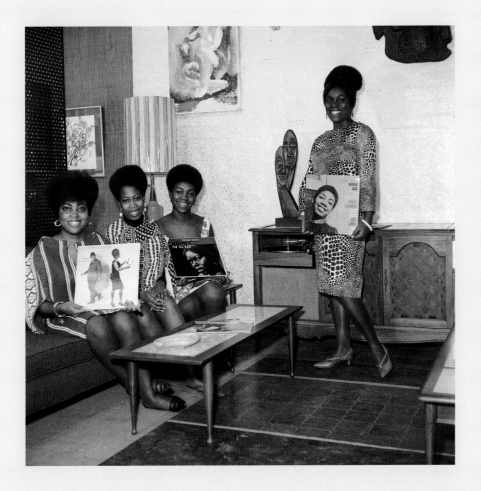

Blue Note Records artists, including Freddie Roach and Lou Donaldson, and were featured on album covers with names such as *Brown Sugar* (1964) and *The Natural Soul* (1962). These covers and their titles were a marked departure from traditional record covers featuring the artists alone, and they signified that the visual rhetoric the Grandassa Models represented was being embraced and celebrated. The presence of the Grandassa Models on these album covers also signaled a shift in attitudes toward fashion, the black image, and beauty standards. American culture was embracing change and challenging social norms through artistic expression.

One artist-activist depicted in Brathwaite's photographs is Carolee Prince, who was one of the era's most innovative designers of jewelry, headpieces, and clothing for the Grandassa Models. Vocalist Nina Simone was one of her clients, and Prince created many of the headpieces Simone wore at her performances. This type of entrepreneurship blossomed, as many of the Grandassa Models made their own clothes and used the shows as an organic way to display their craft and create opportunities to design for others. Consequently the "Black is Beautiful" movement opened economic opportunities for the African-American community as they embraced their creativity and entrepreneurial spirit, starting their own fashion-related businesses and boutiques. The movement also created a demand for magazines such as *Essence* (first published in 1970), which

Brenda Deaver, ca. 1965. She modeled with AJASS from 1964 to 1966 and appears on a Blue Note album cover titled *Oh Baby*. The photograph was taken in a space that AJASS opened from 1965 to 1967 called Grandassa Land, located on Seventh Avenue (Adam Clayton Powell Jr. Boulevard) between 126th and 127th Streets. Grandassa Land was a small café-style gathering place where meetings, lectures, poetry, and mini skits by AJASS Repertory Theatre took place.

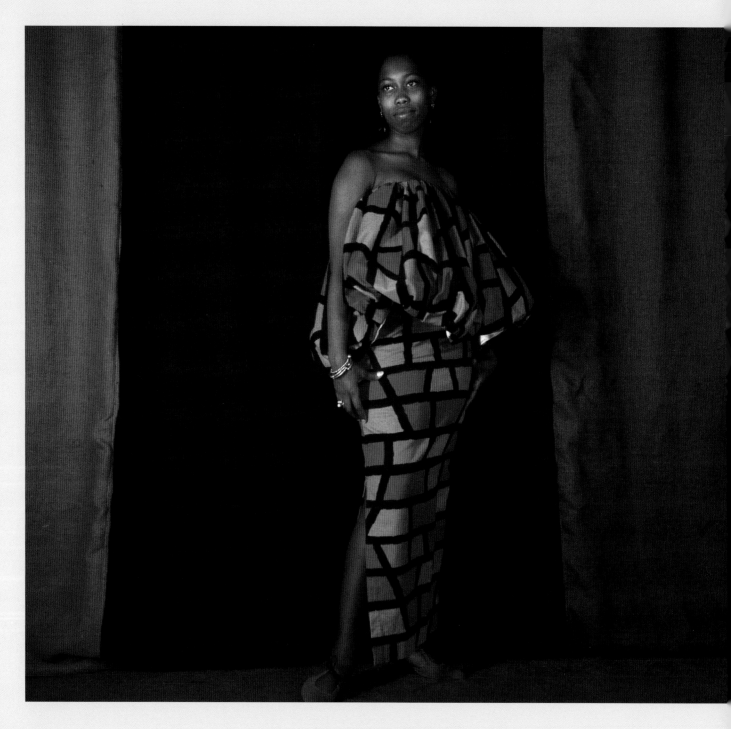

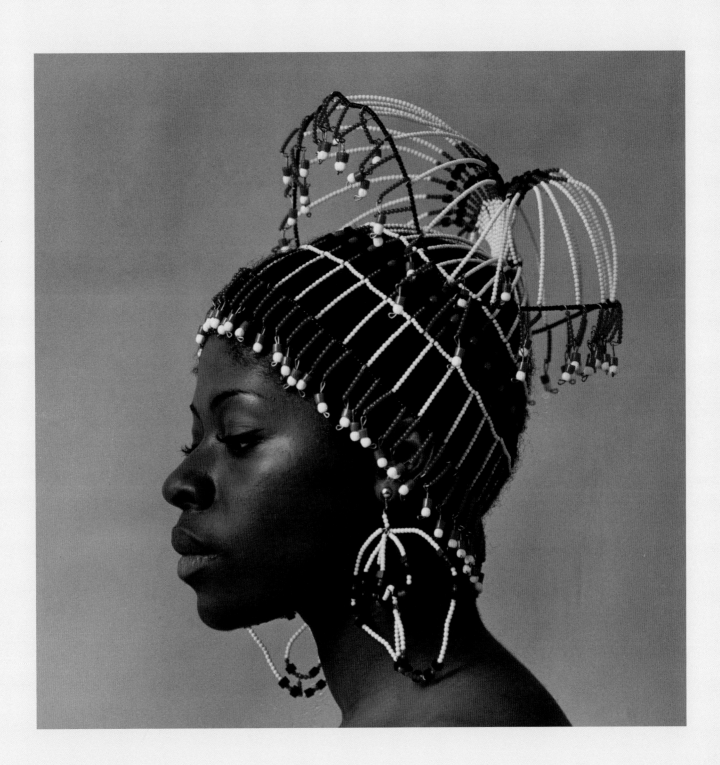

**137 Fashion and Consciousness**

were established to represent women previously overlooked in fashion, art, and culture. Beauty standards were being challenged, and the fashion industry reflected that. By the late 1960s, African-printed textiles mainstreamed into the lively vocabulary of Seventh Avenue's bold and ethnic prints, while the iconic faces of black supermodels Donyale Luna and Naomi Sims graced the covers of *Harper's Bazaar* (January 1965), British *Vogue* (March 1966), and the *New York Times* fashion supplement, *Fashions of The Times* (August 1967).

The "Black is Beautiful" movement and the Grandassa Models demonstrated the power of visual representation and fashion as essential cultural tools in the dissemination of new political ideas, their power to stage visual rhetoric, and their ability to make language visible. That rhetoric remains relevant to this day.

Fashion designer
Carolee Prince
wearing clothing
and earrings she
designed, ca. 1966.

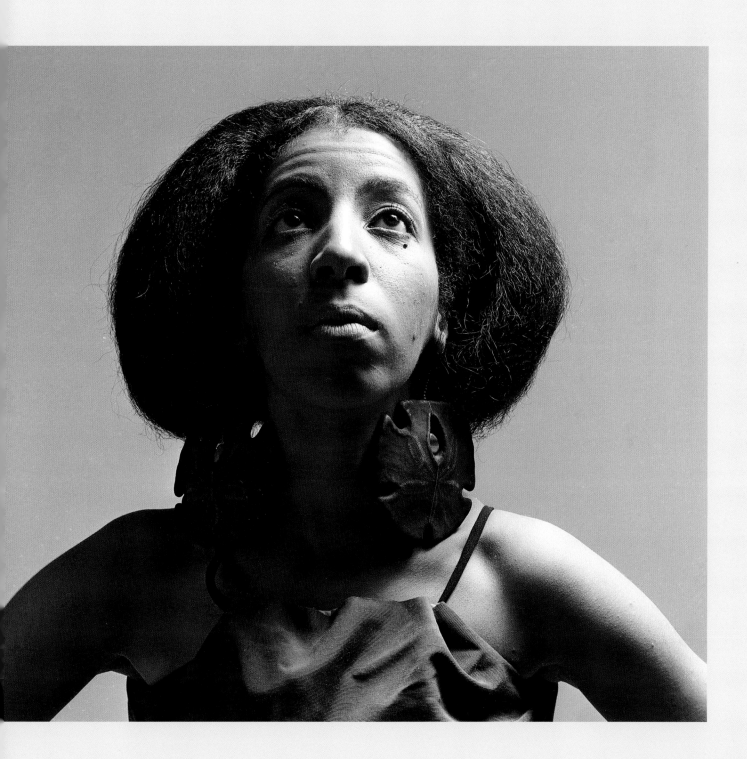

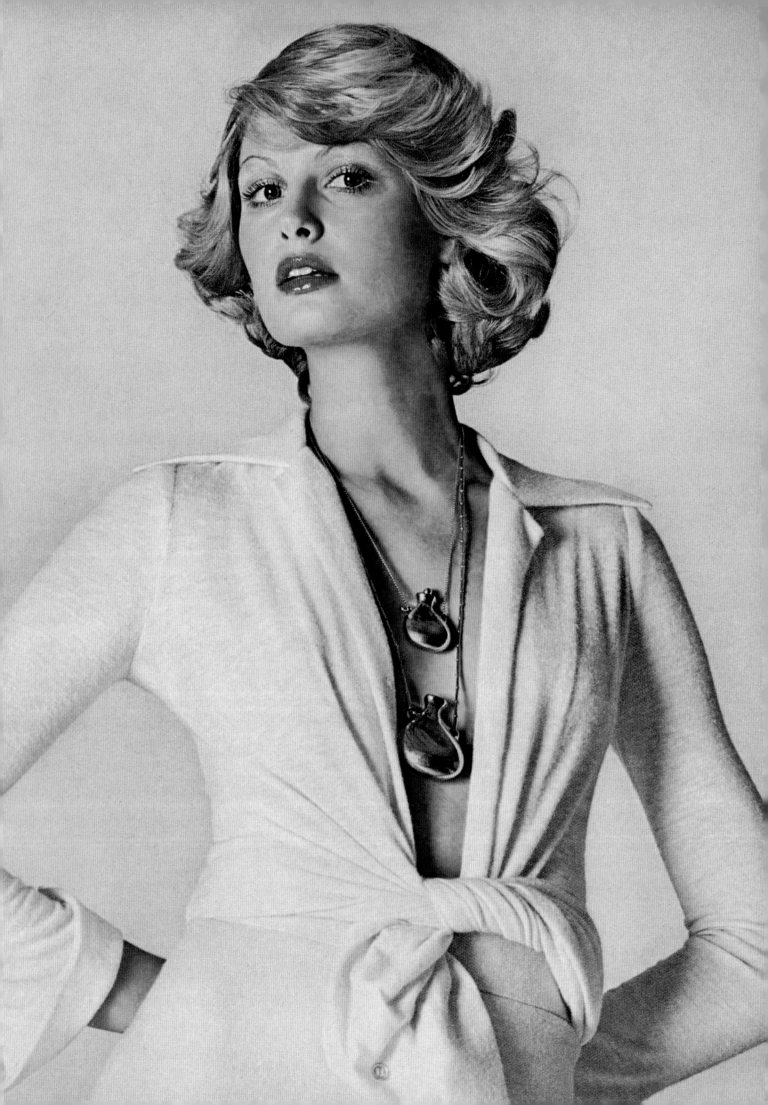

**Phyllis Magidson**

# New Nonchalance
## 1970–1973

"For once, it isn't a hemline or a waistline that's going to change the way you look in your clothes," *Vogue* noted in 1972. "It's a whole mood of dressing— a nonchalance—and it's been coming on since fall. The sportswear attitude is part of it—that kind of easy, racy attractiveness—but with a glamor and luxe you haven't seen before . . . all this nonchalance stands for change in 1972."[1] Illustrating the text was a slinky, unconstructed angora ensemble designed for Halston's ready-to-wear line, Halston Limited, its sober character contrasting with the flamboyance and theatricality of the New Bohemia aesthetic. The message was clear: the fashionable world had exhausted its fascination with the eclectic and frenetic style that marked the era of *Hair*.

The metallics, embroideries, tie-dye, fringe, ethnic references—the "do your own thing" mode of dressing—that characterized late-1960s fashion was supplanted by what *Vogue* described as "pale, whitened, wheaty colorings, and the softness of fabrics."[2] As a result, Halston, Bill Blass, Oscar de la Renta, as well as other designers who dressed fashionable New Yorkers, revisited the muted, monochromatic palette, clean lines, and subtle sophistication of the early 1960s period of Jacqueline Kennedy's reign in the White House. At the same time, they looked toward the future as they addressed the needs of women who had been increasingly enfranchised during the 1960s and were rising up corporate ladders. These fashions were made of easy-to-wear, easy-to-move-in, featherweight, man-made rayon jerseys and versatile synthetic fibers like polyester, all of which had recently been perfected. There were also luxurious cashmere knits, formerly restricted to sweaters and small accessories but now available in yardage, making it usable for dresses and full-length sweater-coats. "I was into free-forms," designer Stephen Burrows noted of his 1970 collection for Bendel's. "I liked free-form draping and consciousness of the body and movement."[3] These clothes were designed to be worn without bras or other constricting and body-shaping undergarments.

Pantsuits and trousers selected by women also became widely accepted in offices, restaurants, and other public places that had previously

forbidden them. By 1972 Ralph Lauren had introduced pantsuits to his women's clothing line that were "plain," in Lauren's own words, "but very classic and clean."[4] They were man-tailored in traditional male fabrics and patterns ranging from business pinstripes to rugged plaids and tweeds. French couturier Yves Saint Laurent had earlier designed men's-style women's clothes, but with a gamine flair—most notably, his "le smoking" pantsuit, which would become increasingly popular during the 1970s. Pants, Saint Laurent explained, "are for everything"[5]

These aesthetic changes were mirrored by revolutions in the relationship between the couture and the ready-to-wear. While haute couture did not disappear—it was still the preference of an elite coterie of women and continued to serve as an aesthetic resource for creative ideas—by the early 1970s, it shared the fashion spotlight with ready-to-wear. Without a doubt, the central figure in this transformation was Yves Saint Laurent. In 1968 he opened a ready-to-wear shop, Rive Gauche, in New York, two years after he had launched the original Rive Gauche in Paris. Saint Laurent was the first French couturier to introduce a high-quality, ready-to-wear collection alongside his premier couture collection. He publicly endorsed ready-to-wear as a valid fashion force, able to set trends on its own and not subservient to the couture. In doing so, he acknowledged that the free-form clothing silhouette of the late 1960s did not require the customized fitting and virtuosic construction that were the traditional hallmarks of the couture. "Whether the creation is for haute couture or ready-to-wear is not important," Saint Laurent noted in *Time* magazine in 1968. "The act of creation for the two is the same." Commenting that he would like to turn his back on the very rich, he noted, "People on the streets have more impact."[6] New York department stores also reflected the rise of high-quality ready-to-wear: in 1969 Bergdorf Goodman, which had pioneered the in-store custom department, closed its Custom Salon. President Andrew Goodman commented in the *New York Times*, "Being overly extravagant is in poor taste and not of the moment." On a less socially aware note, he added that the director of the custom department would "design ready-to-wear for the Couture Boutique," which would expand to take over some of the space vacated by the custom shop.[7]

This change in style was accompanied by a change in fashion leadership. Diana Vreeland, the doyenne of 1960s Youthquake as well as the promoter of the decade's New Bohemia, anticipated the trends of the 1970s. "The decade just past has made us all heirs to a legacy of extraordinary ideas from which great leeway and change have come. And will continue to come," Vreeland wrote in *Vogue*'s January 1970 issue. "It took the sixties to knock old standards of beauty into a cocked hat and change the very meaning of fashion—it was just that mix of inventiveness and recklessness we needed to escape the cookie-cutter mould and see that fashion today is how simply and comfortably we make ourselves heard."[8] The voice of the decades to come, however, belonged to Grace Mirabella, who replaced Diana Vreeland as editor of *Vogue* in 1971. Less flamboyant than her predecessor and more focused on the concerns and needs of career women—from

health to nutrition and being stylish at the workplace—Mirabella christened the era as one of "nonchalance."[9]

By 1973 New York-based American fashion had witnessed a decade and a half of tradition-breaking developments—simple, easy-to-wear clothes that fit the fast-moving lifestyle of American women; the streamlining of garment construction; an eagerness to embrace new ideas in color, silhouette, and types of fabrics; and newfound confidence in the ability of American designers to set trends. Yet, in the eyes of Paris, New York was still an unsophisticated, provincial source of fashion that depended on the French couture for direction. This perception changed on the evening of November 28, 1973, when New York publicist Eleanor Lambert used a fundraising gala for the restoration of the Queen's bedroom at the French chateau at Versailles as a vehicle to overturn the Parisian-dominated hierarchy, providing American fashion with the greatest validation it had ever known. The event centered on a fashion "face off" between New Yorkers Bill Blass, Stephen Burrows, Halston, Anne Klein, and Oscar de la Renta—the A-team of American design and the first New York designers invited to show in Paris—and Paris's own couture masters Yves Saint Laurent, Emanuel Ungaro, Pierre Cardin, Marc Bohan of Dior, and Hubert de Givenchy. "The French show was held first," the *New York Times* coverage noted, "but from the moment Liza Minnelli strode onstage [for the American runway] belting 'Bonjour Paris,' accompanied by models in a symphony of vanilla to brown tones, the blue and gold theater resounded with bravos and sustained applause." The article was headlined "Fashion at Versailles: French Were Good, Americans Were Great," acknowledging victory on the part of the New York contingent. Its fashion debut in Paris was, according to the *Times*, "a blend of easy understatement and wild fantasy, sophistication and prettiness, demureness and daring, wrapped, for the most part, in a blaze of color . . . It was generally acknowledged that the night belonged to 'les Américains.'"[10]

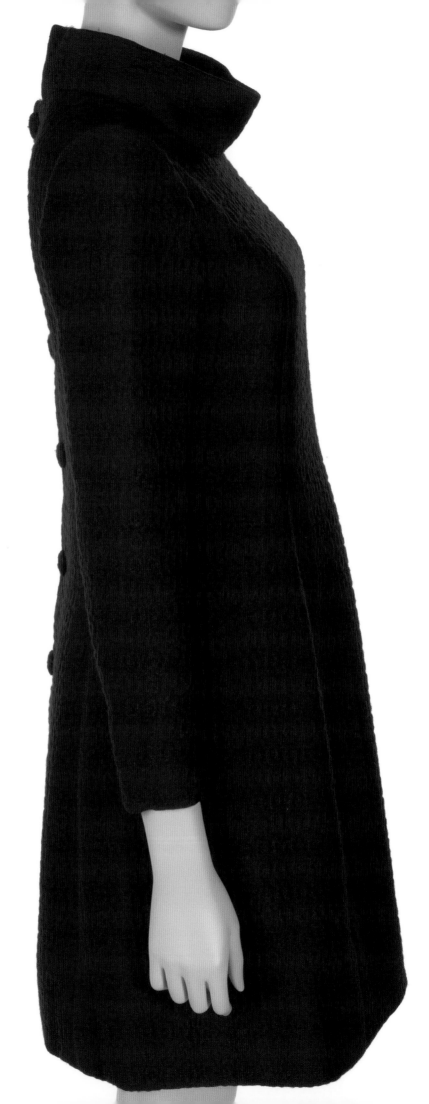

**Arnold Scaasi**

Back-buttoning dress
of matelassé with
standing funnel collar,
1969.

**Oscar de la Renta**

Dress of cotton with
polka dots, late 1960s.

**James Galanos**

Dress of wool
with belt, 1969.

144

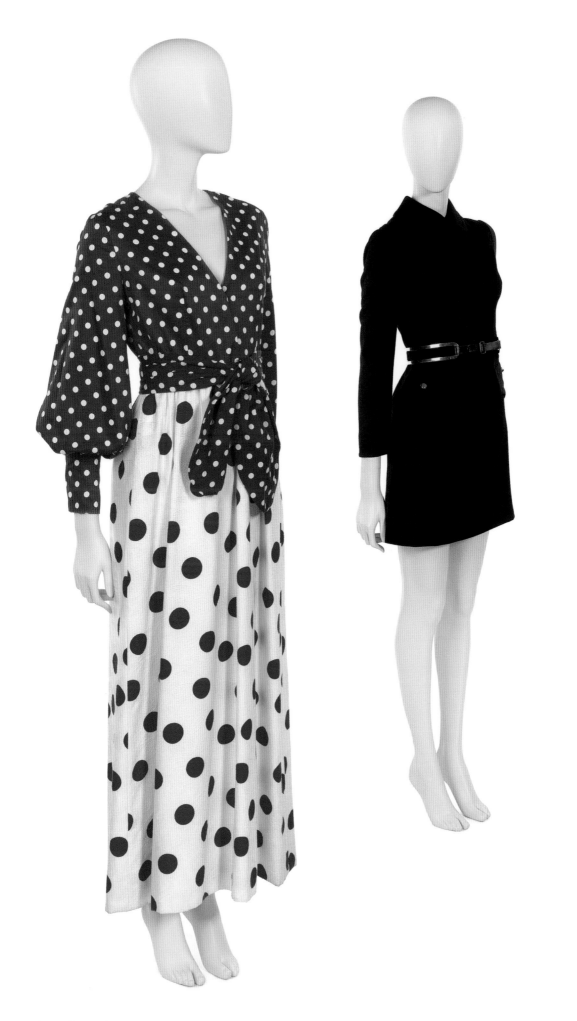

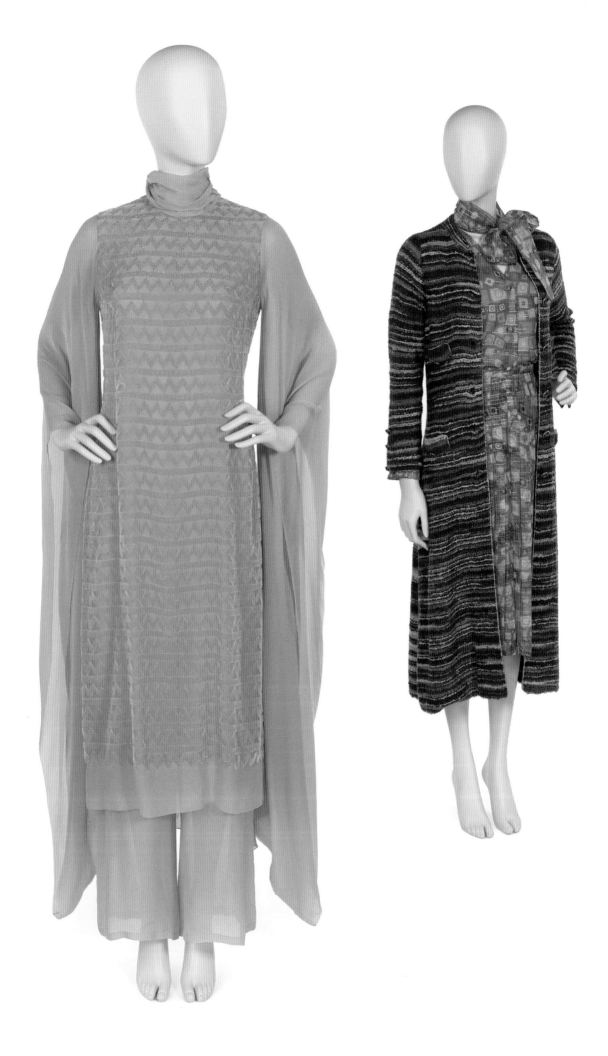

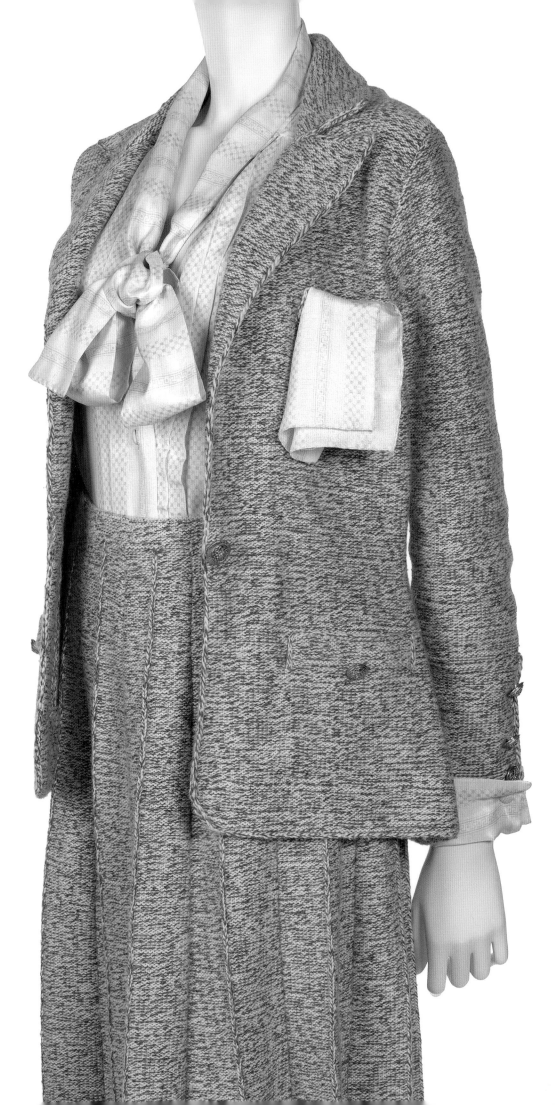

**Attributed to Marc Bohan for the House of Christian Dior**

One-piece tunic-over-pants garment of voided velvet and chiffon, ca. 1969.

**Adolfo**

Dinner ensemble comprising coat of boucle wool knit and two-piece dress of silk, early 1970s.

**Adolfo**

Suit of tweed wool knit with silk blouse and matching pocket scarf, 1972.

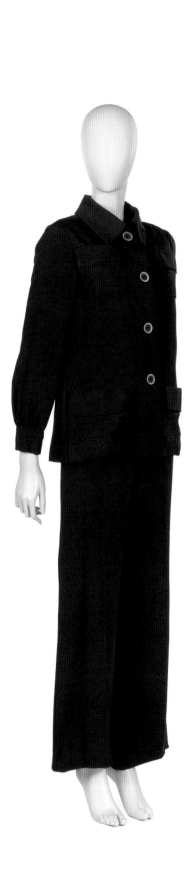

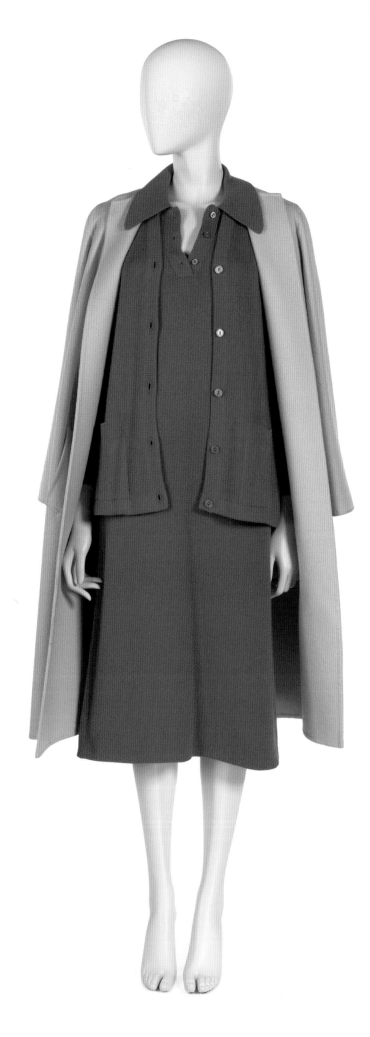

**Bill Blass**

Jumpsuit ensemble of silk broadcloth, 1970.

**Halston**

Day ensemble comprising coat of double-faced wool twill and sheath dress and cardigan of cashmere, ca. 1973.

**Rudi Gernreich for Harmon Knitwear**

Dress of wool geometric knit, 1971.

**Stephen Burrows for Stephen Burrows' World at Henri Bendel**

Evening dress of pieced synthetic single knit jersey, 1960s.

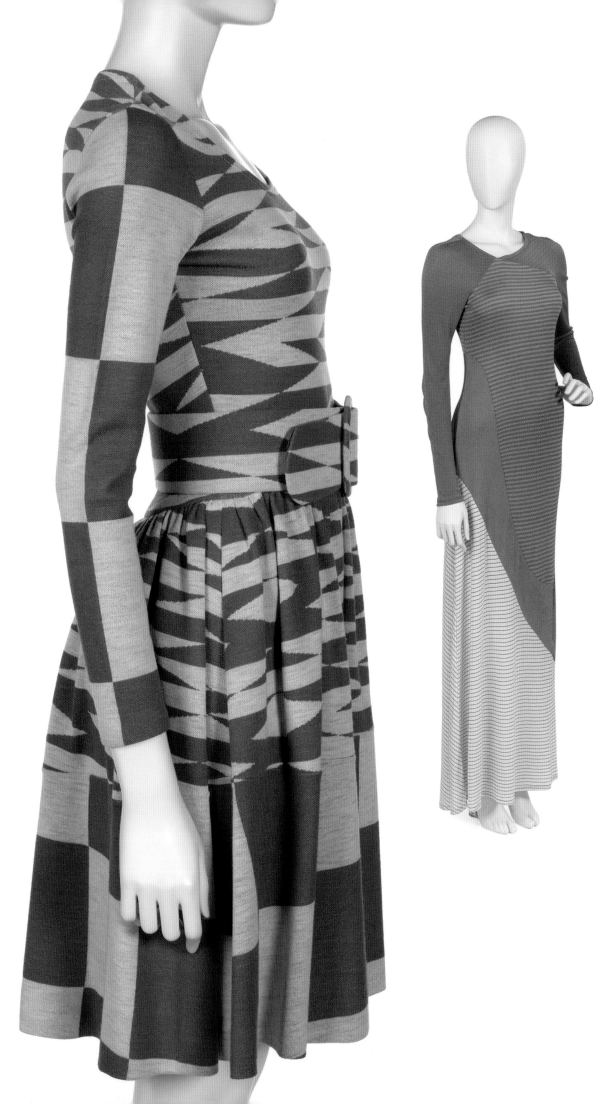

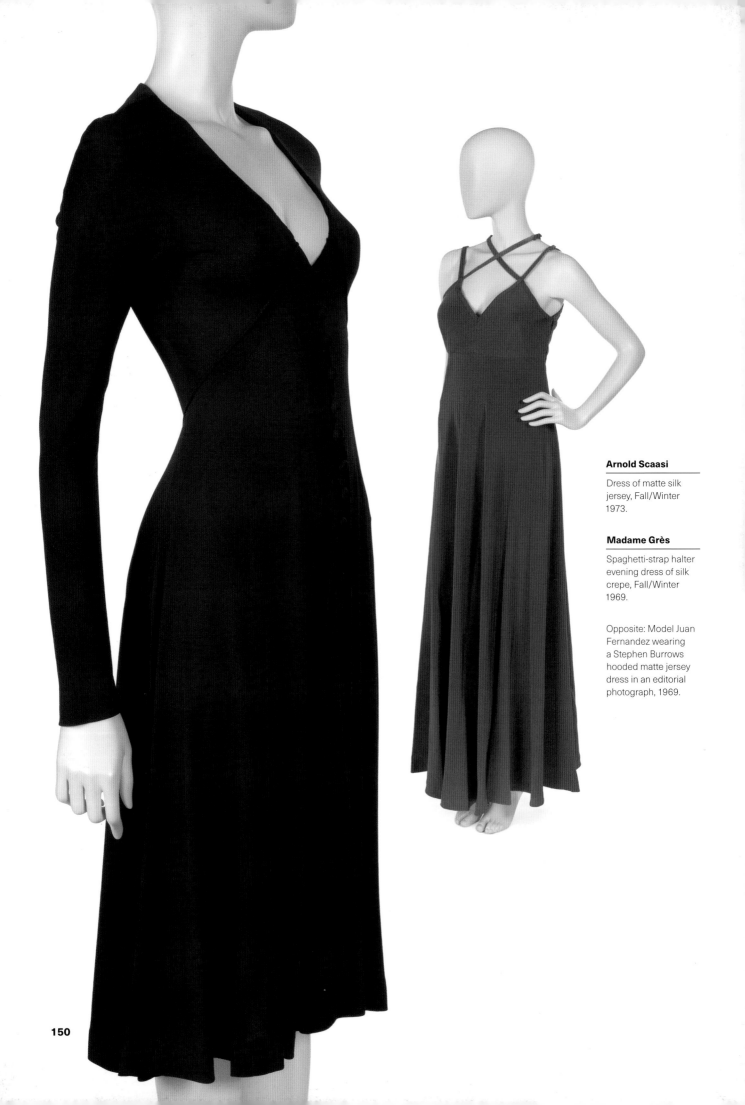

**Arnold Scaasi**

Dress of matte silk jersey, Fall/Winter 1973.

**Madame Grès**

Spaghetti-strap halter evening dress of silk crepe, Fall/Winter 1969.

Opposite: Model Juan Fernandez wearing a Stephen Burrows hooded matte jersey dress in an editorial photograph, 1969.

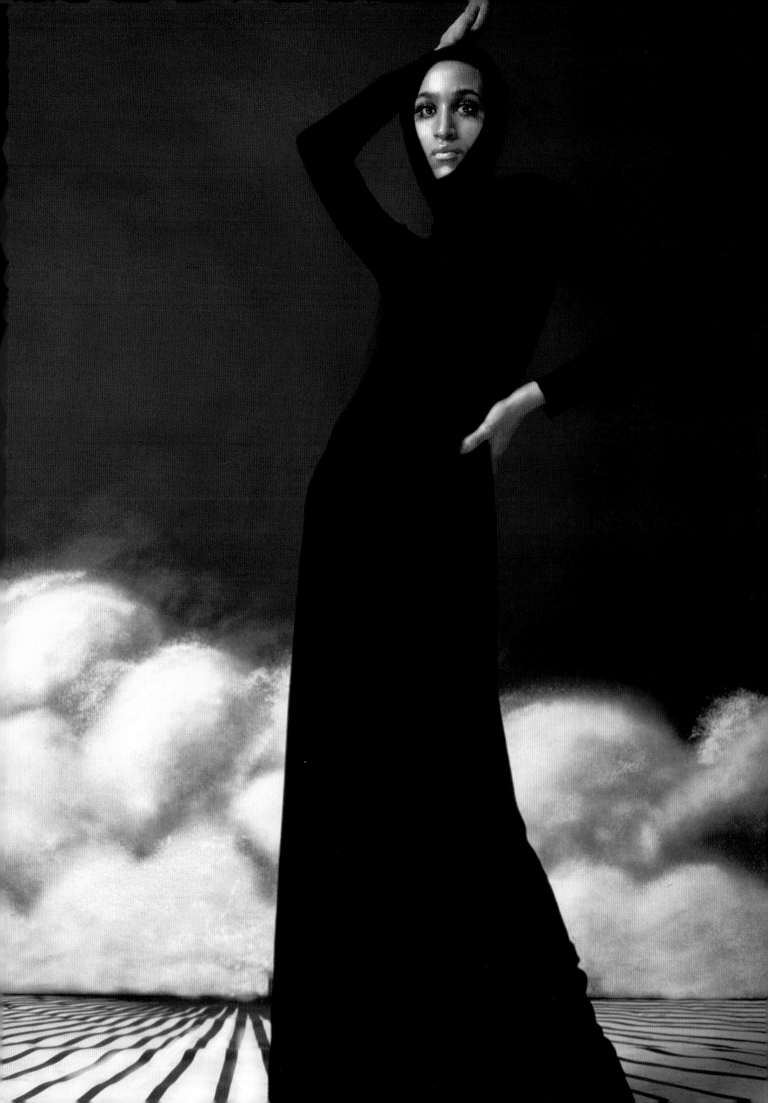

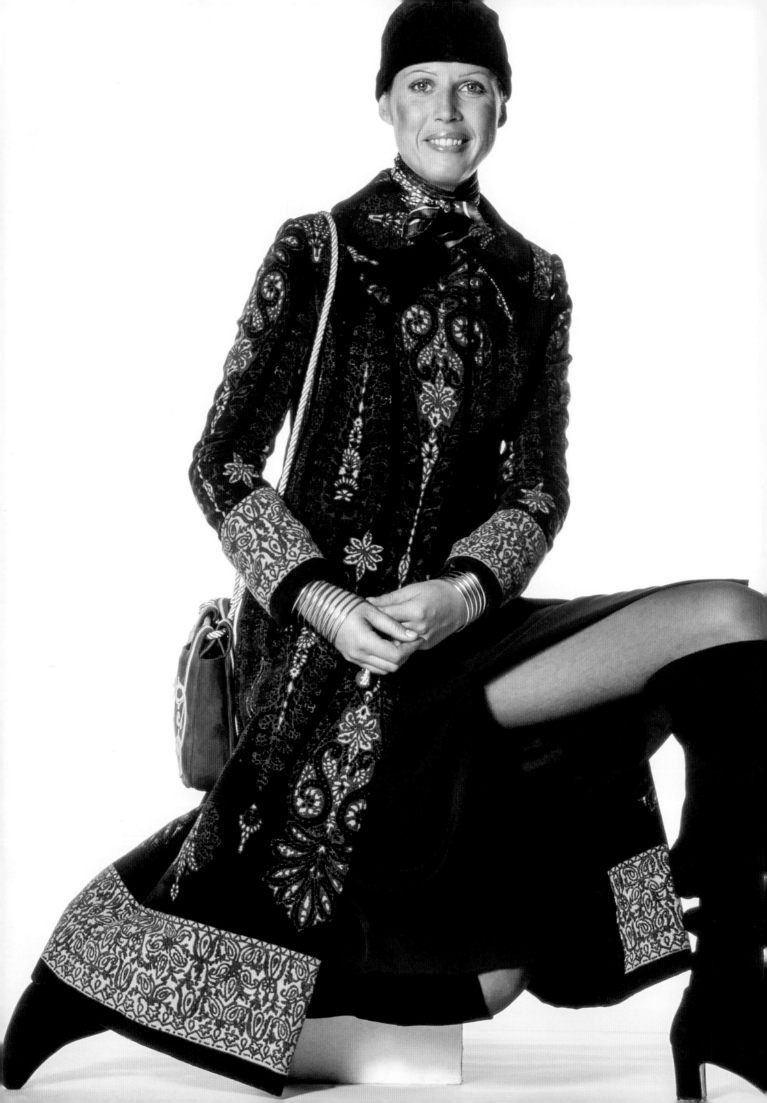

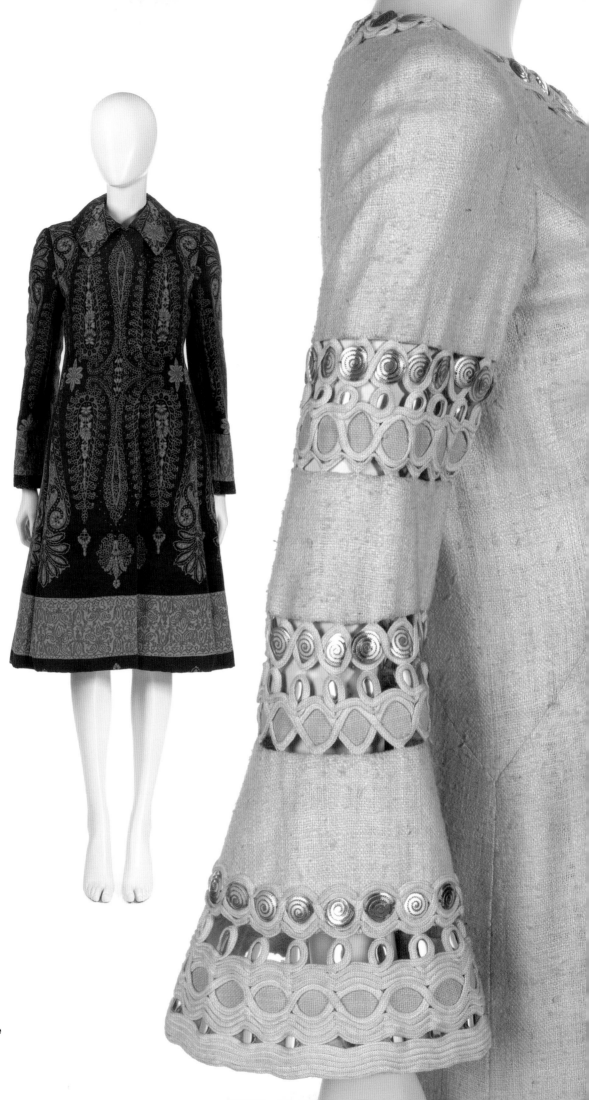

Opposite: Bill Blass coat published in "The New York Collections," *Vogue*, September 1970.

**Bill Blass**

Persian-inspired midi coat of paisley-patterned velour-finished wool, 1970.

**Pierre Balmain, Paris**

Evening dress of unbleached, loosely woven, slightly slubbed linen, Spring 1969.

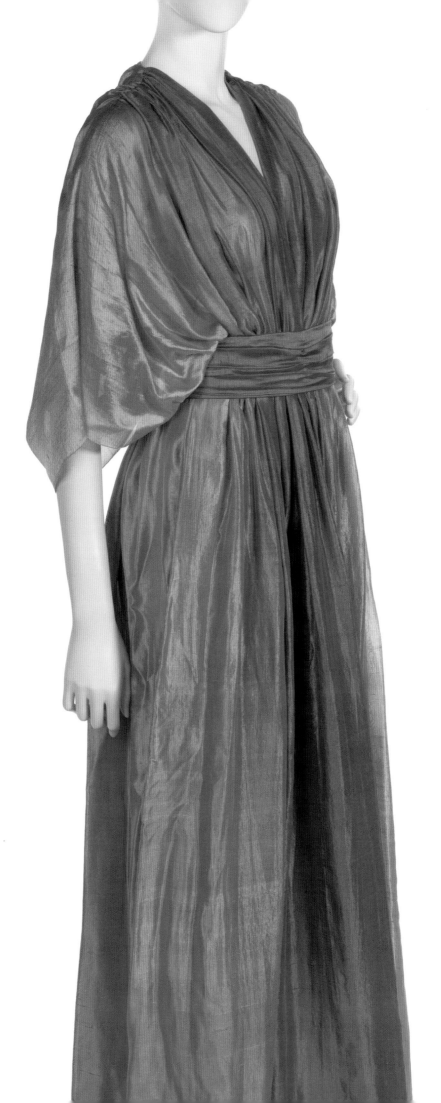

**Irene Galitzine**

Evening caftan of
slubbed silk, with belt,
ca. 1970.

**Valentino**

Evening dress of silk
and accordian-pleated
silk organza ruffles,
1968.

**Norman Norell**

Evening ensemble
comprising coat and
dress of nylon net
embroidered with
faux pearls worn over
underdress of silver
lamé, late 1960s–70.

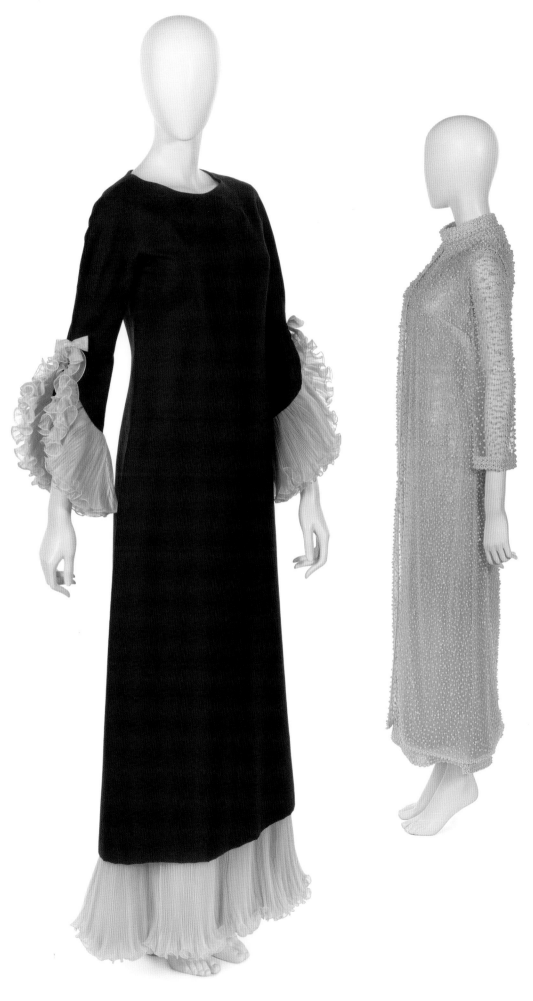

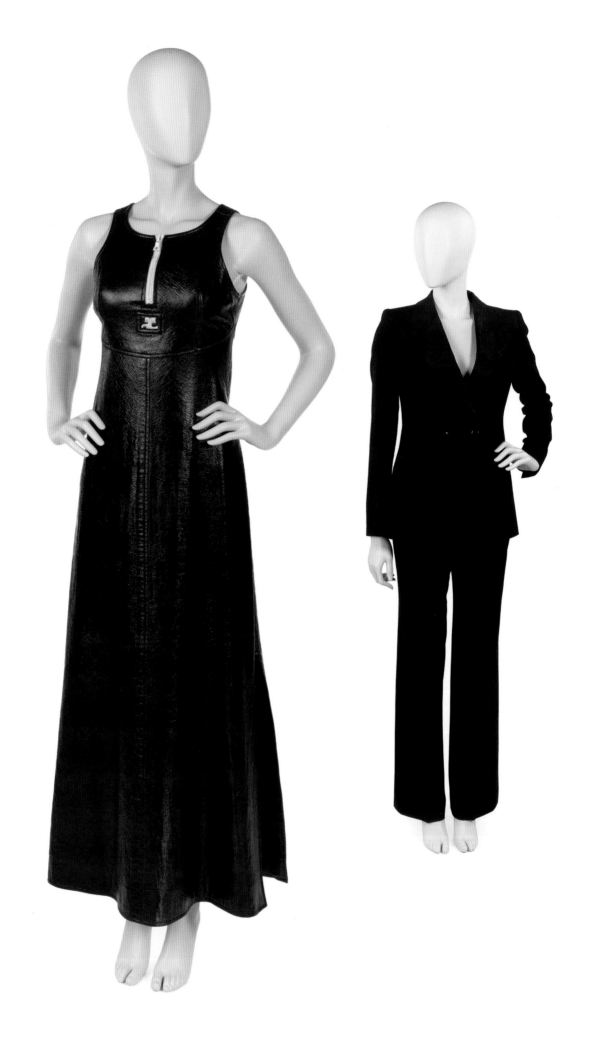

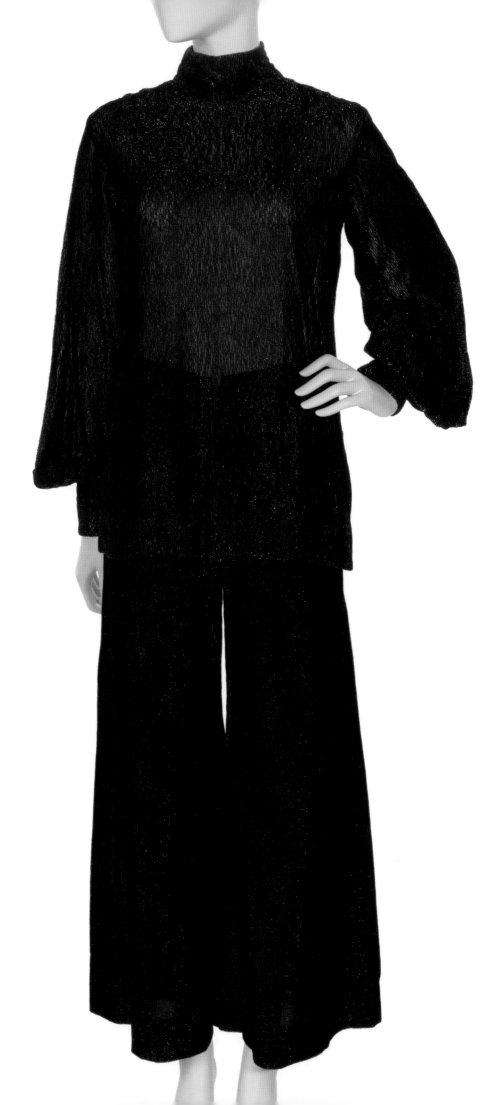

**Courrèges Paris Hyperbole**

Dress of crinkle-texture vinyl on cotton and spandex ground, ca. 1970.

**Yves Saint Laurent**

"Smoking" evening ensemble comprising tuxedo-style jacket and pants and silk chiffon blouse (not shown), Fall/Winter 1971.

**Yves Saint Laurent Rive Gauche**

Evening pajamas comprising chiffon tunic and fine-stripes-shot-with cellophane voided velvet trousers, ca. 1970.

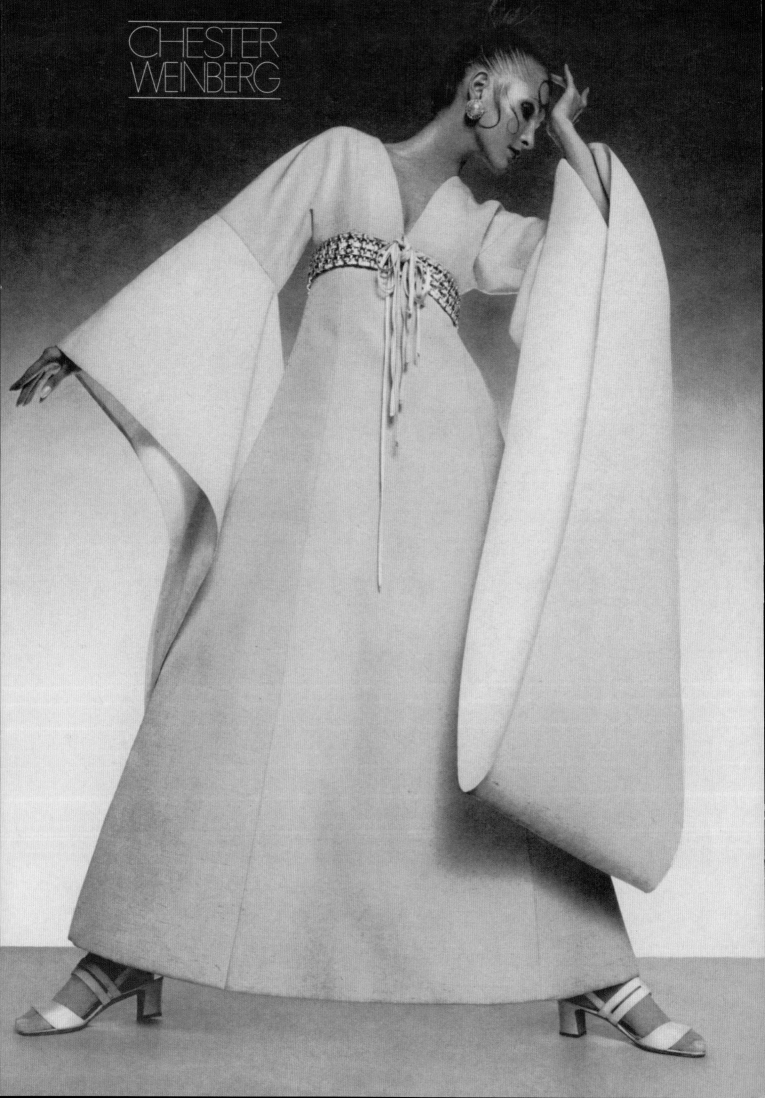

CHESTER
WEINBERG

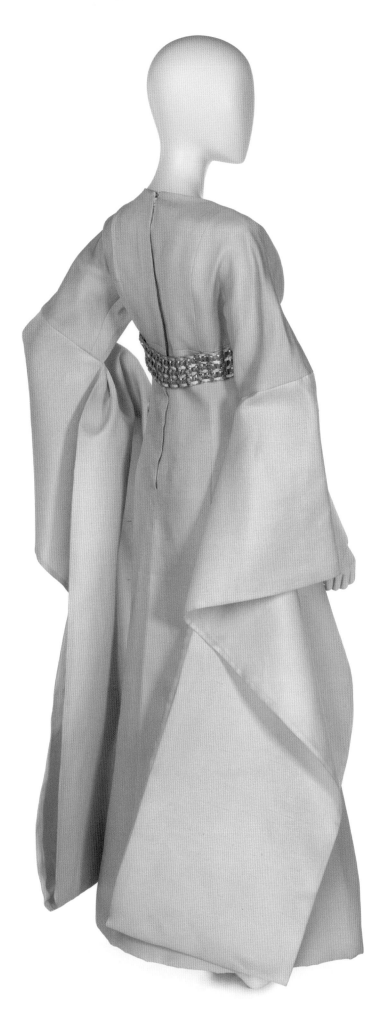

Opposite: Advertisement for Chester Weinberg, published in *Vogue,* February 1, 1969.

**Chester Weinberg**

Evening dress in unbleached silk gazar with ribbon-threaded, gilt-metallic chain belt, 1969.

# Notes

## First Lady Fashion

**1.** *Women's Wear Daily*, January 31, 1961.
**2.** Victoria Lincoln, "A New Sense of What's Important," *Vogue*, January 1, 1960, 108.
**3.** "Fashion Naturals U.S.A.," *Vogue*, January 1, 1960, 139.
**4.** "Designer Oleg Cassini; Styled Jacqueline Kennedy," *The Washington* Post/Associated Press, March 18, 2006, accessed November 14, 2016, http://www.washingtonpost.com/wp-dyn/content/article/2006/03/18/AR2006031800102.html.
**5.** "You Don't Have to Look Hard...To See Another Jackie," *Life*, January 20, 1961, 17.
**6.** *Vogue*, February 1, 1961, page 125.

## Fashioning the 1960s in New York

**1.** Joel Lobenthal, Radical Rags: Fashions of the Sixties (New York: Abbeville Press, 1990), 88.
**2.** Ibid.
**3.** Anne Morra, "Tiger Morse: Fashion Guru and Andy Warhol Star," *Inside/Out: A MoMa/MoMA PSA Blog*, July 23, 2014, http://www.moma.org/explore/inside_out/2014/07/23/tiger-morse-fashion-guru-and-andy-warhol-star.
**4.** Abracadabra featured "one-of-a-kind" designs by students and graduates from the Tobé-Coburn School, Parsons School of Design, and the Fashion Institute of Technology. "Under 21: Way-out fashion in a bizarre young world," *Life*, August 4, 1967, 37–43.
**5.** Amy Larocca, 'The House of Mod," *New York Magazine*, available online, http://nymag.com/nymetro/shopping/fashion/spring03/n_8337/index1.html (accessed 7 January 2015). See also "Women in New York Fashion: A Research Agenda," *Geraldine Stutz Fellowship*, Parsons School of Design, accessed January 7, 2016, http://adht.parsons.edu/GeraldineStutz/.
**6.** Sheila Weller, "Betsey Johnson: A Role Model, Still," *The New York Times* online, February 13, 2015, accessed September 1, 2016, http://www.nytimes.com/2015/02/15/style/betsey-johnson-a-role-model-still.html.
**7.** Caroline Rennolds Milbank, *New York Fashion: The Evolution of American Style* (New York: Harry N Abrams Inc., 1989), 206.
**8.** Geraldine Stutz became only the third woman in the history of fashion retailing in New York to preside over a major fashion establishment, following Hortense Odlum of Bonwit Teller (1934–1940) and Dorothy Shaver of Lord and Taylor (1945–1959). "Henri Bendel & Geraldine Stutz Timeline," Parsons School of Design, accessed September 1, 2016, http://adht.parsons.edu/GeraldineStutz/?page_id=723.
**9.** Russel Taylor, *Exceptional Entrepreneurial Women: Strategies for Success* (New York: Quorum Books, 1988), 35.
**10.** Jesse Kornbluth, "The Battle of Bendel's: How the Midwest took over New York's Citadel of Chic," *New York Magazine*, February 23, 1987, 35.
**11.** Marylin Bender, "Bendel's President Sees Herself as Customer," *The New York Times*, May 10, 1965, 37.
**12.** Sharon Zukin, "B. Altman, Ralph Lauren and the Death of the Leisure Class," in *Point of Purchase: How Shopping Changed American Culture* (New York: Routledge, 2004), 135–136.
**13.** "Geraldine Stutz's Henri Bendel," *Clothes*, 17–18.
**14.** Joan Kron, "Home Beat," *The New York Times*, June 2, 1977, 51.
**15.** "Geraldine Stutz, Henri Bendel, 1977," interview by Dorothy Hannenberg, Oral History Project of the Fashion Industries, Special Collections, FIT Library, Fashion Institute of Technology, State University of New York.
**16.** Jean Rosenberg, interview by Hazel Clark and Lauren Sagadore, November 21, 2014, transcript.
**17.** Milbank, 206.
**18.** Angela Taylor, "Living—and Shopping—Easy in 'East Village' Boutiques," *The New York Times,* December 8, 1965, 60.
**19.** Ibid.
**20.** Robert Sawyer, "Limbo St. Marks™: Resurrecting an Icon" (Unpublished paper, December 24, 2015).
**21.** Ibid.
**22.** Ibid.
**23.** With thanks to Andrea Aranow for this information; in conversation with the author, November 28, 2016.
**24.** Amy Larocca, "The House of Mod," *New York Magazine*, available online, accessed 7 January 2015, http://nymag.com/nymetro/shopping/fashion/spring03/n_8337/index1.html.
**25.** Richard Diennor and Andrea Orr, "Lady Bug Files for Chap. 11: All But 15 Stores to Shut," *Women's Wear Daily*, December 6, 1989, 15.
**26.** "Henri Bendel & Geraldine Stutz Timeline," Parsons School of Design, accessed September 23, 2016, http://adht.parsons.edu/GeraldineStutz/?page_id=723.
**27.** Milbank, 210.

## Youthquake

**1.** "Youthquake," *Vogue*, January 1, 1965, 112.
**2.** "Paris," *Vogue*, September 15, 1964, 101.

**3.** Geoffrey Beene, Marylou Luther, *Geoffrey Beene: The First Twenty Five Years* (New York: Geoffrey Beene, Inc., 1988), 3.
**4.** "It's OP from Toe to Top," *Life*, April 16, 1965, 54.
**5.** Marylin Bender, *The Beautiful People* (New York, Dell Publishing Co., Inc., 1967), 185.
**6.** "*Vogue*'s Own Boutique of Suggestions, Finds, and Observations," *Vogue*, November 15, 1965, 79.

## Liberating Fashion

**1.** Linda Charlton, "Women March Down Fifth in Equality Drive," *The New York Times*, August 27, 1970, A1, 30.
**2.** According to the 1960 census, the average man earned about $4,100 a year, whereas the average woman earned $1,300. U.S. Department of Commerce, Bureau of the Census, *Current Population Reports: Consumer Income*, Series P-60, n. 26, June 9, 1961, 1. NB: The term "sexual harassment" was not used at the time.
**3.** Elizabeth Kendall, *Autobiography of a Wardrobe* (New York: Anchor Books, 2009), 113.
**4.** Kendall, 74. Emphasis in original.
**5.** Sheila Wheeler, "Betsey Johnson: A Role Model, Still," *The New York Times*, February 13, 2015 and *Rags*, vol. 5, October 1970, 20.
**6.** Joel Lobenthal, *Radical Rags: Fashions of the Sixties* (New York: Abbeville Press, 1990), 11.
**7.** Lobenthal, 50 and 58.
**8.** Carole Turbin, correspondence of June 27, 2016, and conversation with Margo Jefferson, September 22, 2016.
**9.** Lobenthal, 13.
**10.** Group Portrait of NOW Founders at NOW Organizing Conference in Washington, DC, October 1966, photo by Vince Graas, Schlesinger Library, Harvard University, and Anselma Dell'Olio, "Home Before Sundown," in Rachel Blau DuPlessis and Ann Snitow, eds., *The Feminist Memoir Project.* (New York: Three Rivers Press, 1998), 149.
**11.** "Scenes," *Village Voice*, March 13, 1969, 16 and Robin Morgan, "No More Miss America!" Redstockings Press Release, August 22, 1968.
**12.** Elizabeth Kendall in discussion with the author, September 25, 2016.
**13.** Carol Hanisch, "Two Letters from the Women's Liberation Movement," in Rachel Blau DuPlessis and Ann Snitow, eds., *The Feminist Memoir Project* (New York: Three Rivers Press, 1989), 199.
**14.** "The No Bra Look," *Women's Wear Daily*, August 27, 1969, 12, in Deirdre Clemente, *Dress Casual: How American College Students Redefined American Style* (Chapel Hill: University of North Carolina Press, 2014), 140.

**15.** Lobenthal, 17.
**16.** Clemente, 142.
**17.** Suzanne Gordon in conversation with the author, September 4, 2016; correspondence with Tara Gordon, February 10, 2016.
**18.** Carole Turbin in correspondence with the author, November 5, 2016.
**19.** Carole Turbin in correspondence with the author, regarding Queens College, and conversation with Elizabeth Kendall in conversation with the author, September 25, 2016.
**20.** "Trousers Stride Into Big City Ways," *Women's Wear Daily*, vol. 100, no. 125, June 28, 1960, 5.
**21.** Bernadine Morris, "Saint Laurent Has a New Name for Madison Ave.—Rive Gauche," *The New York Times*, September 16, 1968, 54.
**22.** Lobenthal, 17.
**23.** Carole Turbin in correspondence with the author, June 27, 2016.
**24.** Morris, 54.
**25.** Margo Jefferson in conversation with the author, September 22, 2016.
**26.** Tara Gordon in correspondence with the author, February 10, 2016.
**27.** Jewish Women's Archive, excerpt from Bella Abzug Interview with Global Education Motivators, April 24, 1997.
**28.** "Pity the Poor Working Girl: A Report on Office Dress Codes," *Rags*, vol. 5, October 1970, 25.
**29.** "Pity the Poor Working Girl," 25.
**30.** Margo Jefferson, *Negroland: A Memoir* (New York: Vintage Books, 2015), 166.
**31.** Clemente, 7.
**32.** See Tanisha Ford, *Liberated Threads: Black Women, Style, and the Global Politics of Soul* (Chapel Hill: University of North Carolina Press, 2015) for a discussion of the AJAS shows and the Grandassa Models. The official title of the first show was "Naturally '62: The Original African Coiffure and Fashion Extravaganza Designed to Restore Our Racial Pride and Standards."
**33.** Ford, 102.
**34.** Charlton, 30.
**35.** Lobenthal, 157.
**36.** Shulamith Firestone, "Notes From the First Year," New York Radical Women, 1968, 1.
**37.** "Fashion Fascism: The Politics of Midi," *Rags*, vol. 5, October 1970, 20.
**38.** Elizabeth Kendall in conversation with the author, September 25, 2016.

## New Bohemia

**1.** John Gruen, "Where is New Bohemia Going," *Vogue,* August 1, 1967, 101.
**2.** Jon Carroll, "A Rags Special Report: Boutiques

and Hip Capitalism," *Rags,* February 2, 1971, 39.
**3.** Gruen, "Where is New Bohemia Going," 141.

## Fashion and Consciousness

**1.** Tanisha C. Ford, *Liberated Threads Black Women, Style and the Global Politics of Soul* (Chapel Hill, NC: UNC Press Books, 2015), 55.
**2.** Ibid., 56.

## New Nonchalance

**1.** "Fashion: 1972—The New Nonchalance in Fashion," *Vogue,* January 1, 1972, 50.
**2.** Ibid.
**3.** Stephen Burrows, interview by John Robert Miller, February 19, 1999, tape 1 side B, transcript.
**4.** Beth Ann Krier, "Clean and Classic Clothes," *Los Angeles Times*, September 19, 1971, 4.
**5.** "Fashion: Yves in New York," *Time*, September 27, 1968, 63.
**6.** Ibid.
**7.** "The End of a Salon," *The New York Times*, May 13, 1969, 36.
**8.** "It's A New Decade—A Whole New Ball Game! Are You Ready For It?" *Vogue*, January 1, 1970, 93.
**9.** "Fashion: 1972—The New Nonchalance in Fashion," 50.
**10.** Enid Nemy, "Fashion At Versailles: French Were Good, Americans Were Great," *The New York Times*, November 30, 1973, 32.

# Index

# Acknowledgments

Many people have made *Mod New York* possible, and we wish to thank them for their efforts in its planning and realization. Wide-ranging interviews and conversations added valuable insights, and we thank Andrea Aranow, Stephen Burrows, William DeGregorio, Frederick Eberstadt, Placida Grace Hernandez, Avra Petrides, Sarah Jane Rodman, Alan Rosenberg, and Claire B. Shaeffer. Allison Johnson of the Ralph Lauren Library contributed a valuable packet of archival materials. Jonathan Scheer, President of J. Scheer & Company must also be thanked for his textile conservation and dry cleaning expertise in helping to make the Museum's costume collection look its best.

We thank the lenders to the exhibition, and all those who provided images for the book. Natalie Shivers provided outstanding editorial advice, helping to shape the manuscript's content in its most formative stages. As always, the project involved the efforts of many people at the Museum of the City of New York. We thank Whitney W. Donhauser, Ronay Menschel Director, as well as Lee Berman, exhibition specialist; Matt Heffernan, registrar for exhibitions and loans; Sarah M. Henry, deputy director and chief curator; Todd Ludlam, director of exhibitions installation; Susan Madden, former senior vice president for external affairs; Tracy McFarlan, manager of public programs; Autumn Nyiri, manager of curatorial affairs; Frances Rosenfeld, curator of public programs; Polly Rua, vice president for institutional advancement; Morgen Stevens-Garmon, theater archivist; Alice Stryker, director of grants and sponsorships; Jacob Tugendrajch, who oversaw publicity with outside consultant Gary Zarr; and Lindsay Turley, director of collections. We especially want to single out Sara Spink, who handled the myriad details of the project, both the book and the exhibition, with great care and humor.

The exhibition's superb installation design was created by Studio Joseph. We also greatly appreciate the elegant and lively book design by Yve Ludwig. Elizabeth White, our editor at The Monacelli Press, saw us through the entire project from start to finish.

*Phyllis Magidson and Donald Albrecht*

# Credits